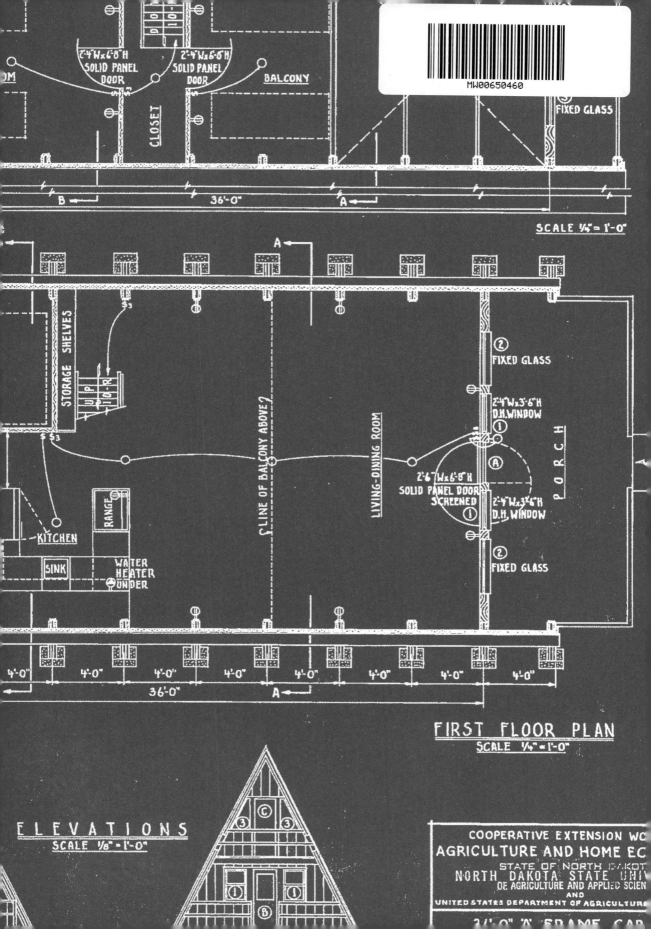

2'-4"Wx6'-8"H
SOLID PANEL
DOOR

2'-4"Wx6'-8"H
SOLID PANEL
DOOR

BALCONY

FIXED GLASS

CLOSET

B ← 36'-0" A ←

SCALE ¼" = 1'-0"

A

STORAGE SHELVES

$3

U P D R

$3

KITCHEN

RANGE

SINK

WATER HEATER UNDER

LINE OF BALCONY ABOVE?

LIVING-DINING ROOM

② FIXED GLASS

2'-4"Wx3'-6"H
D.H. WINDOW
①

Ⓐ

2'-6"Wx6'-8"H
SOLID PANEL DOOR
SCREENED
①

2'-4"Wx3'-6"H
D.H. WINDOW

② FIXED GLASS

PORCH

4'-0" 4'-0" 4'-0" 4'-0" 4'-0" 4'-0" 4'-0" 4'-0"

36'-0" A →

FIRST FLOOR PLAN
SCALE ¼" = 1'-0"

ELEVATIONS
SCALE ⅛" = 1'-0"

③ Ⓒ ③

① Ⓑ ①

COOPERATIVE EXTENSION WO
AGRICULTURE AND HOME EC
STATE OF NORTH DAKOT
NORTH DAKOTA STATE UNIV
OF AGRICULTURE AND APPLIED SCIEN
AND
UNITED STATES DEPARTMENT OF AGRICULTURE

24'-0" "A" FRAME CAB

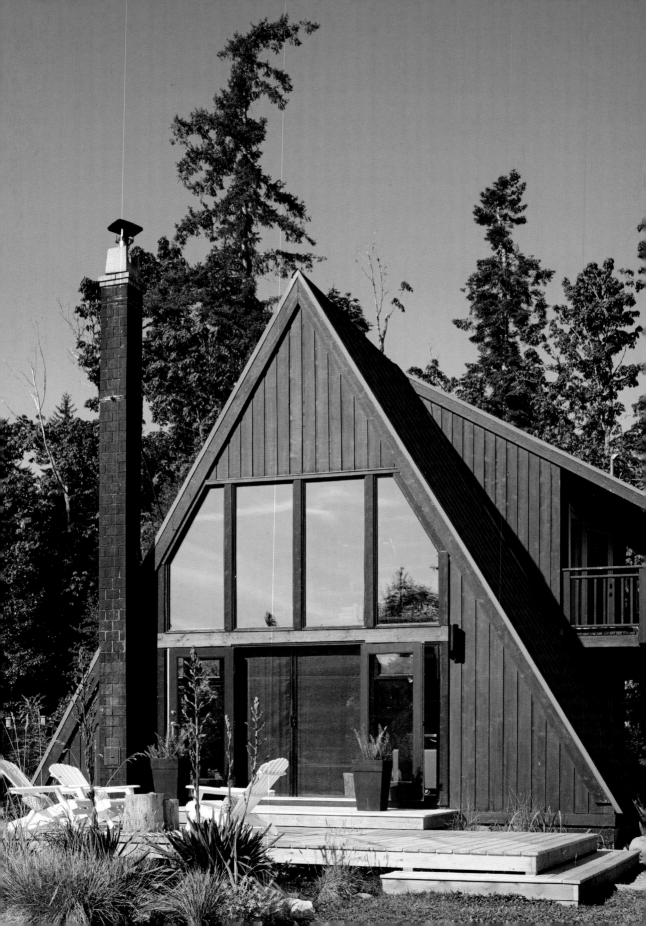

THE MODERN

A

FRAME

PHOTOGRAPHY BY BEN RAHN

INTRODUCTION BY CHAD RANDL

GIBBS SMITH
TO ENRICH AND INSPIRE HUMANKIND

25 24 23 10 9 8

Text © 2018 Gibbs Smith Publisher
Introduction © 2018 Chad Randl
Photographs © 2018 Ben Rahn

Published by
Gibbs Smith
P.O. Box 667
Layton, Utah 84041

1.800.835.4993 orders
www.gibbs-smith.com

Designed by Sheryl Dickert
Printed and bound in China
Gibbs Smith books are printed on either recycled, 100% post-consumer waste, FSC-certified papers or on paper produced from a 100% certified sustainable forest/controlled wood source.

Library of Congress Cataloging-in-Publication Data

Names: Rahn, Ben, photographer (expression)
Title: The modern A-frame / photographs by Ben Rahn.
Description: First edition. | Layton, Utah : Gibbs Smith, 2018.
Identifiers: LCCN 2017031768 | ISBN 9781423647638 (hardcover)
Subjects: LCSH: A-frame houses--United States. | A-frame houses--British
 Columbia--Vancouver Island.
Classification: LCC NA7205 .M625 2017 | DDC 728/.370973--dc23
LC record available at https://lccn.loc.gov/2017031768

A remodeled 1959 A-frame in the Sierra Nevada Mountain Range serves as the full-time residence to a family of four in Olympic Valley, California.

NEXT PAGE: A 1964 A-frame in northeast Portland stands at 3,000 square feet and is a year and a half into an extensive interior remodel.

WHEN I STARTED MY ARCHITECTURAL PHOTOGRAPHY STUDIO, I CALLED IT "A-FRAME" SO WE'D BE FIRST IN THE PHONE BOOK. IT'S GREAT HOW THINGS COME FULL CIRCLE.

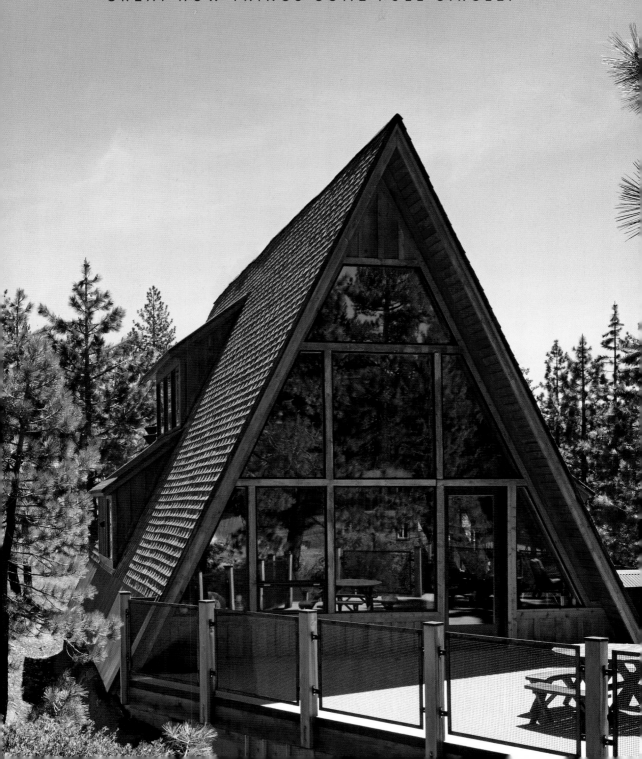

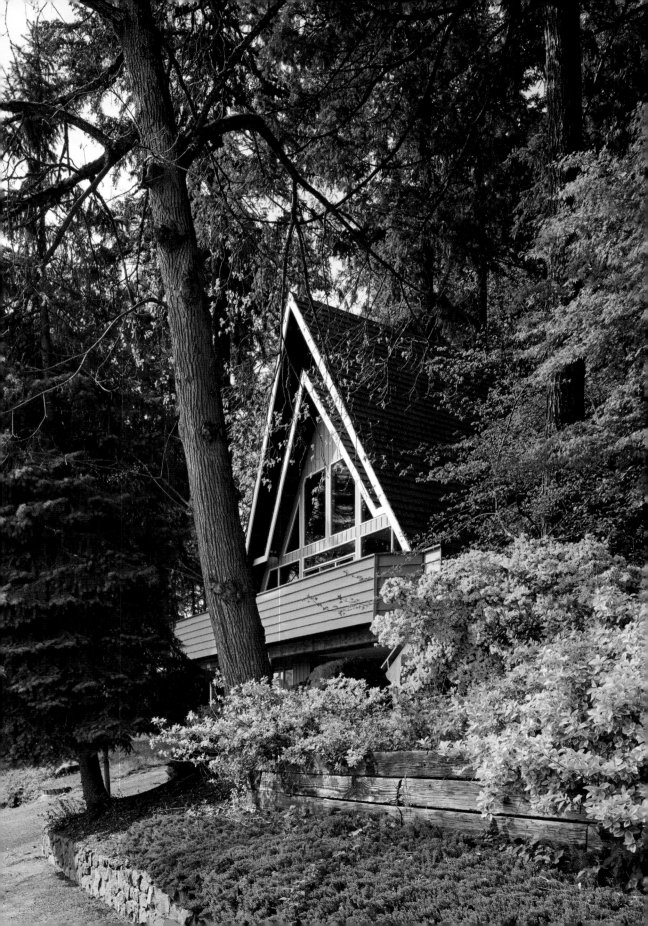

CONTENTS

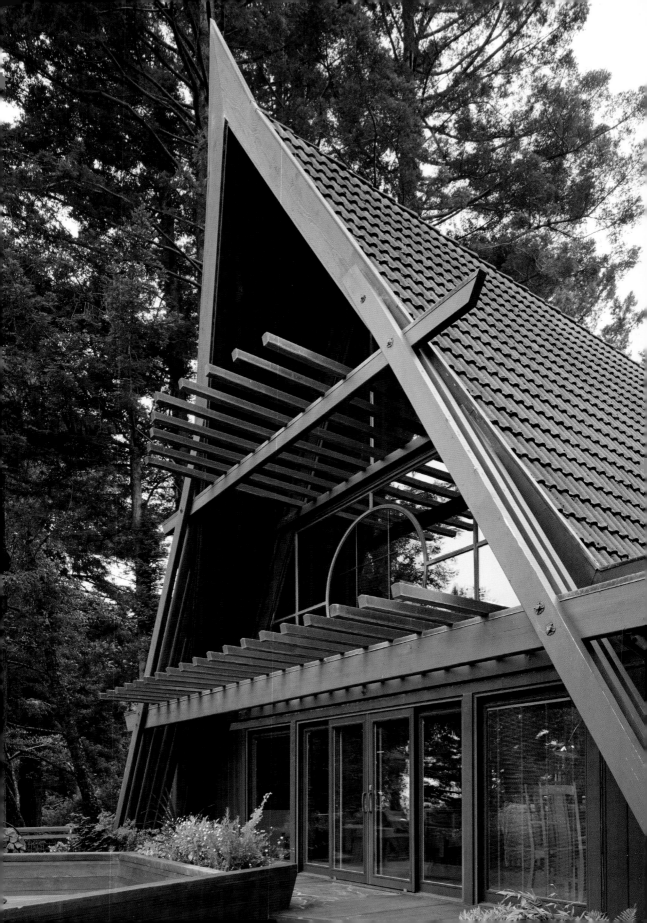

INTRODUCTION

Design ideas come and go. They rise up through a combination of forces—the persistence of influential or determined advocates, a resonance with the spirit of the age, editors looking for good copy and alluring images. Then they fall away, almost imperceptibly at first, as the concept moves from startlingly new to conventional, from challenging the status quo to being the status quo. As an idea becomes common and then cliché, early promoters lose interest or even disown it. Only after a period of time and forgetting might the idea reemerge. A new generation, motivated by admiration for the idea's merits or nostalgia for the era that it evokes picks it up and reinterprets its meaning through contemporary priorities and tastes.

The triangular building is one such idea. Born of a neolithic search for shelter, it was also utilized as storehouse, stable, and shrine. Mostly forgotten by the early twentieth century, enough precedents survived to trace the lineage of a new revival. Finding new use as a base for recreation, the A-frame became one of the most recognizable (and malleable) building forms of the 1950s–70s, typifying an era of optimism, abundance, and play. Then triangular design seemed to disappear—from the preferences of tastemakers, from the pages of magazines, from popular consciousness, if not from the landscape. In recent years, the reemergence of the A-frame has been marked less by the construction of entirely new examples and more the rehabilitation and creative adaption of designs dating from that postwar boom.

Westgate Paradise in Trinidad, California, a custom 1960s Japanese A-frame with a Japanese garden, is available as a vacation rental.

It's little wonder such an unassuming building appeared on so many disparate points of the globe across the span of millennia. The angle of excavated postholes demonstrate the ancient presence of structures assembled of opposing rows of beams tilted to meet at a point overhead and with a covering that served as both walls and roof. Japanese *tenchi-kongen* forms set into the ground, pole and thatch houses of New Guinea set on platforms above ground, and Scandinavian *sadeltakshus* "saddle roof houses" all shared this triangular shape. Its beams and covering were made with whatever material was readily at hand, from bamboo to birch, from sod to wood shingles. Gable ends were enclosed with wattle and daub, or plank, or brick. Vernacular builders appreciated the triangular building's combination of structural strength and efficiency, but they must have also liked its geometric purity and symbolic potency.

These same attributes appealed to designers such as Bruno Taut and Rudolf Schindler who picked up the form in the first decades of the twentieth century. An Austrian émigré to Southern California and protégé of Frank Lloyd Wright, Schindler was a central proponent of modern architecture. During the 1920s and 1930s he designed a number of triangular structures that demonstrated his interest in integrating form technology and contemporary materials. His Gisela Bennati Cabin built on a hillside above Lake Arrowhead, California, with its innovative use of plywood, glazed gable ends, and open loft interior was a clear precursor to the thousands that would follow.

In the aftermath of World War II, the United States enjoyed a period of unprecedented economic expansion that brought leisure time and disposable income to ever larger portions of the population. Second cars and second televisions were followed by second homes built on shorelines and newly carved ski resorts. A playful design vocabulary seemed appropriate for this new recreation environment and architects responded, extending Schindler's experimentation with triangular forms. MIT architecture student Henrik Bull developed an influential example cantilevered over the slopes in Stowe, Vermont; Andrew Geller nestled a version like driftwood among the dunes of a Long Island beach. San Francisco designers John Campbell, Worley Wong, and Terry Tong developed an early triangular house kit consisting of all the materials weekend carpenters needed to build their own including precut lumber, hardware, and nails.

The publication of these versions in influential magazines such as *Arts & Architecture* and *Sunset* introduced the trend to ever larger audiences. By the 1960s, national wood product companies and local lumber yards were pro-

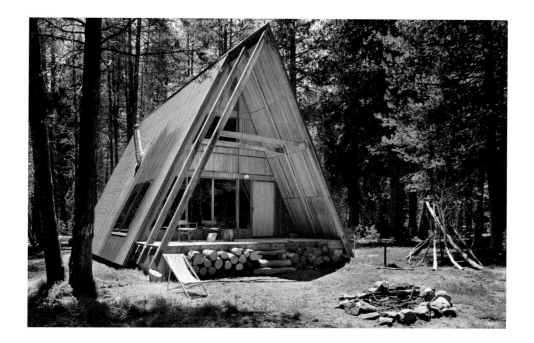

This vacation property A-frame is a new build with modern interiors. It's located in Far Meadow, Yosemite, California.

ducing plan books and prefabricated kits. The term A-frame came into widespread use and, because of the idea's popularity, came to encompass any structure with a steeply pitched roof. The A-frame's spread was not limited to the United States as the form again reasserted a global presence. Postwar A-frame vacation homes were built from the Alps to Argentina and Australia, as in the past, utilizing local materials to both practical and aesthetic ends.

Partly due to its association with prosperity and the good life, partly because its form was instantly recognizable, the A-frame also had considerable commercial appeal. Triangular motel offices, pet stores, and gas stations appeared along shopping strips from coast to coast. Fast food chains such as Whataburger and Der Wienerschnitzel developed A-frame motifs for their outlets. Prominent roofs illuminated by floodlights and painted bright red and orange served as enormous billboards distinguishing these establishments from others, luring cars off the road, and sticking in the minds of consumers. To some, the skyward reach of the A-frame was a spiritual evocation. Places of worship, including Eero Saarinen's chapel at Concordia Theological Seminary in Indiana, the Air Force Academy Cadet Chapel in Colorado, and others in South Korea, Norway, and elsewhere, utilized the triangular form, likening it to hands folded in prayer.

Then, for more than two decades starting in the mid-1970s, the A-frame became

a formula non grata. Poisoned by its own popularity, the A-frame saw a precipitous drop in interest and cool factor. Arbiters of taste considered it tired and dated as new recreation typologies and practices emerged. Resort condos and homes with conventional forms and year-round amenities replaced quirky cabins and cottages intended for seasonal use. Perhaps there was nothing more damning to the once–avant garde credentials of triangular design than to be reproduced as a fast food restaurant or as a children's toy (Fisher-Price's Little People A-frame doll house was introduced in 1974). The 1970s energy crisis dealt a further blow, increasing the cost of travel to distant vacation spots and the cost of climate controlling A-frames that (with open interiors, lack of insulation, and unventilated ceilings) were notoriously difficult to keep warm in the winter and cool in the summer.

Beginning in the late 1990s, however, there began a small trickle of renewed interest in A-frame design. A few plans were still on offer for amateur builders. A few amateur builders were still building from those plans or their own. More substantially, by the 2000s there was a growing interest in purchasing surviving postwar A-frames specifically with the intent to revitalize them. The A-frame was swept up in a current of rising appreciation for what had come to be called "Midcentury Modern," a trend that had likewise increased the estimation of all things Charles and Ray Eames–related and the appearance of retailers such as Design Within Reach. The challenge of updating an old idea and asserting its contemporary relevance drove other A-frame rehab projects.

A building typology defined by its distinctive triangular appearance might seem an unlikely candidate for reinterpretation. Yet from its earliest history the A-frame accommodated great variety. To those looking closely, postwar designs drew together multiple interpretations within their angled walls, at the same time evoking the unpretentiousness of a vernacular hut and the studied purity of Modernism. They were contemporary and traditional, edgy yet inviting. Some designs featured dormers that cut through the roof plane on the second or first floor; some reoriented the structure so that a glass-fronted ground-level dormer became the primary facade and entrance. Others played with the roof pitch, emphasizing the vertical by steeply angling the roof walls, or alternately flattening the form, attenuating it along the ground plane. Some versions pushed together two or more triangular volumes in a cross-gable or T-shaped plan (one featured eight intersecting gables).

Variations reveal designers grappling with liabilities innate to the A-frame, especially the shortage of headroom and daylight. They exhibit responsiveness to the needs of individual clients. They demonstrate the designer's desire

to inject their creative energies and style into this form while retaining the A-frame's iconic recognizability and its appealingly clean arrangement of line and plane. The inherent restrictions of the form present an alluring challenge. It's why A-frames have been the subject of studio exercises in architecture schools like the University of Virginia. As faculty and practicing designers know, limitation—in site, or budget, or materials—often stimulates creative solutions.

A-frame renovation remains a niche activity. Postwar A-frames appeal to a select group interested in design and design history, to those seeking simplicity or a departure from convention. They will remain unappealing to those who remember the form mostly for its period of decline when it was considered more tacky than trendy, its connection to history a liability rather than an asset. And they will no doubt remain unappealing to those who equate square footage with happiness. If these disinterested parties buy an A-frame it's usually for the valuable land upon which it sits. The A-frame is swiftly demolished and hauled off in a dumpster, redefined as construction debris replaced by something much larger (and usually less angular). Those who are drawn to the A-frame as an idea, who see it as something to save and celebrate and update with a sensitivity to its past have different plans. As the projects in the following pages illustrate, they carry on the tradition of adaptation, finding ways to upgrade the house while acknowledging its history. They seek a livable blend of old and new, using the strictures of the form as a spur to creativity.

The A-frame first excited my interest as a design idea that rose and fell only to rise again. As a student of popular architectural culture, historic preservation, and the process of design, I find these examples fascinating markers of shifting taste across time. Whether triangular buildings, shag carpeting, or Victorian-era Main Street facades, what is treasured one day is disparaged the next. When these ideas reemerge (as they commonly do) they tell us something about the past, but also, reconfigured and interpreted, about the era of their re-adoption. What does the interest in A-frames as documented in this book suggest about our own time? Is it a discomfort with the direction of contemporary design and a desire to retreat to comfortingly recognizable symbols of a bygone era? A symptom of timidity about the future? Or does it suggest a yearning for a time of playful experimentation, when every house doesn't look like every other house and simplicity bred creativity?

—Chad Randl
Author of *A-frame* (Princeton Architectural Press)

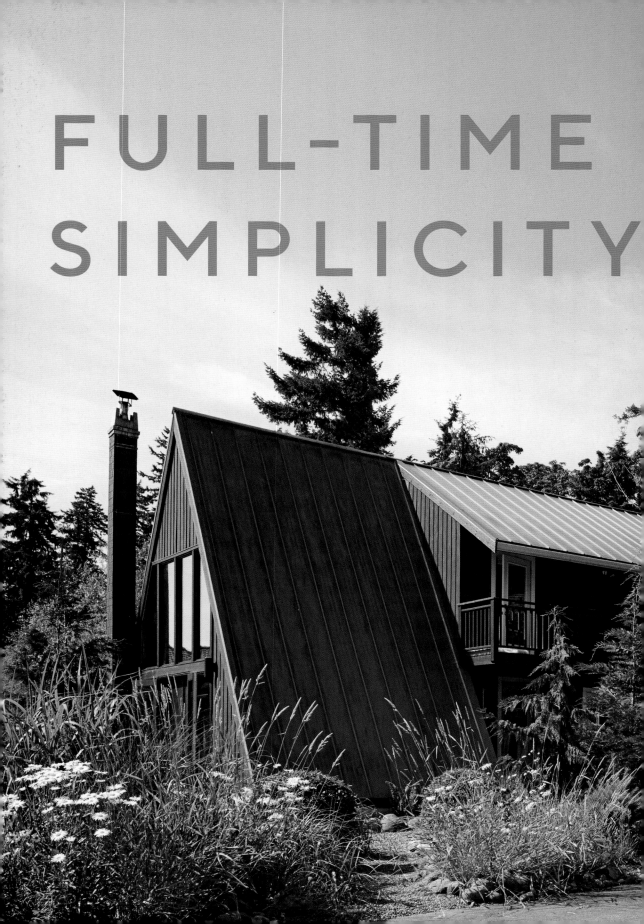

FULL-TIME SIMPLICITY

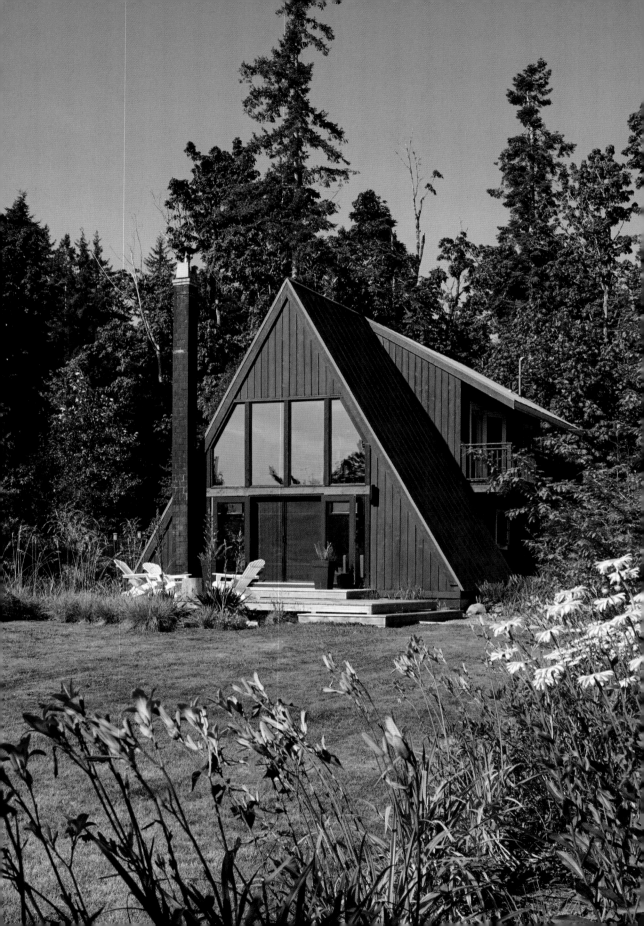

KYST HUS

Union Bay, Vancouver Island

When a home has been on the market for more than a year, and resembles more of an out-building belonging to the adjacent property than a proper residence in and of itself, a prospective buyer might be hesitant to invest in it. However, all this neglected A-frame needed was a creative vision to make it shine.

Christine and Antonie were en route to meet with a realtor on Vancouver Island when they first drove past what they now call Kyst Hus—the dilapidated property stopped them in their tracks. Although the home and its lot were forlorn and wild, they realized this place had the potential to become something very beautiful.

Christine and Antonie's home at the time, located in the Beaches neighborhood of bustling Toronto, did not even have a backyard. This overgrown parcel of land on Vancouver Island would allow their three children (ages four, six, and eight) to run free and unrestricted. Their city life had been enjoyable, but the island A-frame tugged at their hearts. Themselves both raised in rural areas, Christine and Antonie realized how much they wanted to raise their children in a place where they could really roam.

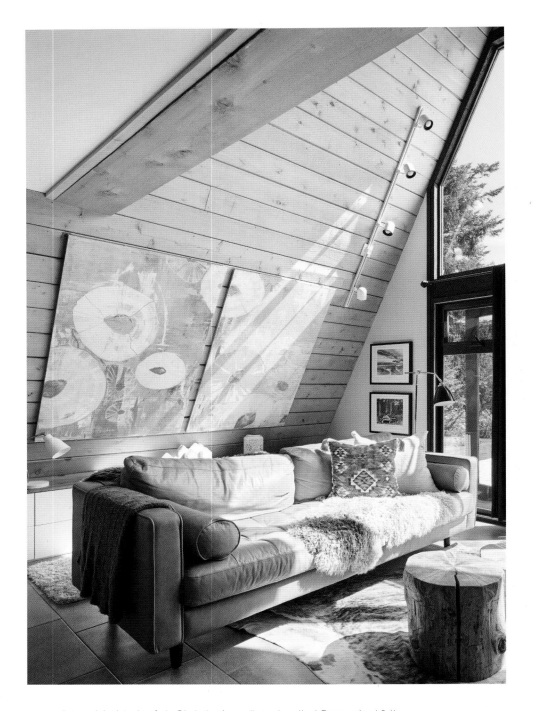

ABOVE: Artwork behind sofa is Christine's—a diptych called *Barnacles I & II*.

OPPOSITE: Tree stumps-turned-coffee tables originated from one of the first trees cut down on the property. When the flower pattern in a couple of the rounds was spotted by Christine and Antonie, they rescued the tree stumps from the fire pile.

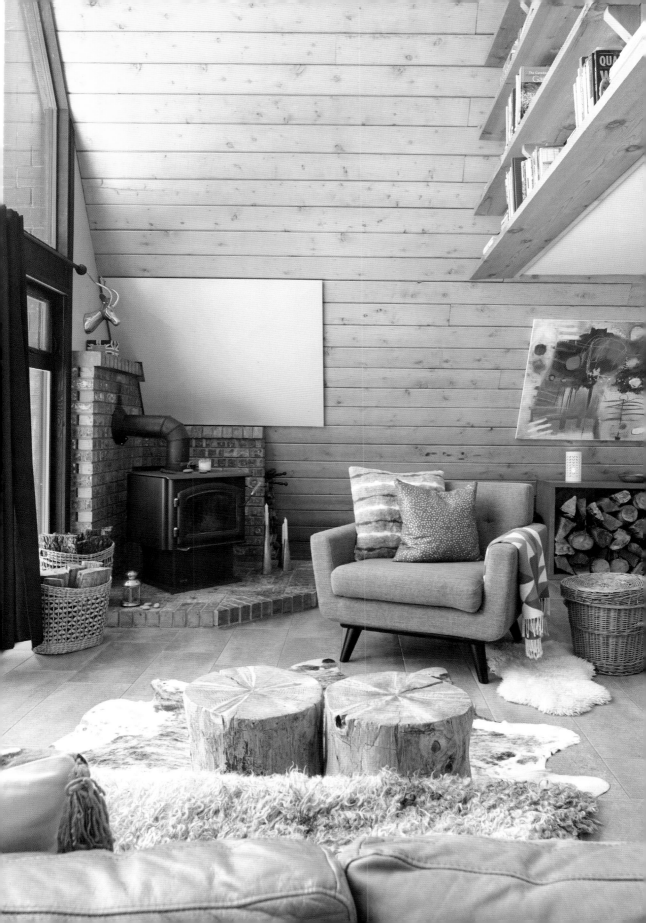

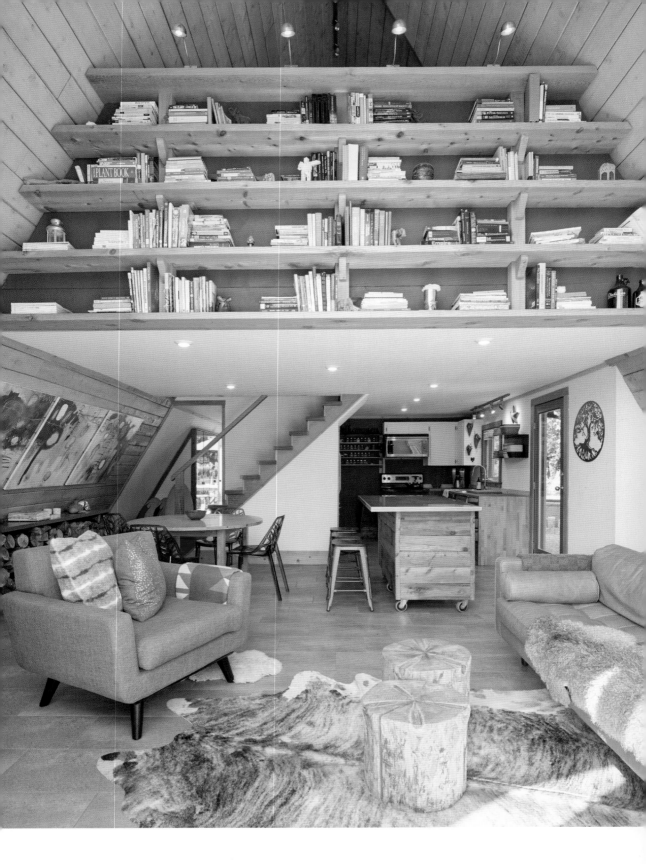

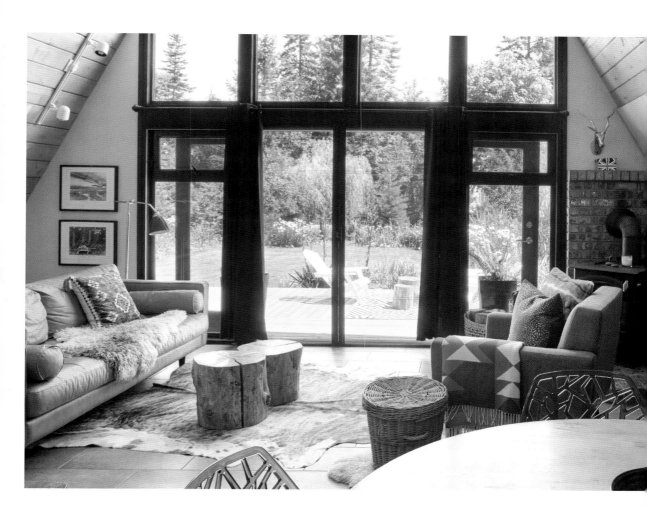

Four weeks after discovering the property, Christine and Antonie had sold their home in the Beaches, resigned from their jobs, said goodbye to friends and family, and moved across the country into their A-frame.

Over the course of the next four years, Christine and Antonie oversaw major renovations to restore Kyst Hus to a home of simple beauty and modern design. They were able to find a builder from the outset who agreed to work closely with them to bring their vision of minimalism and high-function design to life. Kai Lawrence of Standingbear Construction is a local custom home builder who patiently listened to all of Christine and Antonie's ideas

OPPOSITE: As a gift, Antonie built Christine a library at the front of their loft, a beloved feature of the house.

ABOVE: The 1970s A-frame once enjoyed shag carpet and turquoise walls. The new owners have preferred to tailor their home in a simple, open style with earthy neutrals and plenty of rustic textures.

and needs, and helped the family to make the most of their small space.

Due to the condition of the home and surrounding property, nearly everything had to be modernized. In the interior they overhauled the layout; upgraded the kitchen and bathrooms; redid the flooring and stairs throughout; extended the loft area; and replaced lighting, windows, and doors. They updated the unstable outbuilding, originally a garage and carport, to serve

Close-up of the diptych *Barnacles I & II* in the main living space. Kitchen island was customized from Ikea cabinets and wrapped in salvaged cedar fence panels; the top was crafted by a local metal fabricator. Wheels allow the island to be oriented in any direction. A portion of a triptych Christine and her youngest son Kai collaborated on, named by Kai: *All the Fish are Dead.*

as a woodshed and artist's studio. Christine, an artist by trade, is now able to work in what has been christened "Kyst Hus Studio," just a stone's throw from the house.

Landscaping was perhaps their most interesting hurdle to tackle during the massive renovations: the area contains a high volume of rocks and boulders, similar to beaches nearby. Rather than fight the natural topography

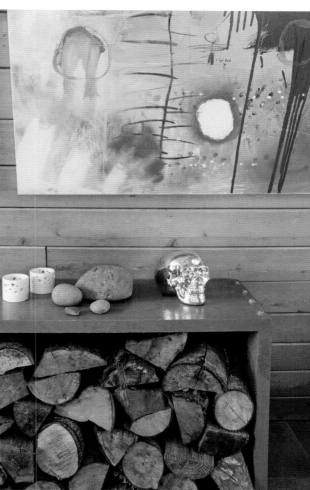

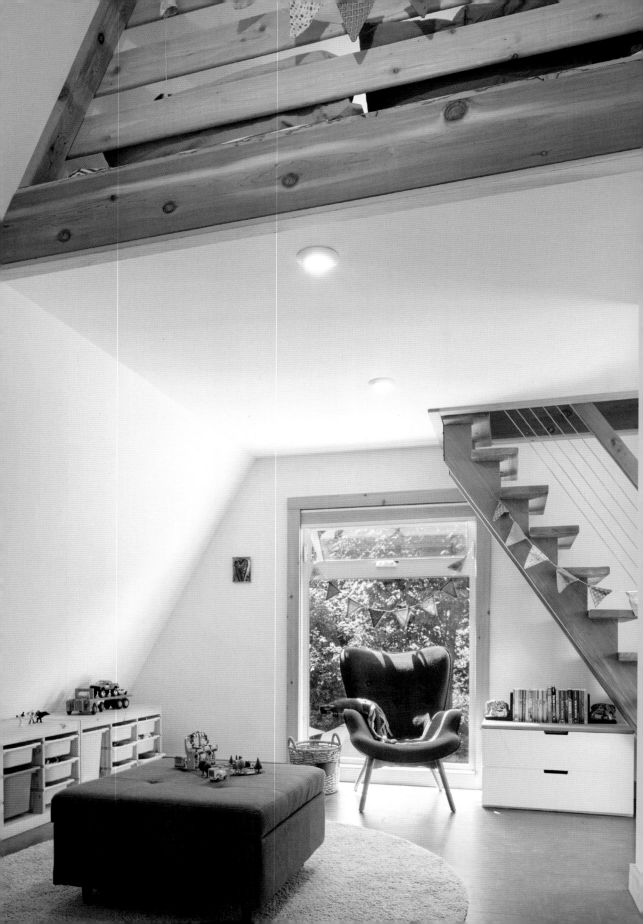

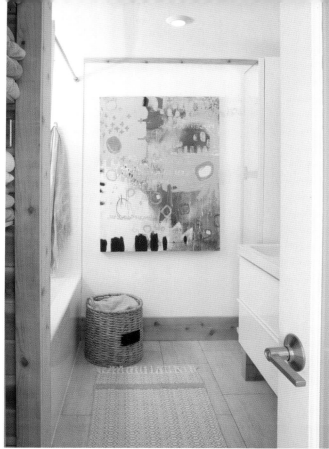

of their new home, Christine and Antonie chose to incorporate the rockwork as an integrated feature in their landscaping.

Living minimally has become a way of life for the family of five. Everything in the home does double duty: something can't just look good, it also has to provide storage. Limiting the color palette to white and natural tones provides an open feel that extends to the outside; the airy feel of midcentury and contemporary furnishings complements the architecture but also works to make the small space feel larger.

Both Christine and Antonie have family ties to Denmark, so it was natural for them that their decor include influences of Danish design. Kyst Hus is perfectly encapsulated by the Danish word *hygge:* a moment that feels especially cozy, charming, or special. Having hygge

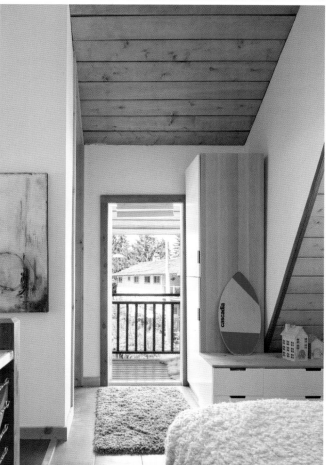

OPPOSITE: Christine made the festive flags in the kids' play space, .

ABOVE: Christine's piece *Abstract No. 10, The Heavens Are Weeping,* hangs from one of the few straight walls in the home in the upstairs bathroom.

BELOW: The master bedroom on the second floor opens to the balcony.

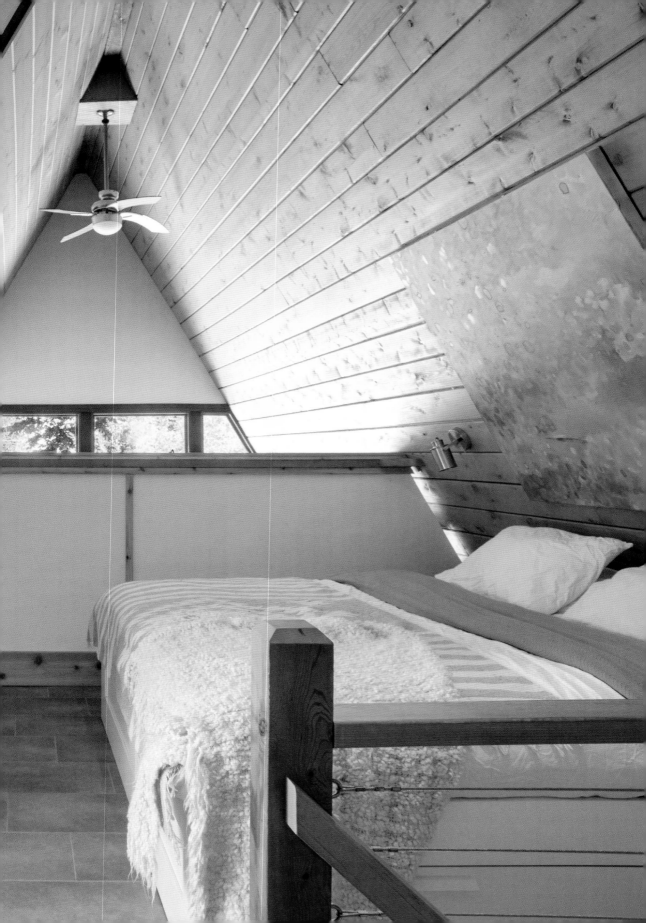

OPPOSITE: The master bedroom looks out onto the living room. Artwork by Christine, *On A Summer's Day.*

ABOVE: The renovation included installing a loft in the master bedroom—the kids sleep in the loft, akin to a giant bunk bed, three in a row.

or being *hyggeligt* is about acknowledging a moment when the ordinary feels extraordinary. "Our experience living here has been very hyggeligt," Christine explains. "Every morning when we wake up, we feel like we are on vacation. That feeling never seems to go away."

Despite being a small gathering space, entertaining has become a regular event in the Kyst Hus A-frame; sharing a meal with two or three other families is the norm. When the warm weather arrives, Kyst Hus *is* the outdoors. With the front and back doors that open onto east- and west-facing decks,

ABOVE: *Kyst Hus* translates to Coastal House in Danish. The family enjoys kayaking, canoeing, and swimming at the nearby beach.

OPPOSITE: The best views of the ocean can be seen from the second-floor balcony.

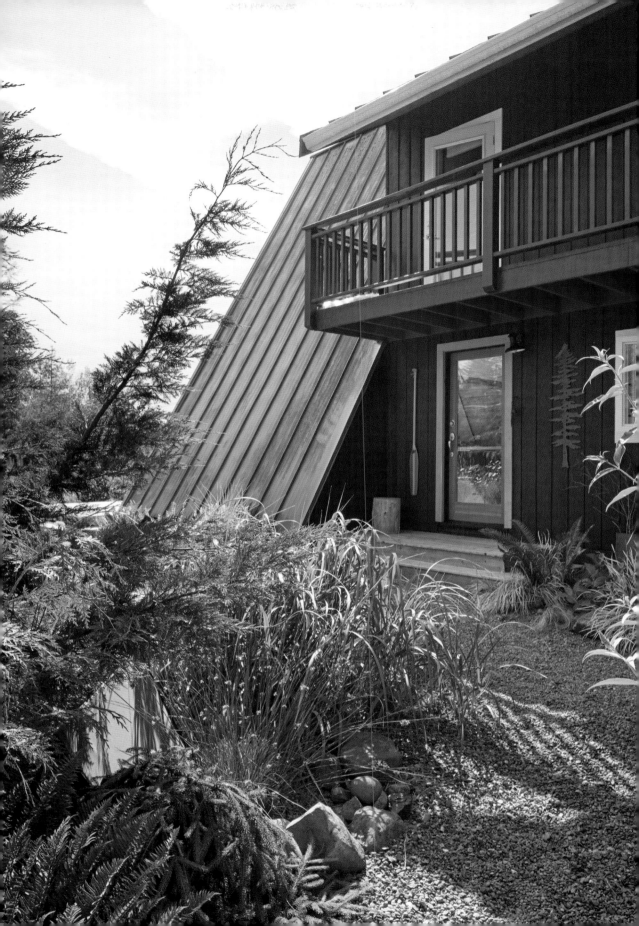

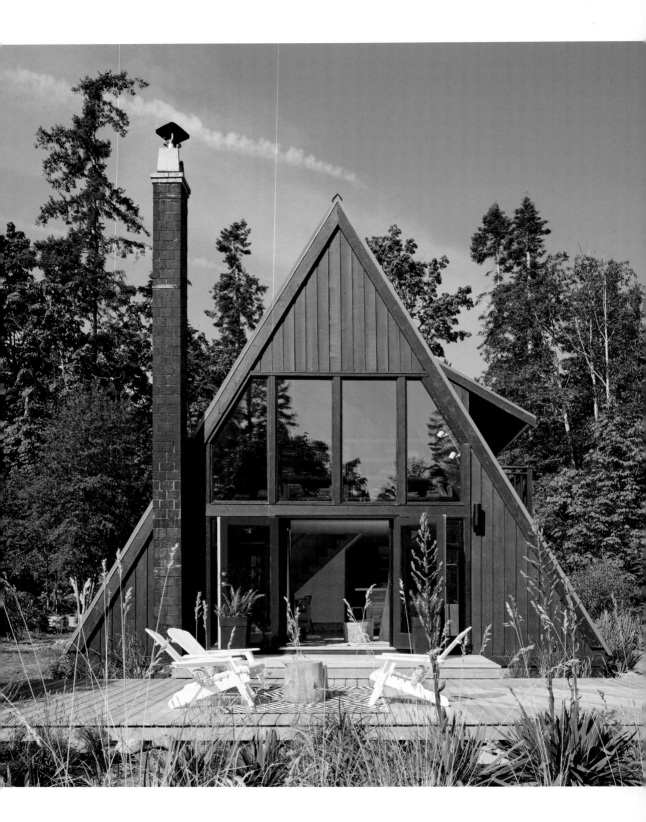

the home seamlessly integrates the garden and surrounding woods. In the winter months, storm-watching through the front windows is a highlight, as well as observing the wildlife that traverses the property.

Christine and Antonie know that when the children become older, their family will look back fondly on the years that they all fit in this one-bedroom cabin together. While they'd love to stay, they recognize that having enough space will become a challenge. The couple is reviewing plans for an addition that could incorporate two extra bedrooms while preserving the integrity of the A-frame. "Perhaps we will have to step away from this home if we don't find a plan we love," Christine muses. "Time will tell! At this point, the kids adore this little cabin and reject any idea of leaving it. That is just fine with us." ▲

The A-frame's expansive windows and deck afford views of the property's gardens and glimpses of the ocean. The family has been working on strategic landscaping to enhance privacy.

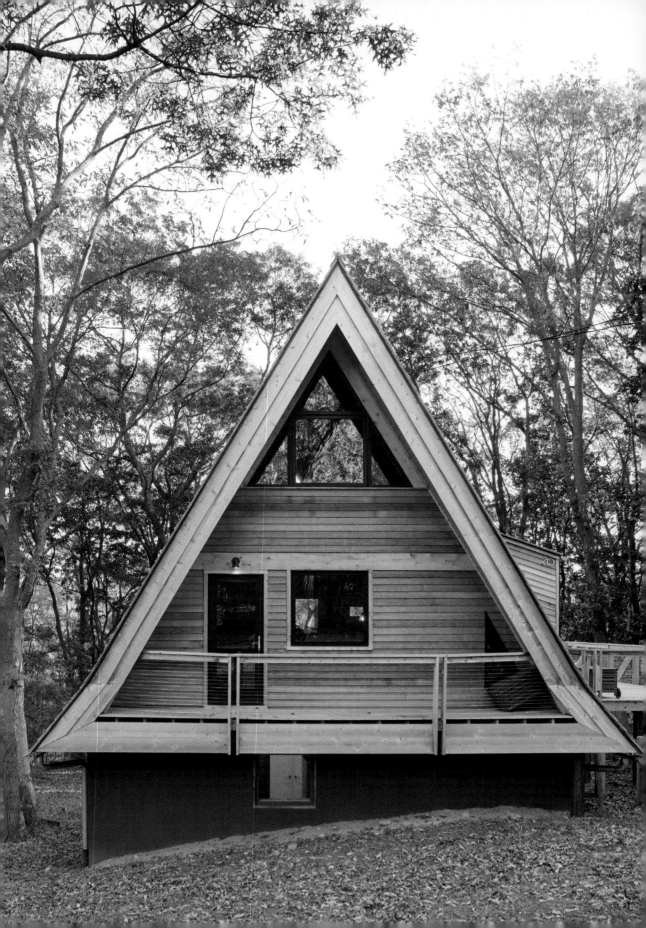

TRIANGLE
HOUSE

Sag Harbor, New York

Triangle House, a clapboard A-frame with yellow cedar roof shakes and red cedar trim, was built into the hillside of Sag Harbor, New York, in 1965. Like many A-frames from this era, it was built from a kit. The original owner, a Queens policeman turned local Sag Harbor barkeep, constructed the house himself. Initially he used it as a vacation home but later relocated to his A-frame permanently.

Current homeowners Edgar and Michelle are only the second proprietors to inhabit Triangle House, which they discovered in 2013 through a local property listing. When they first encountered the house, necessary changes became immediately obvious. There were only two tiny bedrooms tucked away on the main level of the home, and the tiny galley kitchen was inadequate for preparing meals for family and friends. The daylight basement had been left unfinished, and there were no stairs connecting the main level and the basement (necessitating a stroll outside to do one's laundry). Beyond the impracticalities of layout, the lack of insulation in the home required two giant propane tanks to provide heat through the northeast winters. A slapdash sunroom that had been tacked onto the front of the house would have to

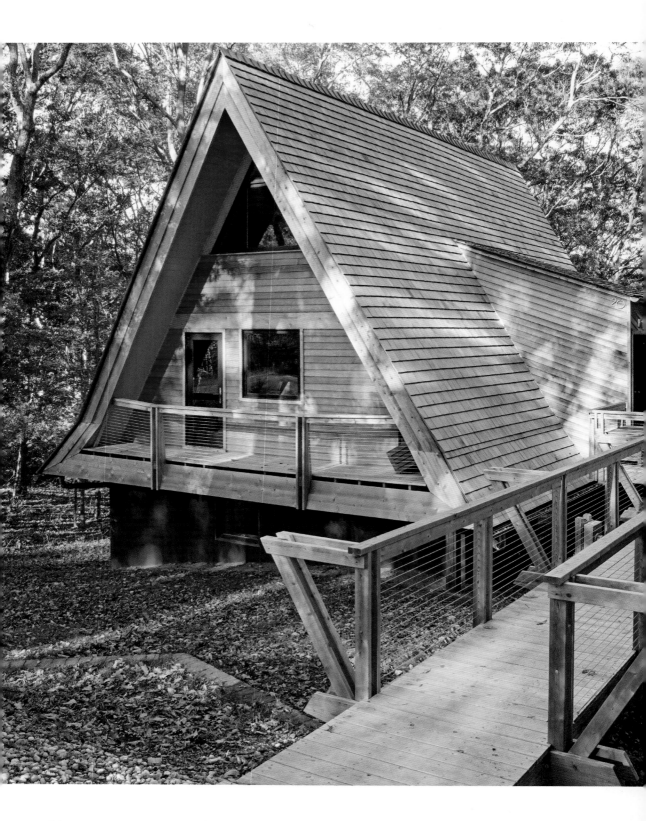

be torn out completely, and a decrepit rear deck left much to be desired in the home's outdoor appearance and function.

Despite all of these hurdles, Edgar and Michelle were ready and willing to completely reimagine the space to make it their own.

The couple devised an "upside-down" configuration and demolished every wall on the main level, stripping the house down to its Douglas fir structure. New insulation and siding was installed, and its heating and electrical systems and plumbing were replaced. The kitchen and bathroom were re-created from scratch in new, more sensible locations of the home.

The airy, open quality of the design was one of the things that initially drew Edgar and Michelle to the house, so it was important to them that this quality be magnified in the remodel. The structural struts on the main level were Edgar's additions, with the intent of creating a new spatial dynamism in the A-frame that hadn't existed before. A new spiral stair was added, and new openings in the concrete block foundation were cut to allow windows in every bedroom.

The family now lives in their A-frame year-round, which is rather small by typical "super-sized" American standards. At just over 1,100 square feet in total, the main kitchen/living/dining room is engaged constantly. The upside-down layout allows them to pursue their interests—chief among them music, art, and

Elevated into the tree canopy, Triangle House gives the distinct impression that one is floating in the woods.

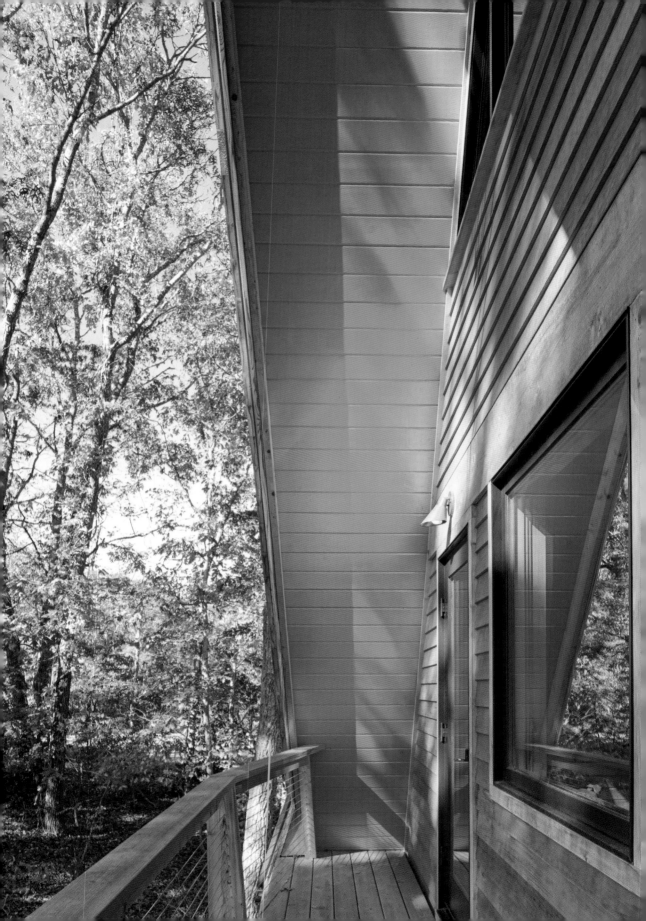

cooking—together in the openness of the space. The kitchen table provides a place to tackle homework or to gather around for a casual dinner with friends. Privacy can be sought in the basement level, where the bedrooms and an additional bathroom are located.

The family has a few more modifications in mind for the A-frame, but not many: the simplicity of the space suits them well. ▲

OPPOSITE: A narrow balcony winds around the house, offering the perfect lookout among the trees and beyond to the Peconic Bay of Long Island.

ABOVE: Rustic and simple in nature, Triangle House sets itself apart from its more conventional neighbors.

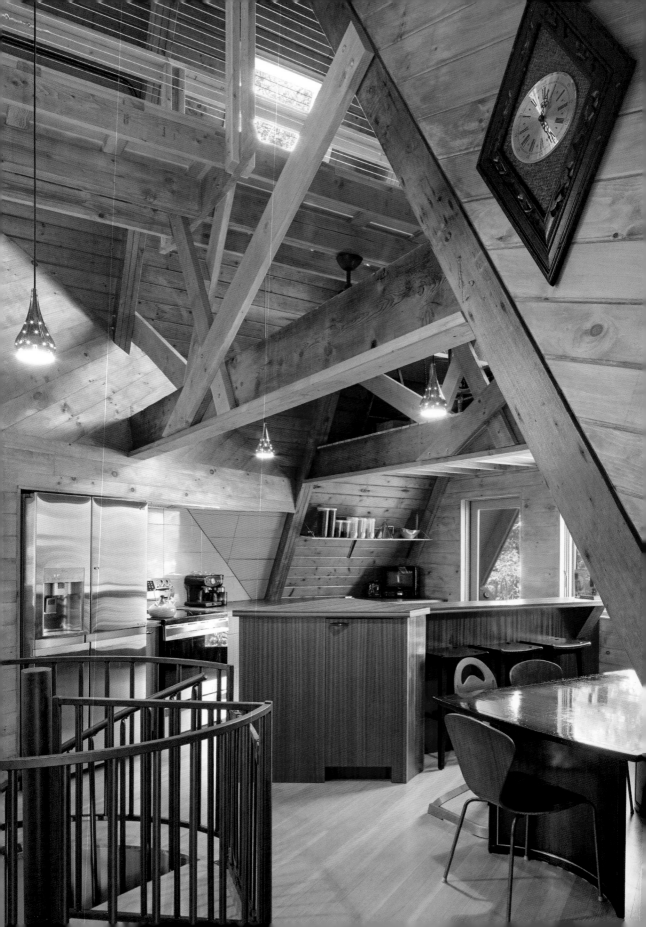

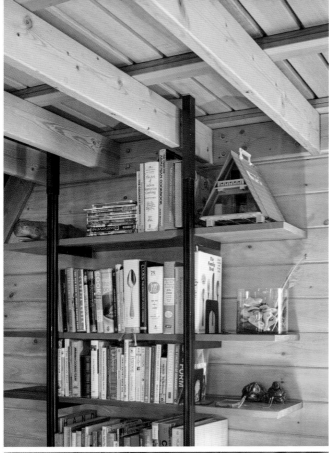

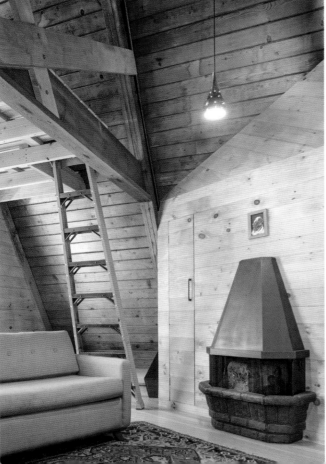

OPPOSITE: Exposed Douglas fir, vaulted ceiling, and open loft space all contribute to Triangle House's signature A-frame elements.

ABOVE: A vintage Fisher-Price Little People A-Frame doll house gets top billing on the family bookshelf.

BELOW: Fireplace is an electric model from Sears, Roebuck, estimated to be about 40 years old. The ladder is Edgar's access point to his office in the loft via the catwalk.

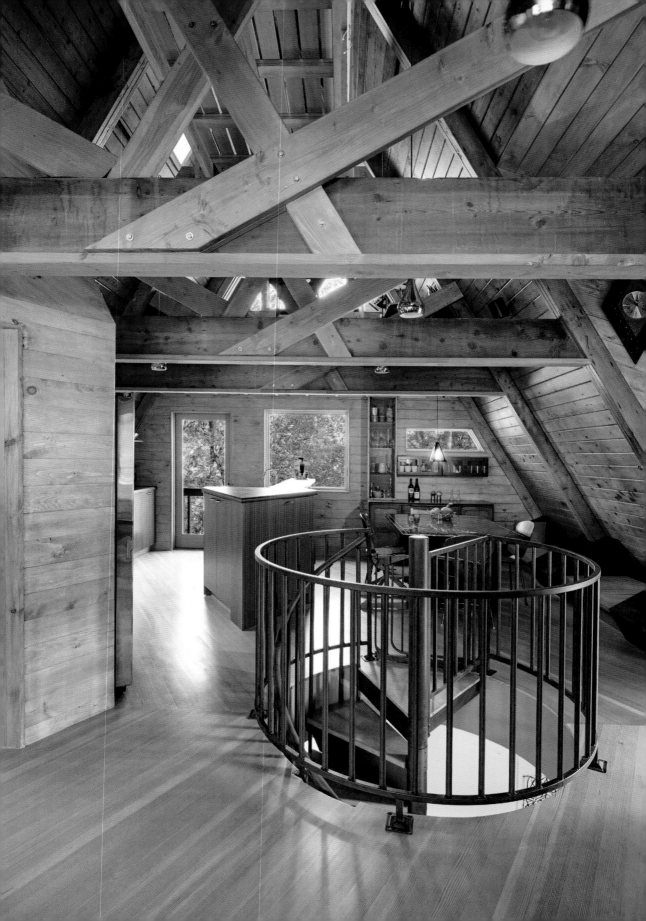

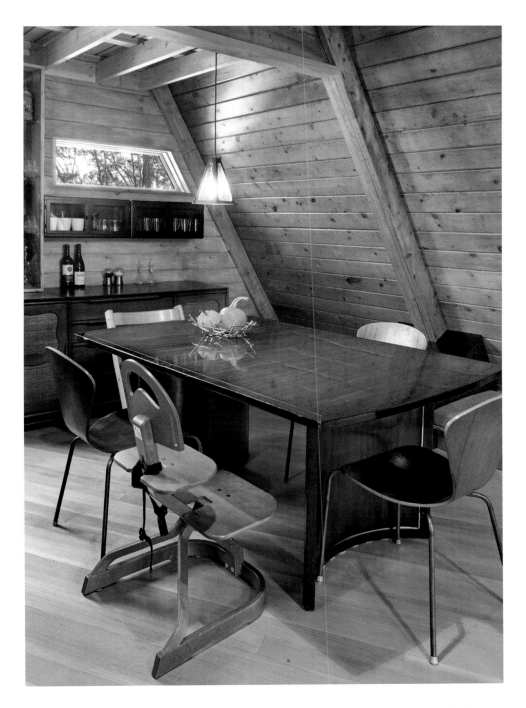

OPPOSITE: Edgar and Michelle had the spiral staircase cut into the main living space during their extensive remodel of the A-frame: a modern update with retro flair.

ABOVE: Table, circa 1970, was purchased at an antique dealer. Chairs are original Arne Jacobsen.

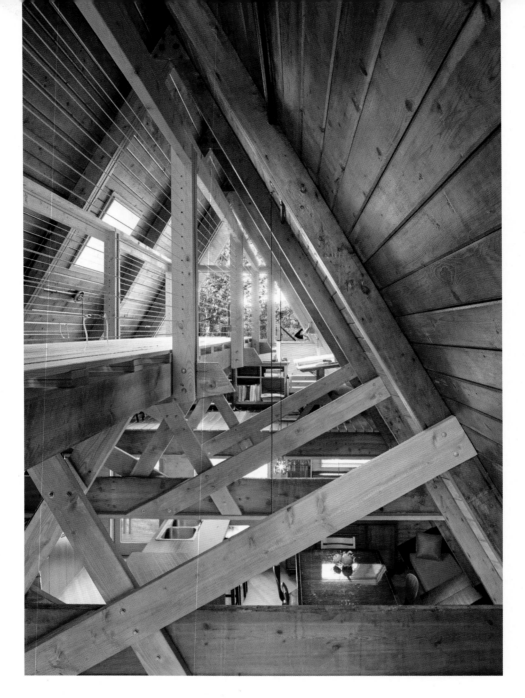

ABOVE: Structural struts bolstering the catwalk work perpendicularly off the existing angles of the roof, contributing to the spatial dynamism of the A-frame.

OPPOSITE: Edgar, an architect by trade, uses the loft as his home office. It is only accessible via a ladder on the main floor, connecting to the catwalk.

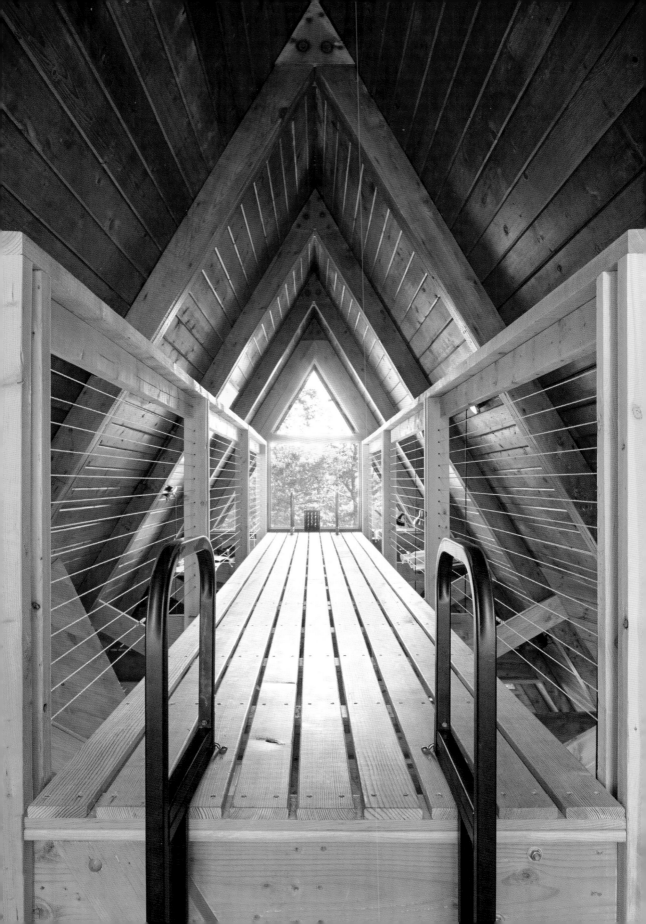

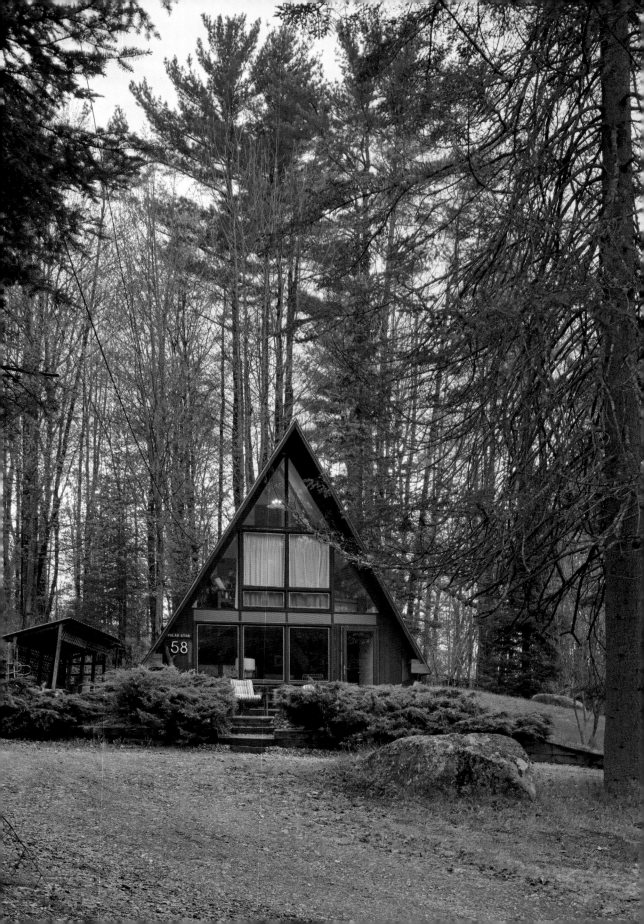

POLAR STAR

Bethlehem, New Hampshire

When Julia relocated to northern New Hampshire from New York for a job, she did so prepared to make her first home purchase—"a very 'adult' step in life," she noted. Polar Star came on the market about a year into her search. The minute Julia stepped into the A-frame, she loved it.

It was both a manageable size and condition for her to call home: the 950 square feet were just enough space for her things from her previous Brooklyn home, and the A-frame had just enough projects to update it the way she wanted to without spending a fortune.

Nellie, the previous owner of this cozy New Hampshire home, ran a tour bus company out of Pennsylvania. Polar Star was her vacation home, and she took impeccable care of it. Nellie had built-in shelving added to the interiors, along with quite a few other unique storage elements—a small metal cabinet inset into the kitchen wall for things like foil and plastic wrap, and storage under the stairs for firewood.

With glass-tile backsplash, KraftMaid cabinetry, and Formica countertops in the kitchen, the classic midcentury design is just the beginning of Polar Star's charm. The house borders a three-acre wooded lot. The views of

the woods from the bedroom are an idyllic way to wake up every morning and provide a front-row seat to the evolving seasons.

The home is cozy in winter with the fireplace stoked up and snow falling all around; the outdoors become a second living space in the summer, as landscaping and gardening projects are taken up and outdoor meals on the patio become a regular occurrence.

 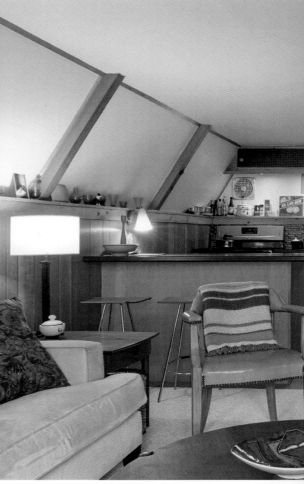

Glass tile backsplash runs throughout the kitchen. Julia's love of midcentury design, and rare finds discovered on her travels abroad, serve to enhance the A-frame's decor. The second bedroom in the A-frame, serving as an office/guest room, looks out onto the front of the property.

As a former apartment dweller in Brooklyn, Julia had the entire third floor of a building to call home; the square footage of that apartment was bigger than the A-frame. But the wooded setting and being a homeowner made it worth the move from the city. Though, being one with nature isn't without its drama at Polar Star: there was that time the A-frame was broken into—by a squirrel. ▲

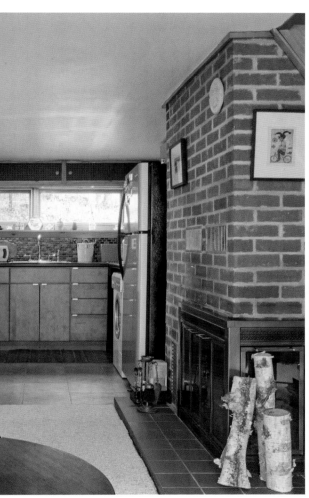
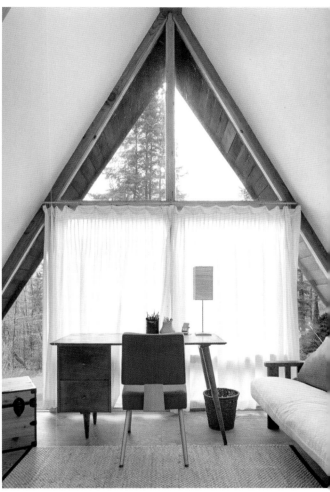

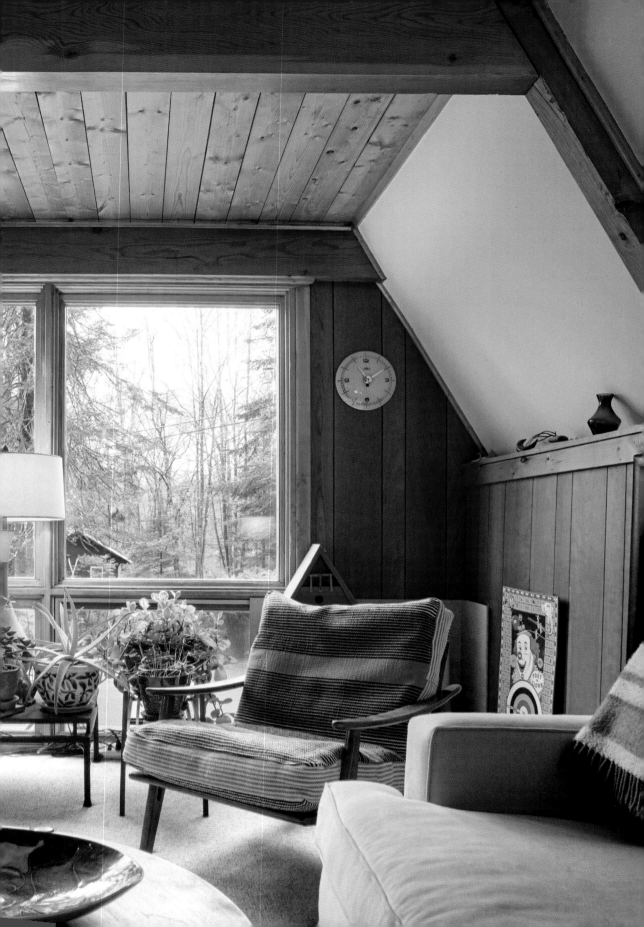

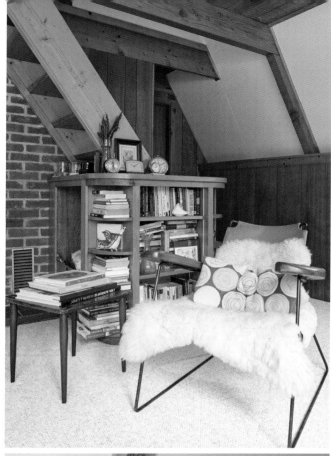

OPPOSITE: Midcentury chair was found by Julia in pieces on the street in Brooklyn; she put it back together.

ABOVE: Julia found this chair in Littleton, NH, at a vintage shop. It was designed in the 1960s by Sam Resnick, a teacher at the Putney School in Putney, VT. The chairs were a limited production made for a school fundraiser.

BELOW: Turquoise leather chair was formerly in the Princess Room at the Mt. Washington Hotel in Bretton Woods, NH.

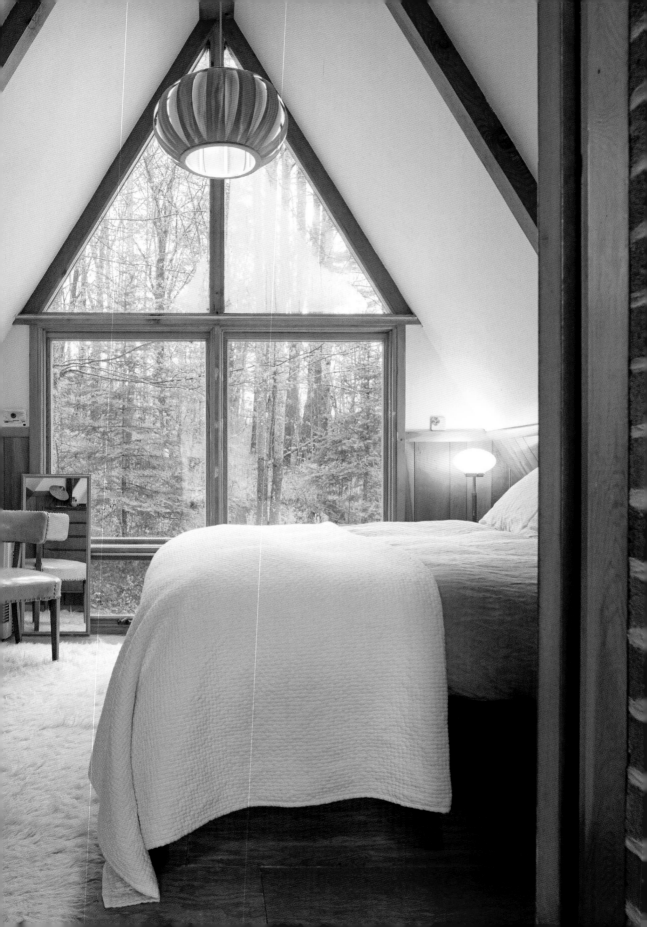

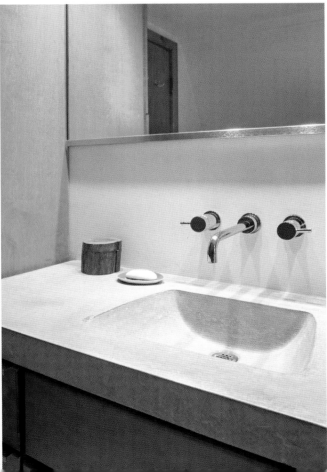

OPPOSITE: The master bedroom looks out onto part of the property's 3-acre wooded lot.

ABOVE: Ann Sacks glass tile in classic mid-mod blue and orange was used for the shower surround.

BELOW: The bathroom vanity and integrated concrete sink (poured by Julia and her boyfriend) is sleek and modern.

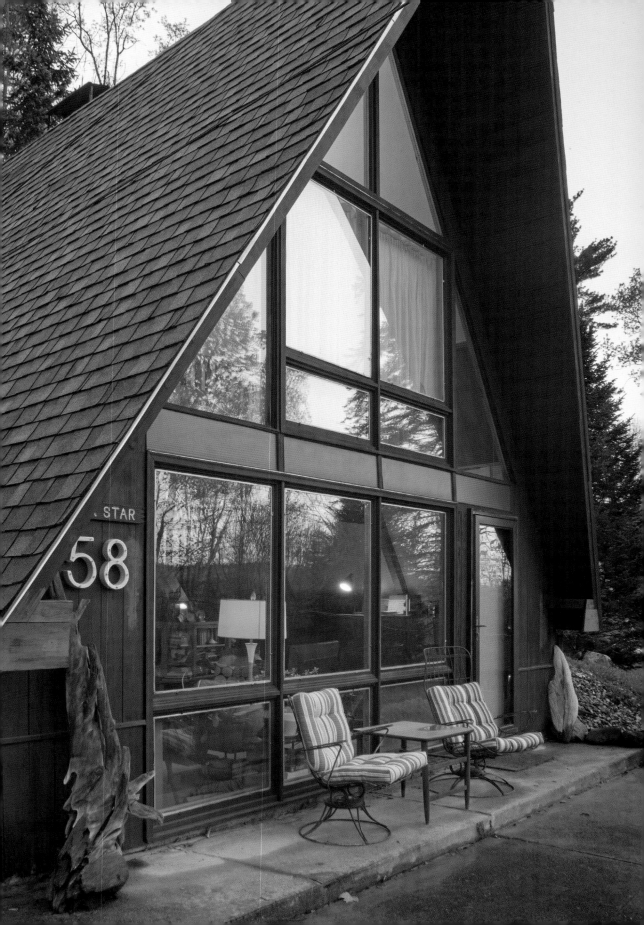

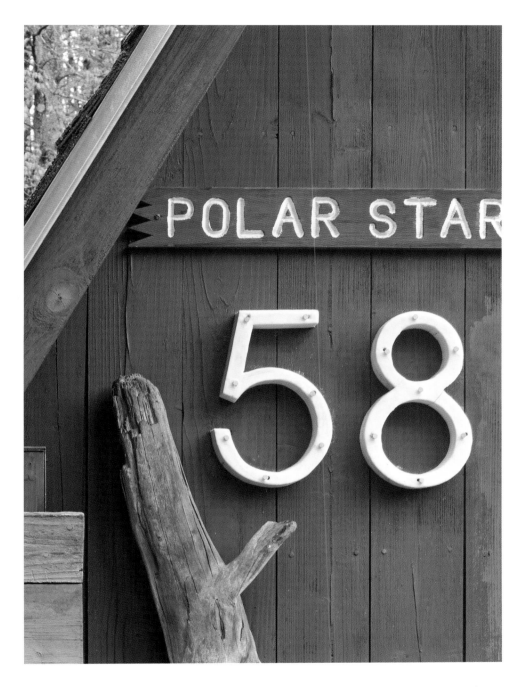

OPPOSITE: The property abuts a 700-acre land trust that will never be developed, so Julia has the peace of mind that she won't be looking out at neighbors anytime soon.

ABOVE: The A-frame's previous owner named the home Polar Star in the 1960s—when Julia moved in, she chose to keep the name. Julia had the house numbers made to add her own personal touch.

A-FRAME
REFRAME

Mill Valley, California

Taken by its charm and setting, homeowners Andrew and Paul fell immediately for the light-filled A-frame they found, quite by accident, just north of San Francisco, in Mill Valley, California. The couple came upon the authentic midcentury home during a spontaneous Internet search for properties under a certain price point. They were not in the market for a new house at the time but were intrigued by their discovery. Since they planned to be in the area the same weekend as its open house showing, Andrew and Paul decided to stop by to see the A-frame in person.

Despite an immediate first impression of neglect, a closer look at the faded treasure in disrepair made it clear that a lot of thought had been put into how the home was built. This sad little house was very special—Andrew and Paul were sure there was a story here. As it turns out, they were right.

A gentleman named Ken Pratt had commissioned the A-frame to be built in 1953 by Wally Reemelin, an industrial engineer at UC Berkeley. Pratt was an architecture and travel feature writer for the San Francisco Chronicle. He had seen the A-frames that Reemelin had built in the Berkeley hills in 1948 and asked Reemelin to build this house for him in Mill Valley. Unlike a traditional

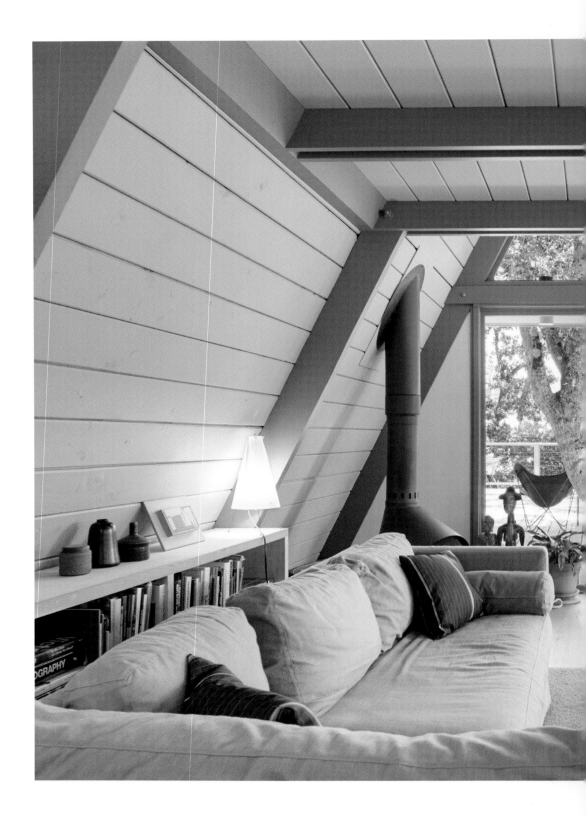

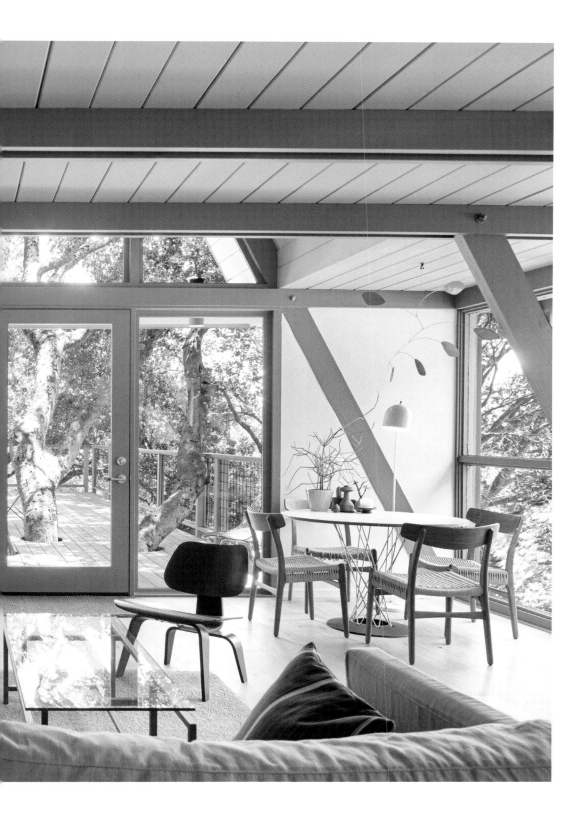

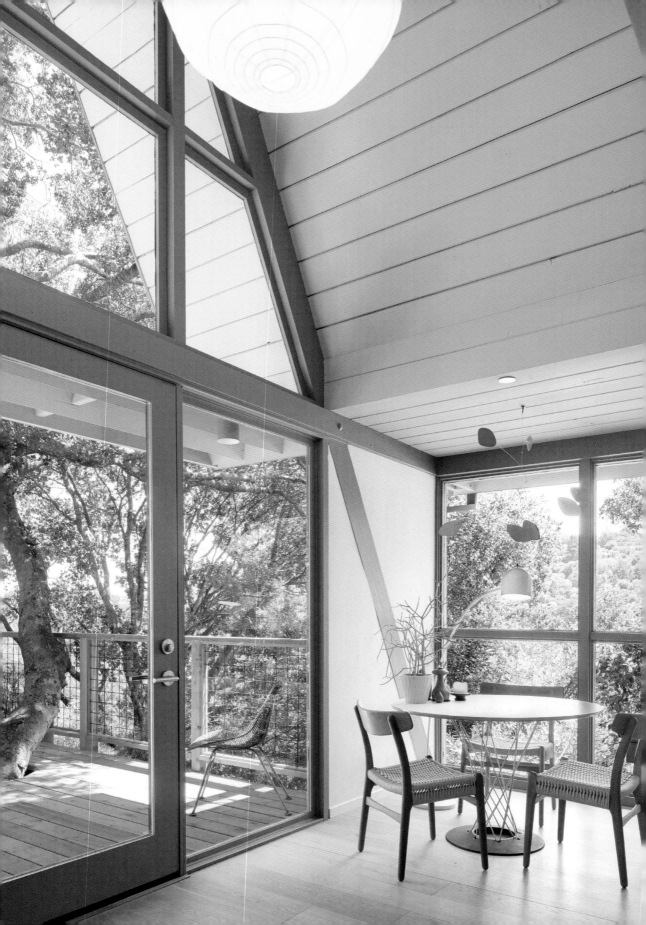

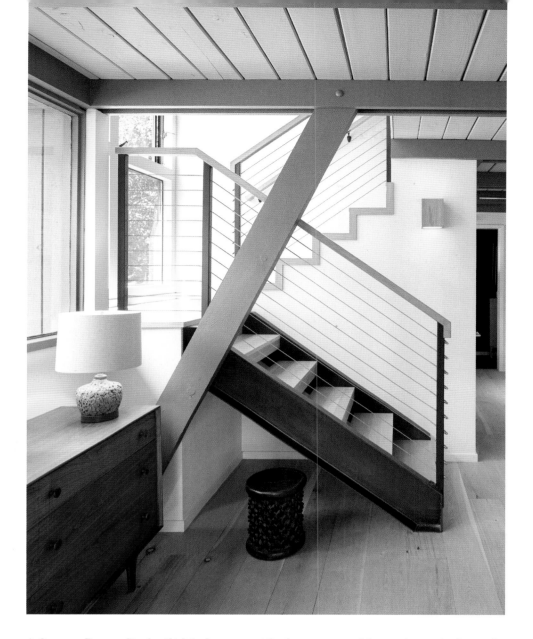

A-frame, Reemelin built his homes with dormers and large bay windows; in the case of Pratt's A-frame, the whole south side of the house flaunted windows with views of the trees and the canyon below.

Nearly sixty years later, Andrew and Paul were taken by the A-frame's quirky vibe and how it represented an era and way of life of the past. It was

OPPOSITE: The A-frame opens onto a 750-square-foot deck, great for entertaining.

ABOVE: The first flight of stairs is floating, a reference to the subtle midcentury modern design that is found throughout the house.

Sunset Magazine à la 1960s—the best of California: open living in an indoor/outdoor space. They loved the house for what it was and what it could be.

Andrew and Paul bought the A-frame in 2011, and shortly after their purchase the delighted pair undertook a complete renovation.

Working with Steve Crutchfield of True North Construction and architect Michael Sands, they created a new layout in both the ground and second levels of the A-frame. Adopting Reemelin's original vision, the team agreed they wanted the house to embrace its surroundings. They used materials and furnishings that were natural—items that would not clash with the lines of the house, keeping it as a simple backdrop to the views of the trees and hills.

The home remains an unpretentious, 1,200-square-foot paradise, still very much in line with the original homeowner's vision. At first Andrew and Paul anticipated using it as only a weekend retreat, but later—smitten by the desire to live more simply—they moved in permanently. We're not surprised. ▲

The updated kitchen took the place of the once-dining area. It features exposed shelving and a custom-built island. Heath Tile was used in the kitchen and downstairs bath.

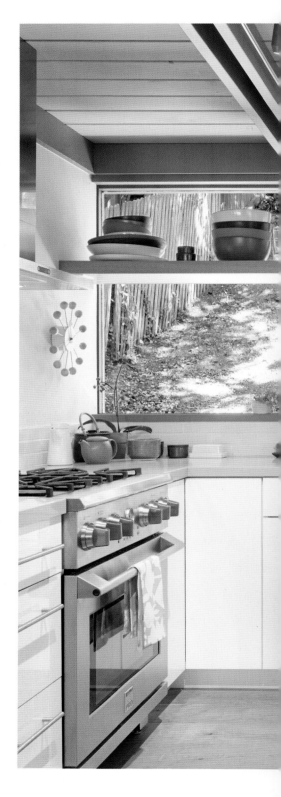

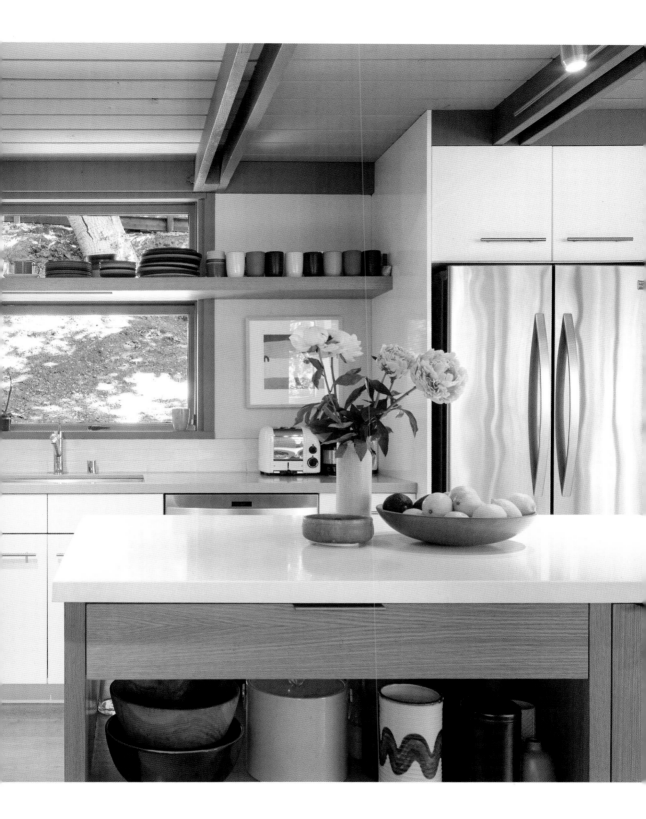

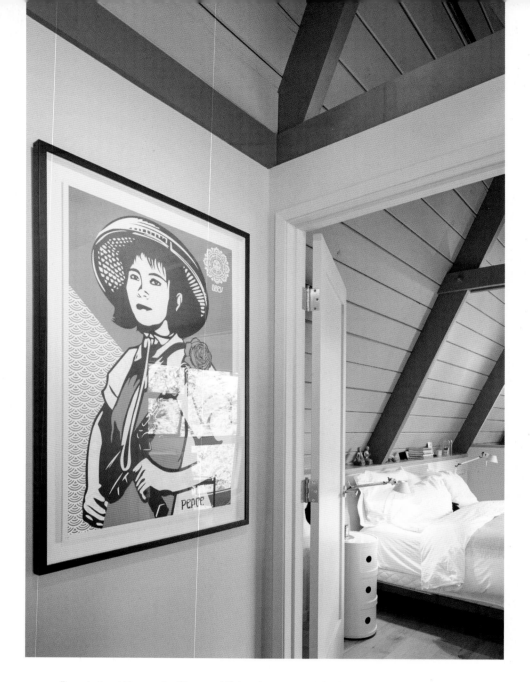

ABOVE: *Revolution Woman* by Shepard Fairey hangs outside the master bedroom.

OPPOSITE: The A-frame beams are spaced every seven feet. Rather than letting this structural necessity become an obstacle in the master bedroom, the furniture has been arranged so that the beams simply serve as a playful reminder that one is standing in the tip of an A-frame.

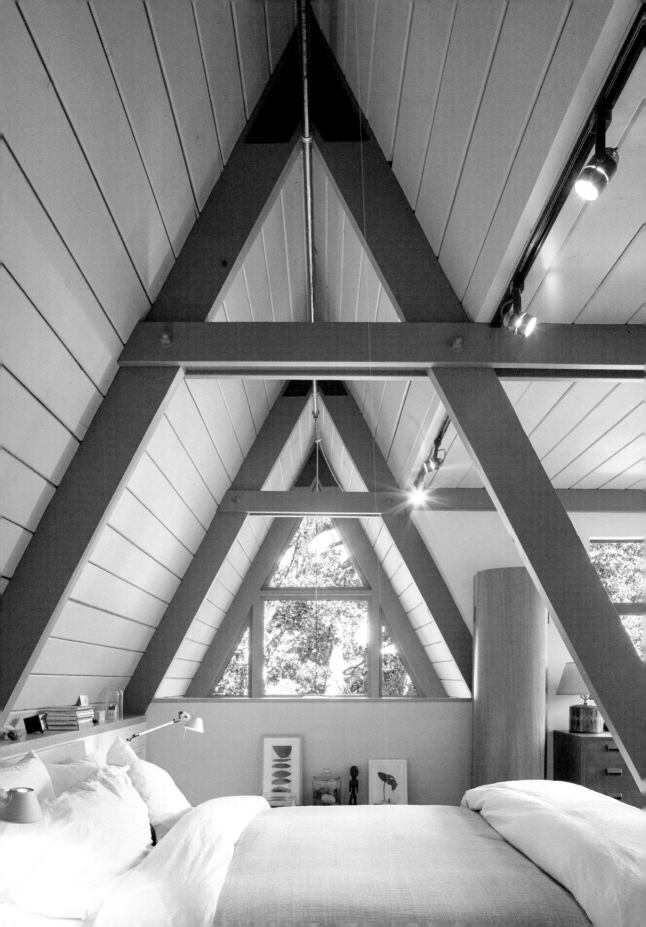

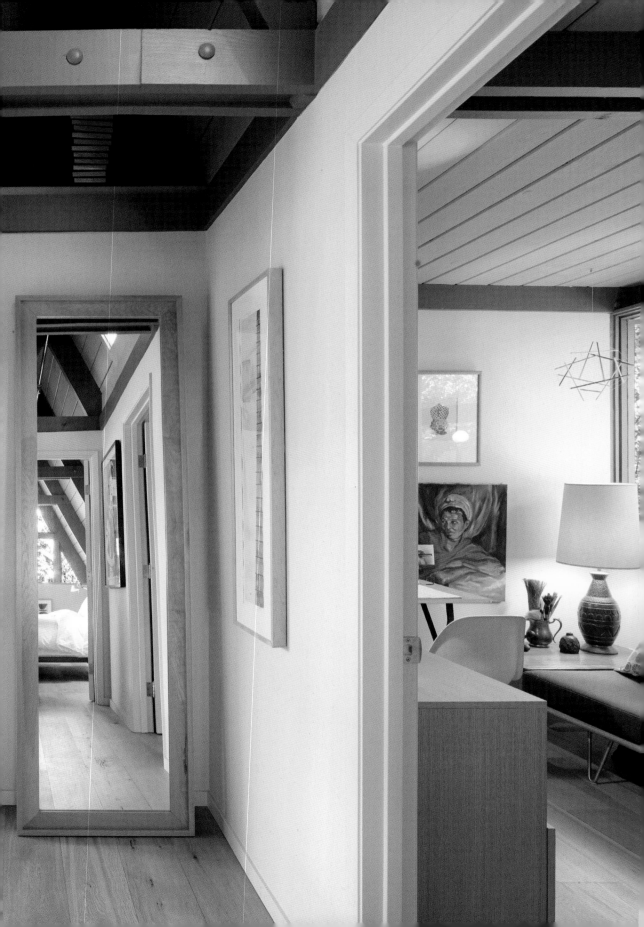

OPPOSITE: A simple palette of colors and materials was used upstairs as well, including the addition of a tongue and groove ceiling.

ABOVE: The updated downstairs bath includes repurposed wood for the countertop.

BELOW: An abundance of windows ensures the home stays light and bright throughout the day..

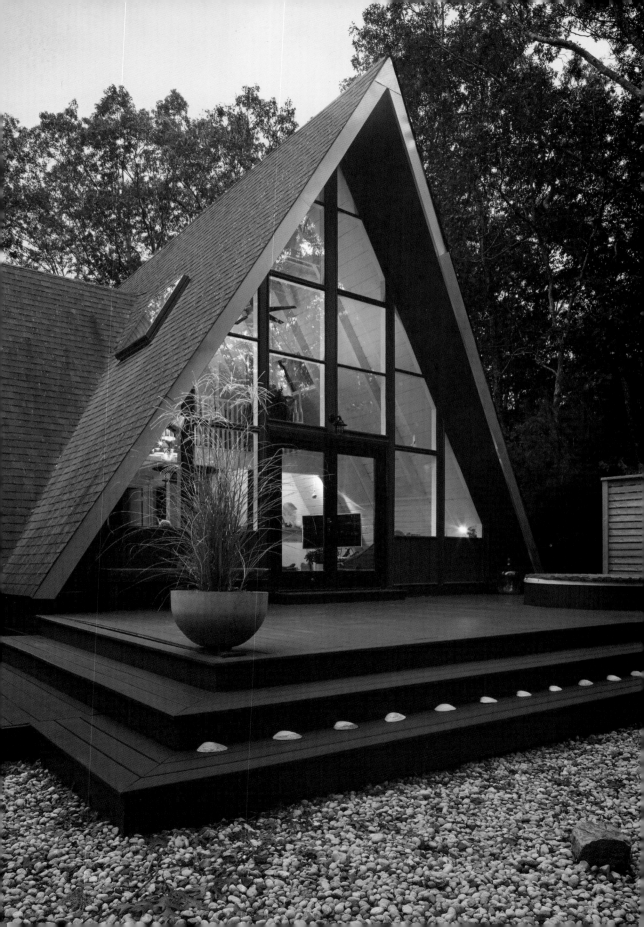

CALM &
COLLECTED

Long Island, New York

Whether on a hike, seeking treasures at a flea market, traveling abroad, or creating a new piece of art, Theresa loves to explore— and so it was fitting when she discovered the A-frame she now resides in year-round with her partner, Freddie.

For the two of them, the purchase was a natural choice. They had rented an A-frame in the hills of Los Angeles while living on the West Coast and it was this experience that caused them to fall in love with the A-frame's high ceilings. "The soaring lines energize one's spirit and soul," Theresa describes. With such vast windows, "the connection to nature while living in an A-frame becomes a catalyst to better connect with yourself."

After a move to the East Coast, Theresa and Freddie settled into another rental, this time in Sag Harbor, New York, in an old sea captain's house that they fully intended to buy. But their love for A-frames was well known, so when a friend tipped Theresa off to one which had just come on the market, she tracked it down, and she and Freddie bought it immediately.

The 1,500-square-foot house is located in Long Island on the East End. Constructed in 1972, the A-frame sits on a half-acre of land providing serene

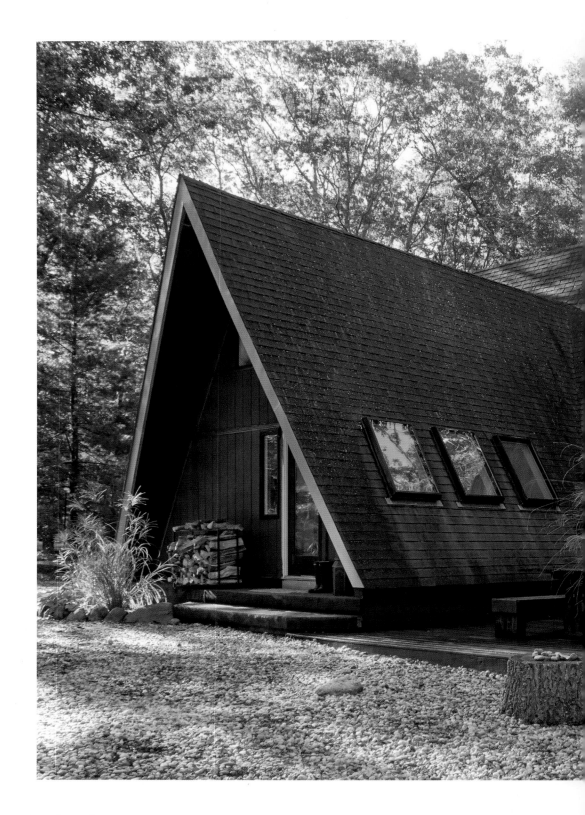

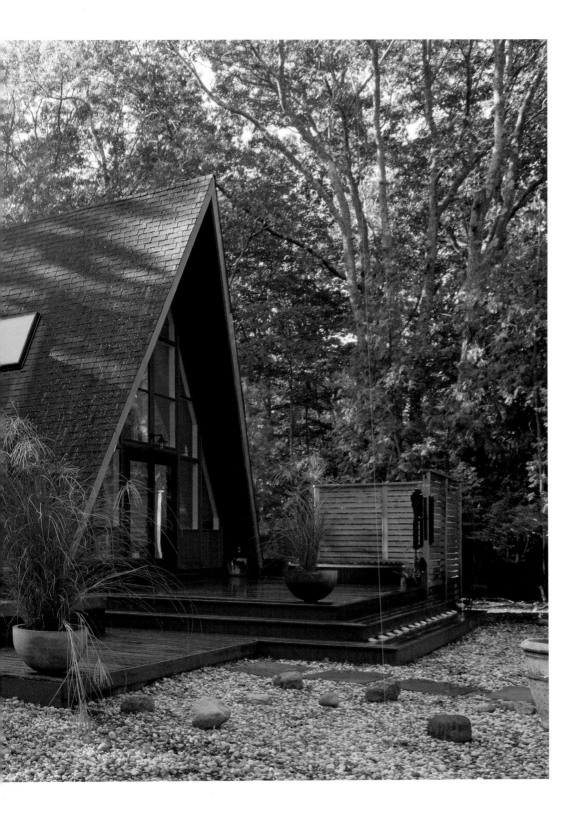

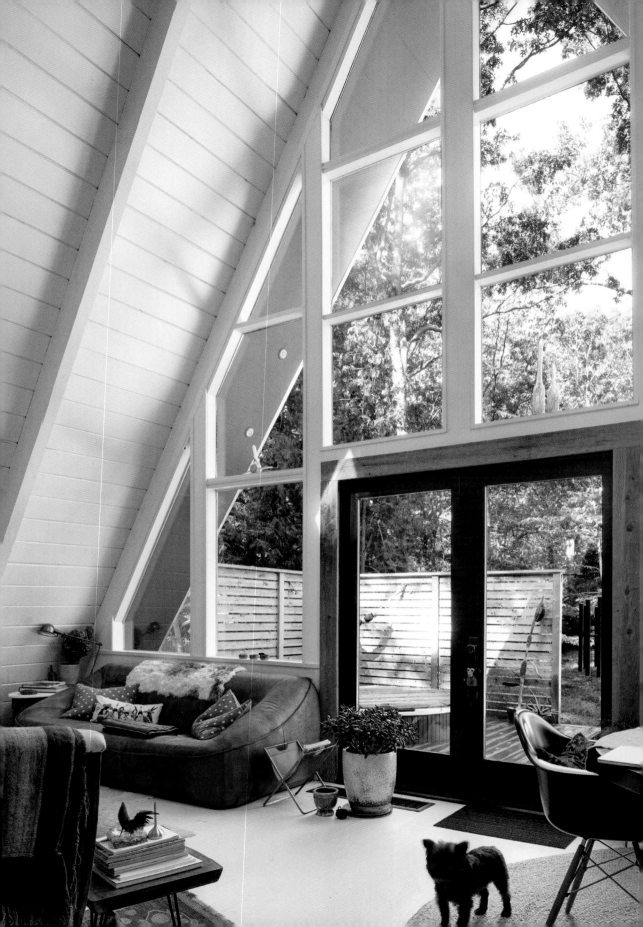

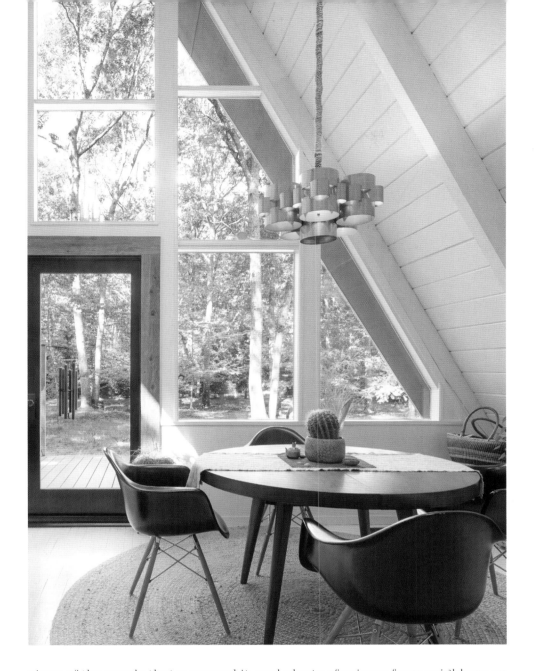

views of the woods that surround it, and plenty of privacy from neighbors on either side. It's walking distance to the bay and a short drive to Montauk for surfing (one of Freddie's favorite hobbies). Their home reflects Theresa and Freddie's love for beauty and well-made things, and an accumulation of their best experiences. Theresa admits that the biggest challenge of living in the

OPPOSITE: Hardy, the 8-year-old Affenpinscher, enjoys the natural sunlight in the main room.

ABOVE: The light over the kitchen table was found by Theresa at the Rose Bowl Flea Market.

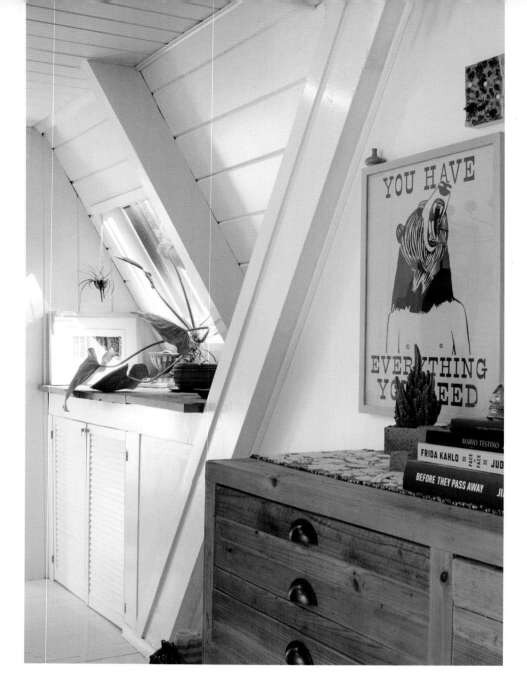

A-frame full-time is exacerbated by her penchant for collecting: it's hard to showcase art on the angled walls. "Where you do have a flat wall, you tend to clutter it," she explains. She's learning that less is more and acknowledges she'll end up having to have fewer things in their house at any given time. But

ABOVE: *You Have Everything You Need* Growling Bear silk screen by Deedee Cheriel.

OPPOSITE: Spiral staircase and fireplace are original to the A-frame.

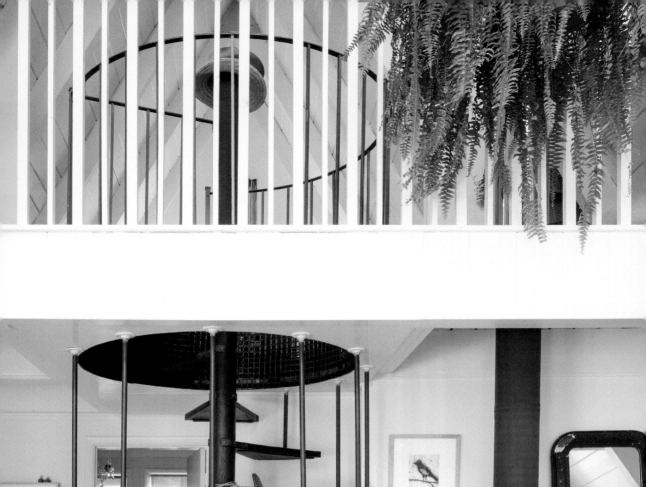
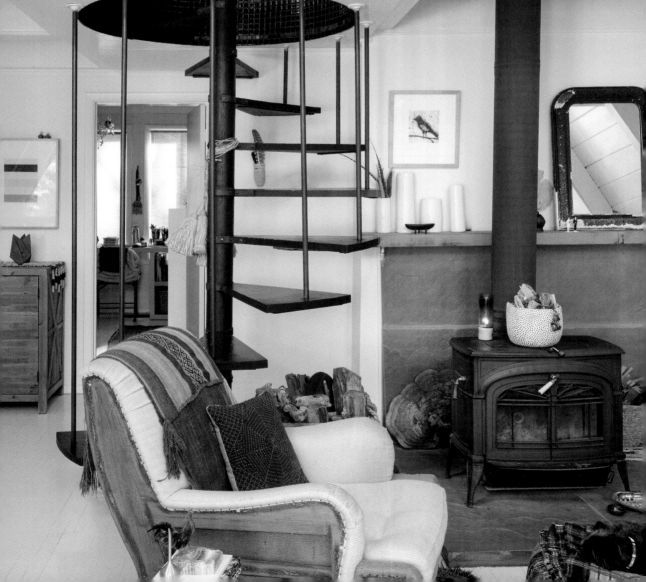

that won't stop her—she can't help but bring home things that she loves. "I will just have to edit more," Theresa concludes.

Theresa's discerning eye and passion for finding soulfully handmade items for their home has made their A-frame feel warm and cozy. Many of these items have been picked up on their travels or have been found in a special way. The result is many little treasures coming together to celebrate the couple's most meaningful memories. The unique attributes of the A-frame and the care that has gone into making this one a home make it a treasure in itself. ▲

Unique textiles make this guest room a colorful and peaceful place to stay. Theresa cites Georgia O'Keeffe and Frida Kahlo as primary influences on her decor.

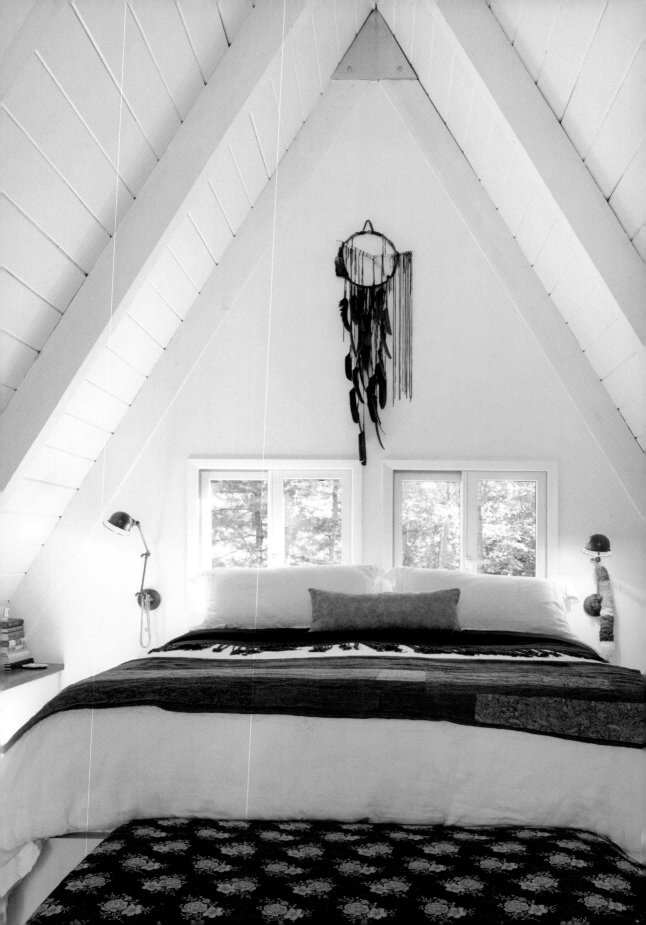

OPPOSITE: Theresa has long nurtured a love of textiles, evidenced by the cozy decor of the master bedroom.

ABOVE: The "double-A" structure of this A-frame houses the kitchen and bathrooms in the "little A."

BELOW: Unique and beautiful objects, thoughtfully placed throughout the home remind the homeowners to be inspired by beauty, life, and nature.

HERITAGE
HOMES

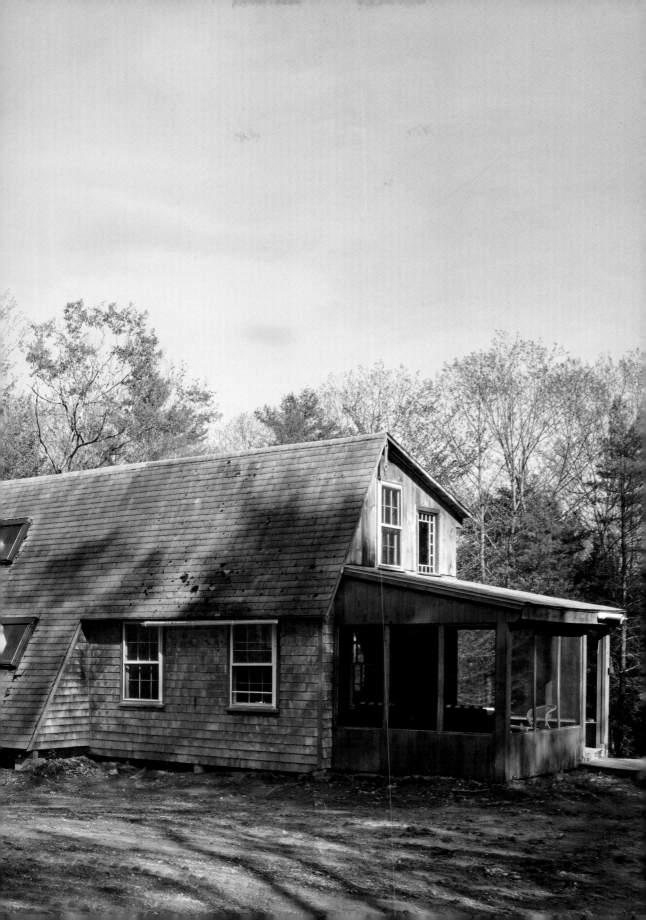

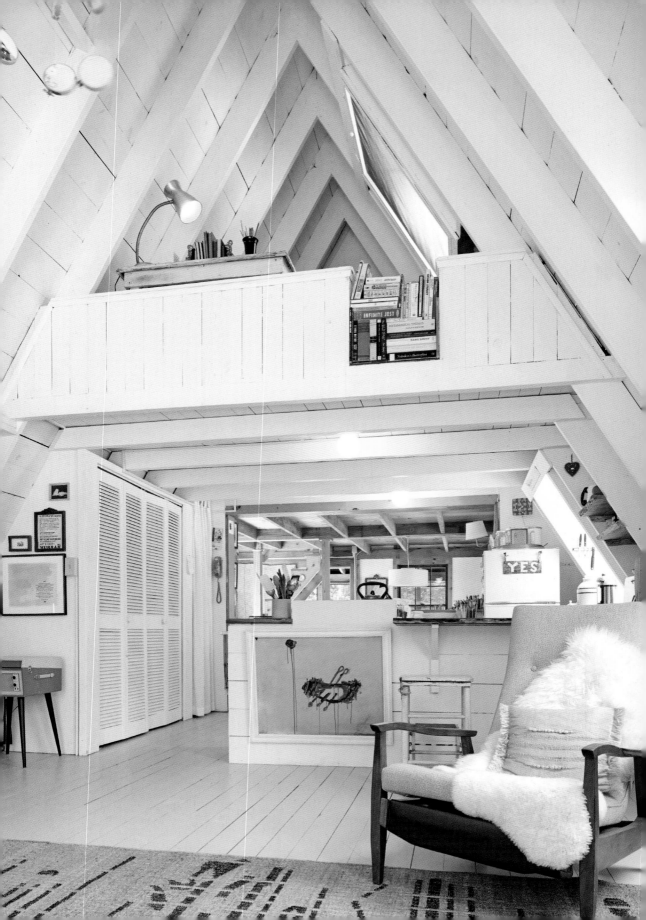

A-FRAME LEGACY

Deering, New Hampshire

The roots of this humble abode are what A-frame dreams are made of. Long before she was born, Sarah's grandparents desired a weekend getaway to escape the beach crowds that would descend upon the South Shore every summer. In search of land on which to build a cabin, her grandfather took out a map and a compass and drew a two-hour drive radius around Scituate, Massachusetts, where they lived. The compass line directed him to Deering, New Hampshire, where they found property for sale. Six acres of land in Deering were purchased, and an A-frame kit was ordered. It was 1963.

The completed A-frame—built by hand, with no electric tools—was completely off the grid and it would stay that way until 2012. Baths were taken in the stream on the property and rain water was collected for washing dishes. The scrappy A-frame even survived a small tornado in 1968, when it was moved six feet off its footing. When it was pushed back into place, the sliding glass door still worked—and still works today. In 1980, Sarah's father built his house on the adjacent land (where he still lives today) so he would be able to help with the upkeep of the home. The A-frame is steeped in sentiment from the close family ties. Sarah, who spent weekends at her dad's place, recalls evenings

at the A-frame spent playing dominoes with her grandparents by kerosene lamp.

When Sarah's grandfather passed away in 1991, her grandmother spent less and less time at their vacation home, and eventually the family decided the A-frame should be sold. When the discussion led to selling it to a friend of the family, Sarah burst into tears at the thought of losing the place which over many years had come to represent home to her.

Her husband, Matthew, sweetly assured her that the two of them would buy it themselves, despite having no idea how to fund the purchase. An agreement was drawn up for Sarah to buy her aunts' shares based on a ten-year payback agreement, and her dad simply donated his share of the home's worth. Soon Sarah and Matthew were able to make the A-frame their own.

The space is neither fussy nor fancy. Kids and dogs are welcome to make themselves at home. As a designer, Sarah is enthralled by the "A" shape. Any uniquely shaped living space is fascinating to her, and figuring out how to live without vertical walls has been a delight. Hanging art on non-vertical surfaces has been a fun challenge for the pair, as well as playing with a 1960s motif to pay homage to the origin year of the house.

With no insulation to compete against the winter cold, and often visited by mice, the A-frame is inhabited only as a warm-weather vacation home. "It's truly a cabin," according to Sarah: "Wood and shingles, I say."

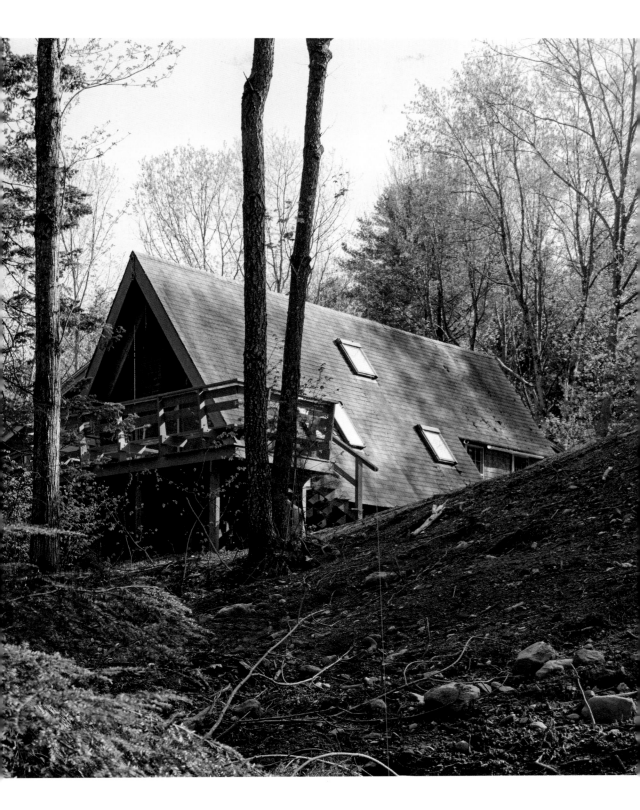

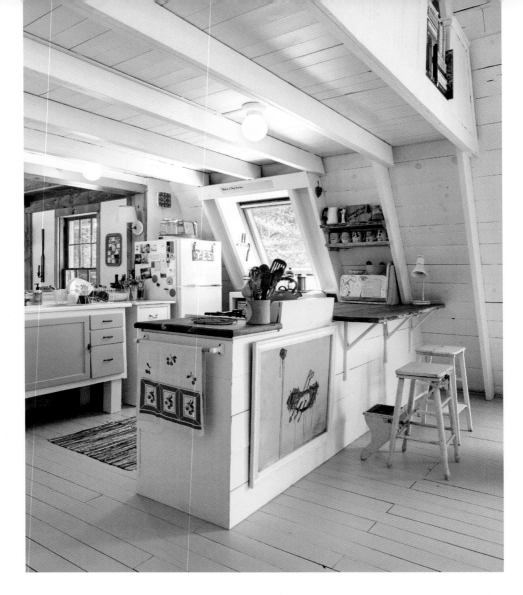

Sarah has committed to using lots of textures and handcrafts in the details: the blankets are all vintage and hand sewn. Women and women's work (such as quilting, embroidery, cross-stitch, and macramé) influence the decor, along with a few Scandinavian elements, as Sarah's grandmother is Swedish and very proud of her heritage.

As an only child, Sarah has inherited her family's history and heirlooms.

ABOVE: The kitchen interior was built by Sarah's father—she sketched out rough ideas for re-configuring the space and he constructed it as a surprise. The raw cherry countertops were made from material Sarah's father had on-hand.

OPPOSITE: The fireplace, despite at a glance appearing original to the home, is actually a gas-burning fireplace and is a very recent addition to the A-frame. The chair is vintage.

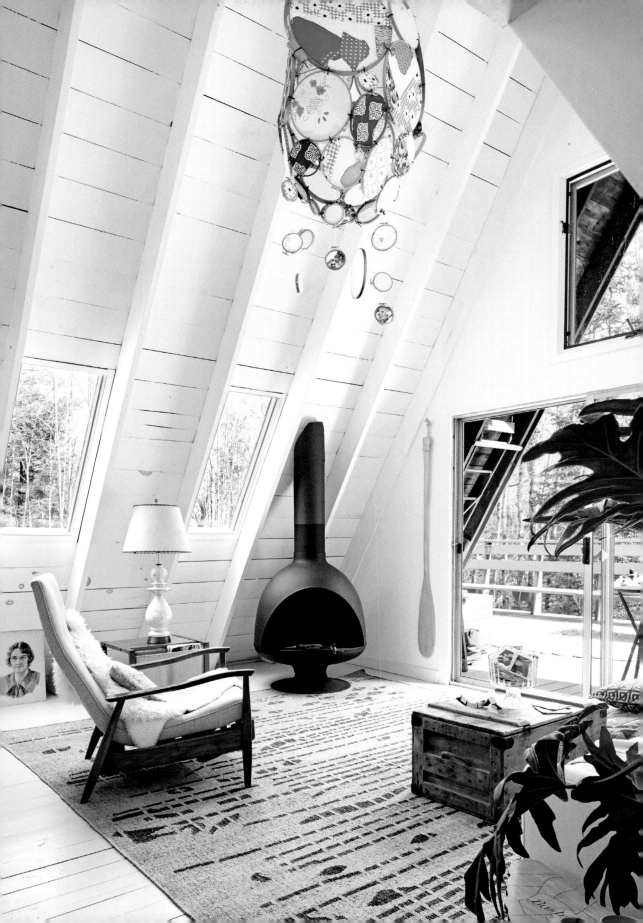

Sarah's grandfather's tools can now be found throughout the A-frame used as decoration. There are not a lot of newly bought items in the A-frame, but the mix of new and old things makes the place come alive—a wonderful mix of family history, and Sarah and Matthew creating their own history in the home as the years go by.

Sarah and Matthew spend the majority of their time lounging in the living room. "Coffee in the morning, cocktails in the evening, and reading on the couch in between" is how they put it. Walking a mile down the road to swim in the pond, or sitting on the porch sipping a cocktail is about as outdoorsy as Sarah and Matthew get. But the connection to nature is still relished: they're four miles out of town on a sparsely populated dirt road. Listening to the wildlife, hearing the leaves rustling in the wind, and seeing the stars come out at night are priceless ways to experience the calm of this cherished home, full of so many memories.

Sarah's and Matthew's hope as a couple is to grow old together in their A-frame and one day hand the keys off to their son and *his* children. As a designer, and as a granddaughter, Sarah has learned how to gracefully honor her family history while injecting the present and themselves into the home as well. It's a home that represents where she came from and where she wants to be. ▲

Family treasures adorn shelves in the dining room: The wooden planer belonged to Sarah's grandfather; the photos are a random collection of group shots Sarah began collecting years ago. The Time Life series belonged to Sarah's grandparents and has been on that shelf her entire life. The bottom shelf is packed with comic books—a favorite genre for Sarah and Matthew.

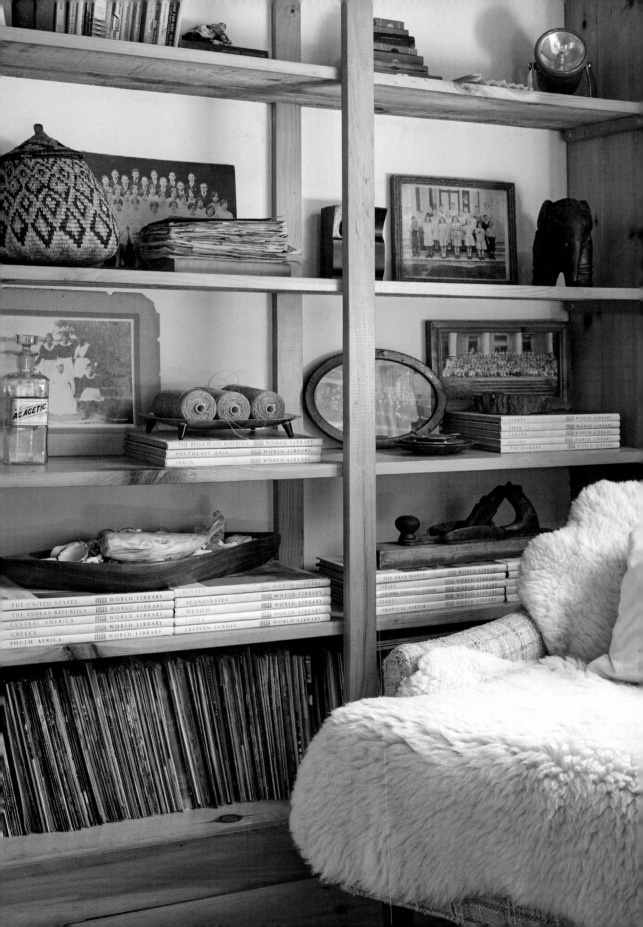

The dining room was built by Sarah's grandfather in 1980 as an addition to the kitchen. Vignettes of old (and sometimes new) things throughout the home convey fresh energy to the space.

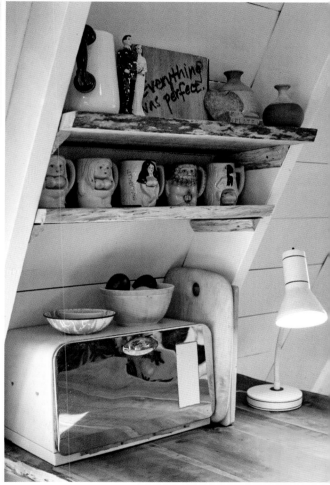

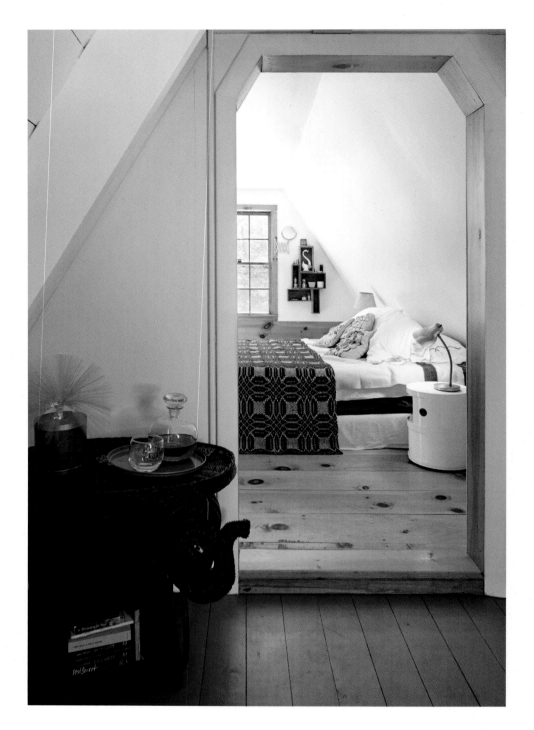

ABOVE: The master bedroom was part of the 1980 addition completed by Sarah's grandfather. The blankets in the home are all vintage and hand-made. The wicker elephant was a thrift store find.

OPPOSITE: The loft in the peak of the A-frame overlooking the living room is a special spot, used as a library, and often a quiet writing room.

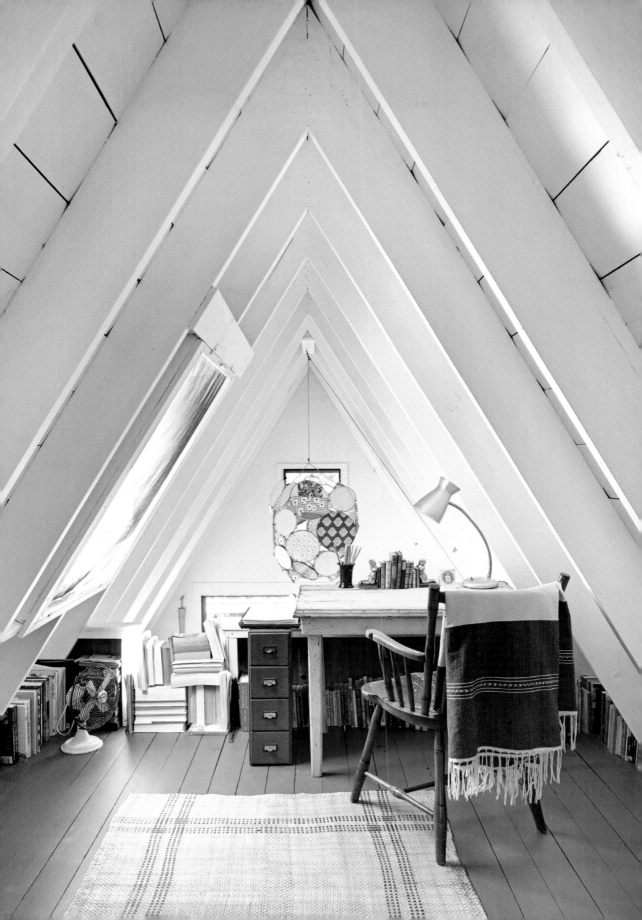

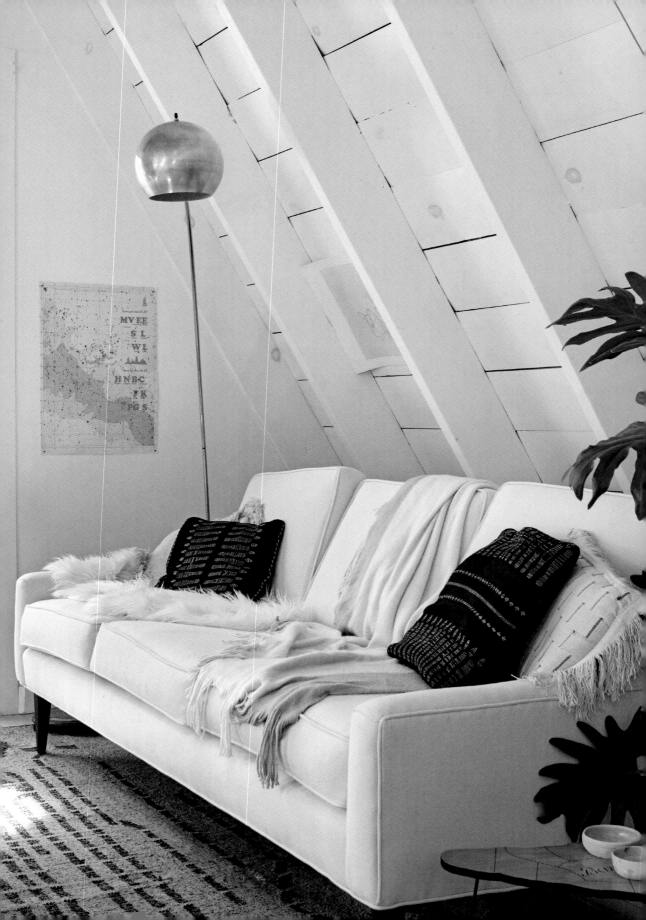

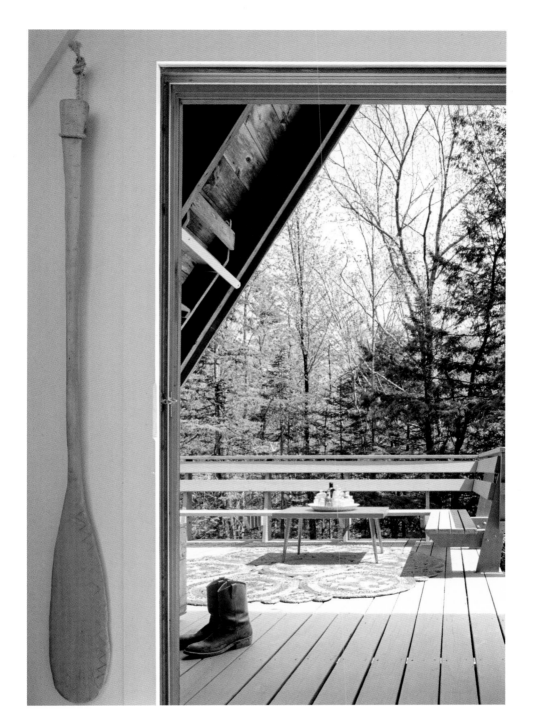

OPPOSITE: The living room sofa belonged to Sarah's maternal grandparents. Initially upholstered in a deep orange wool (and decades old), a recent canvas reupholstering gave the sofa new life.

ABOVE: The oar alongside the sliding glass door was hand-carved by Sarah's teenage son while on a months-long outdoor expedition.

ABOVE/OPPOSITE: Plenty of outdoor space has enabled Sarah and Matthew to host parties with as many as 40 guests in attendance, camping out overnight.

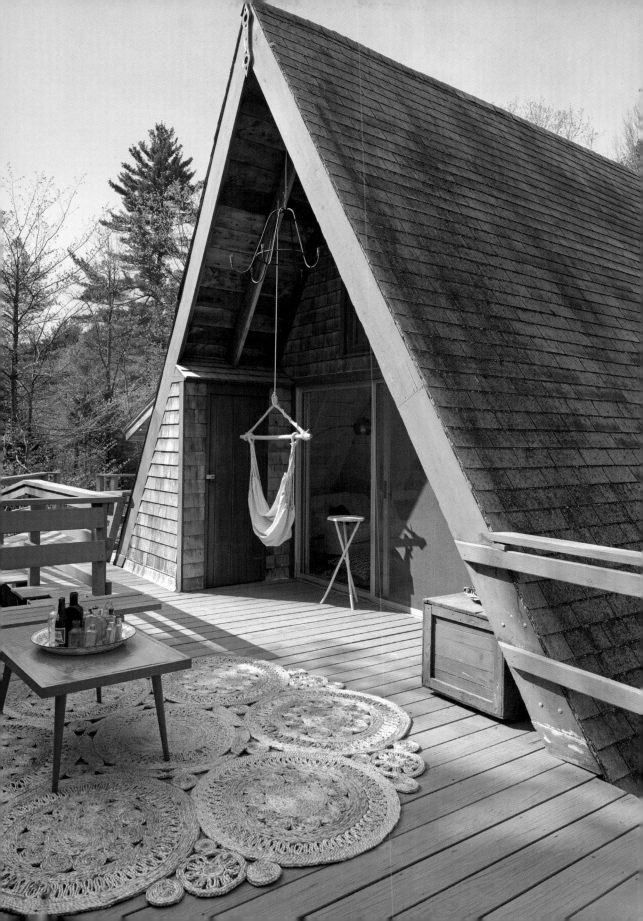

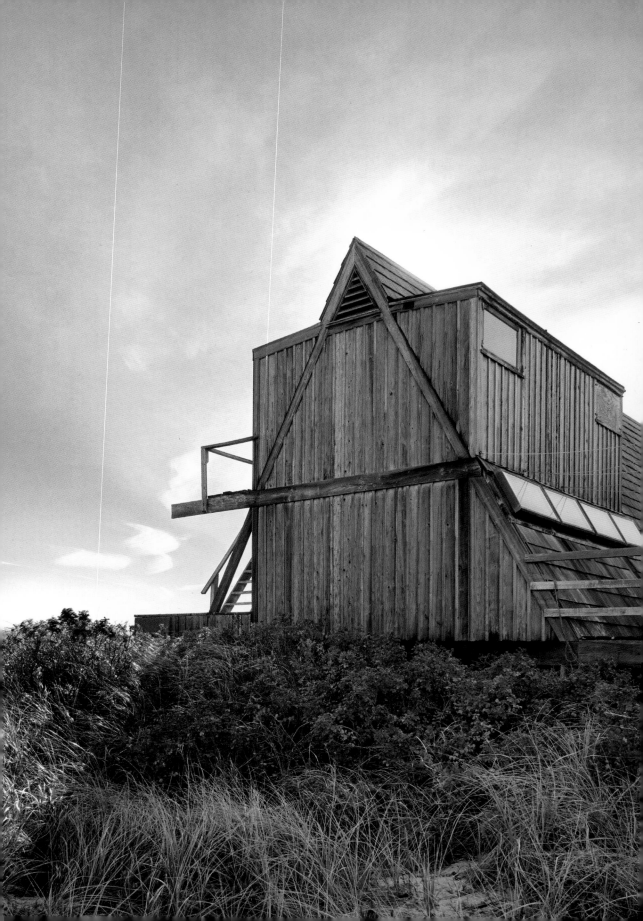

SUMMER PLAYHOUSE

Amagansett, New York

"Summer use playhouses" was how architect Andrew Geller described the
beachfront homes he designed along Long Island, New York, throughout the
1950s and '60s. Trained in industrial design, Geller designed these playhouses
in his free time. Fashioned with modernist leanings, the homes were quirky,
functional, and—with most being priced at under $10,000—quite affordable.

In 1958, Geller was commissioned by Leonard and Helen Frisbie to design
a simple beach house on a dune in Amagansett, New York. Their only require-
ments were that it had to be simple and must include a small deck that would
reach over the ridge of the dune. Six decades later, the home maintains its
quirky beach house charm. A tad windswept after all these years, it now serves
as an annual summer retreat for the Frisbies' children, Lenora and William,
and their families.

The two siblings agreed early on that elaborate renovations were neither
needed nor desired. The beach house provides comfortable, though certainly
rustic, accommodations for its visitors in the summer months: there is no insu-
lation or heat, and a single indoor/outdoor shower serves as the most modern
amenity the home has to offer. Pulley-drawn ladders lead up to the loft space

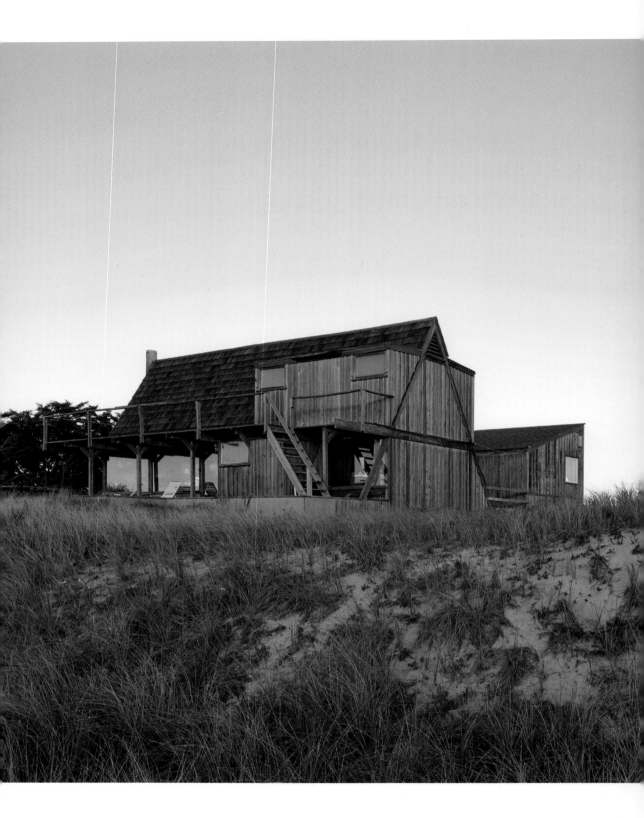

for elevated views. Folding counters in the kitchen and tiny upstairs rooms with bunk beds make the most of the small space.

Proving to be a bit of a time capsule, most of the playhouse's decor and effects are the Frisbies' original furnishings. The few replacements made over the years were selected to look like they've been there since the beginning. Found beach objects displayed in nooks and on shelves become art. Expansive windows provide enchanting views of the sand and the sea.

Nature plays a very large role in the experience of its inhabitants. Immediate ocean access is one thing, but William's son, Matt, testifies to the camp-like experience: "You find your body getting into the rhythm of nature, where you're getting up with the sun."

Month-long visits to the Frisbie house are filled with each occupant's favored hobbies. Swimming, body boarding, reading, playing the guitar, and fishing abound. Many nights are spent camping out on the deck or on the beach below. Their days usually end with a surf or walk along the beach.

The Frisbie house carries on the tradition of simplicity and synchronicity with nature—and as Lenora and William plan to keep the A-frame in the family—the tradition will continue for years to come. ▲

A guest house was added to the beach property in 1971.

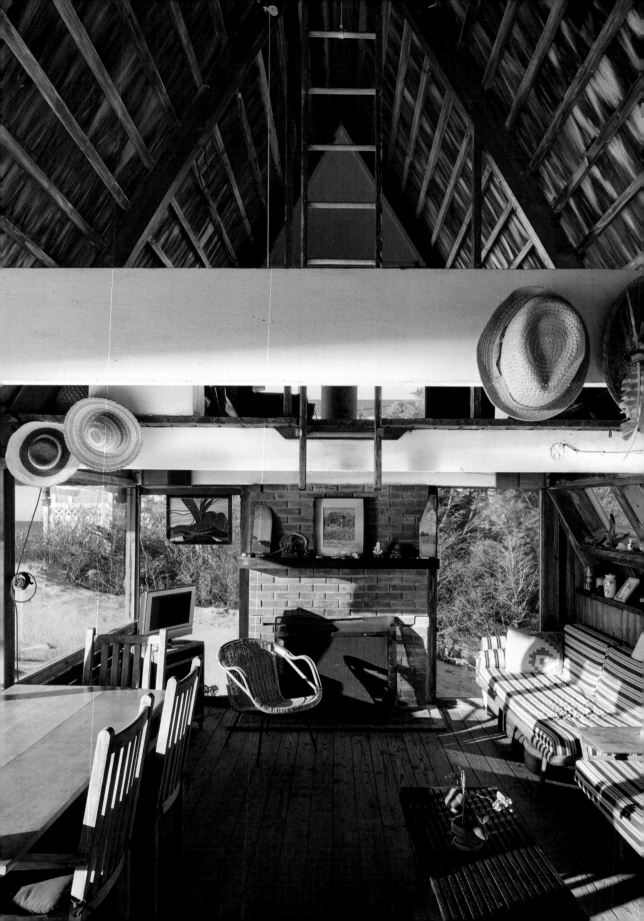

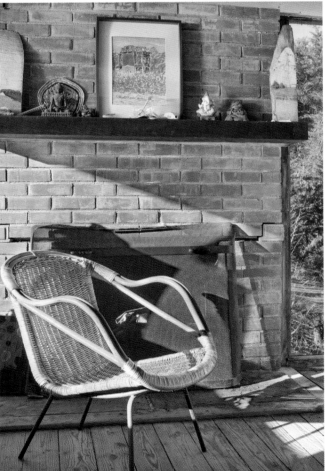

OPPOSITE: A pulley-drawn ladder connects to the loft.

ABOVE/BELOW: The A-frame has become an eclectic time capsule as second and third generation family members spend summers there.

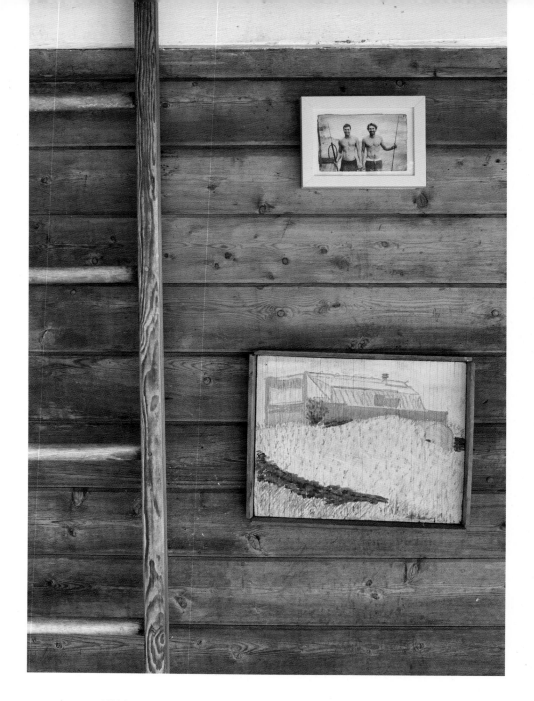

ABOVE: Leonard Frisbee painted this likeness of the A-frame; he used to paint on found beach wood while staying at the house.

OPPOSITE: The A-frame has maintained much of its original furniture and decor. Any additions have been chosen with the intention of matching the A-frame's beachy rustic aesthetic.

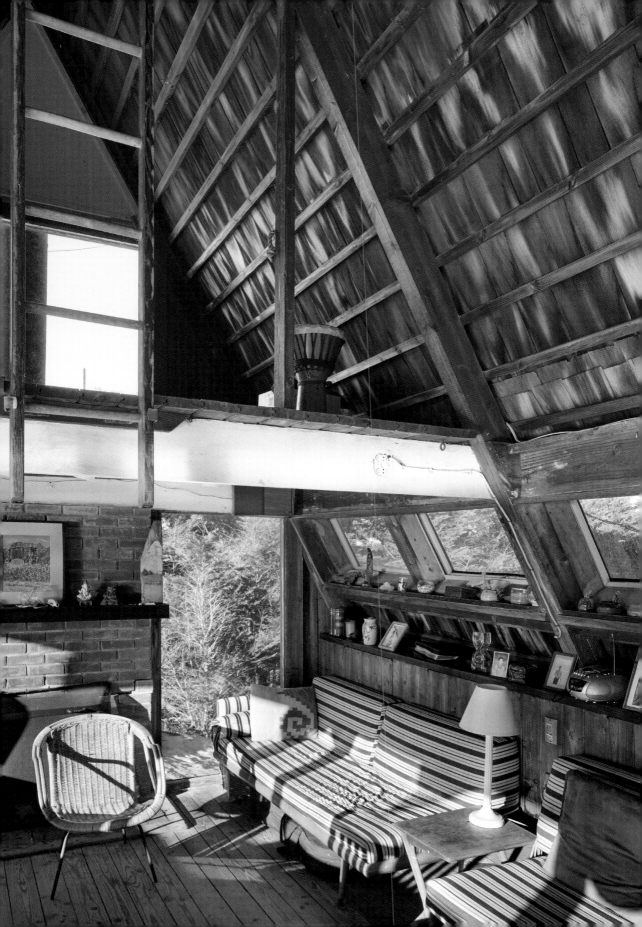

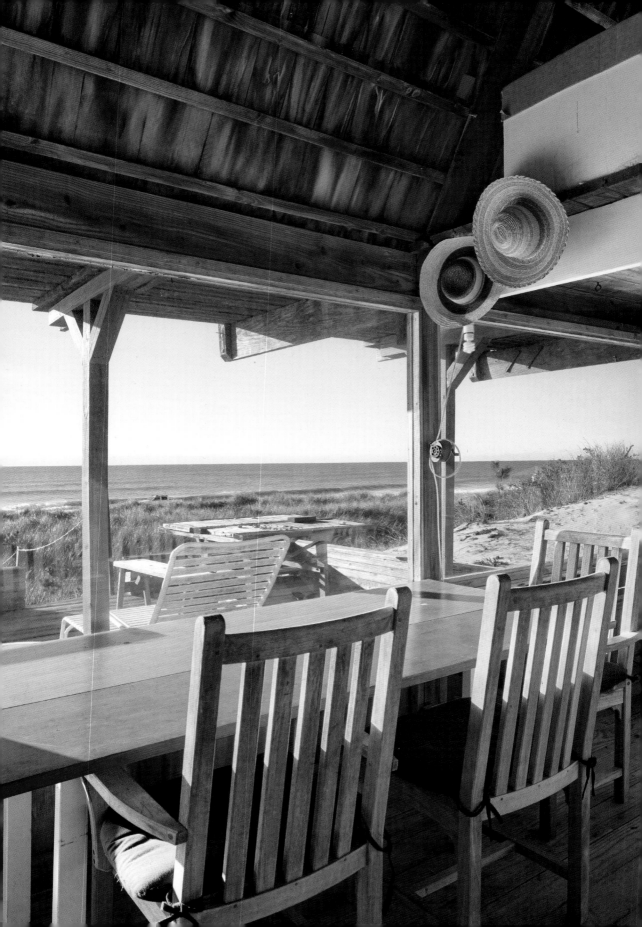

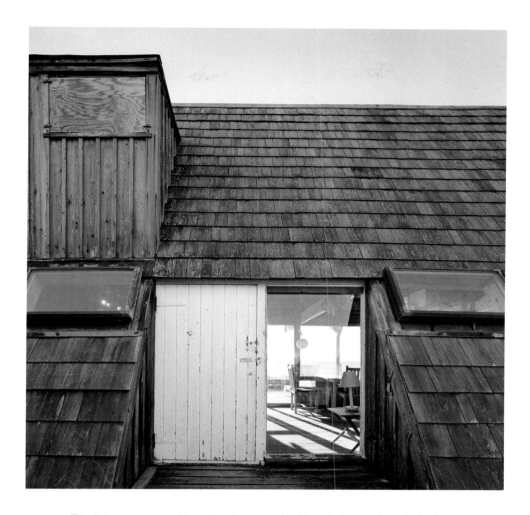

OPPOSITE: The living room provides a front-row seat to the windswept beach. On less active days, sunsets are enjoyed from the oceanside deck with a cocktail in hand. On rainy days the family huddles inside for board games.

ABOVE: Plywood boards up a broken window on the second level of this beloved family A-frame. Skylights provide warmth and light to the interior.

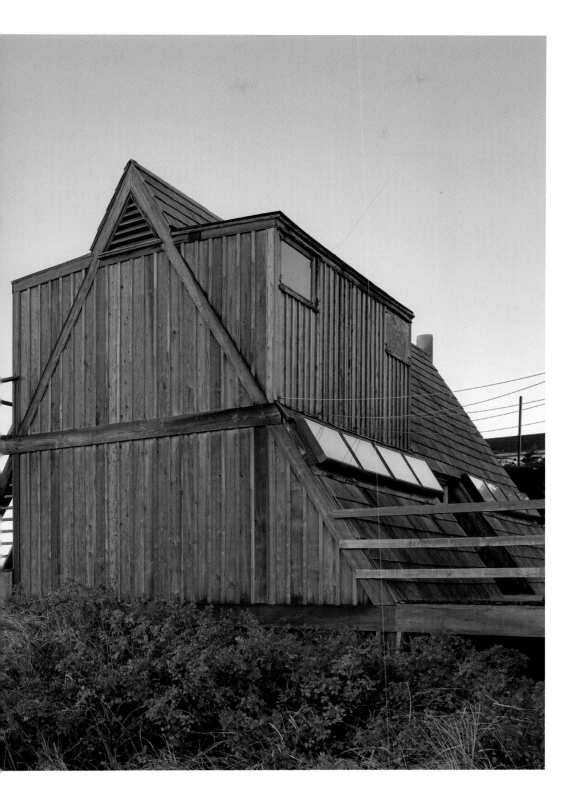

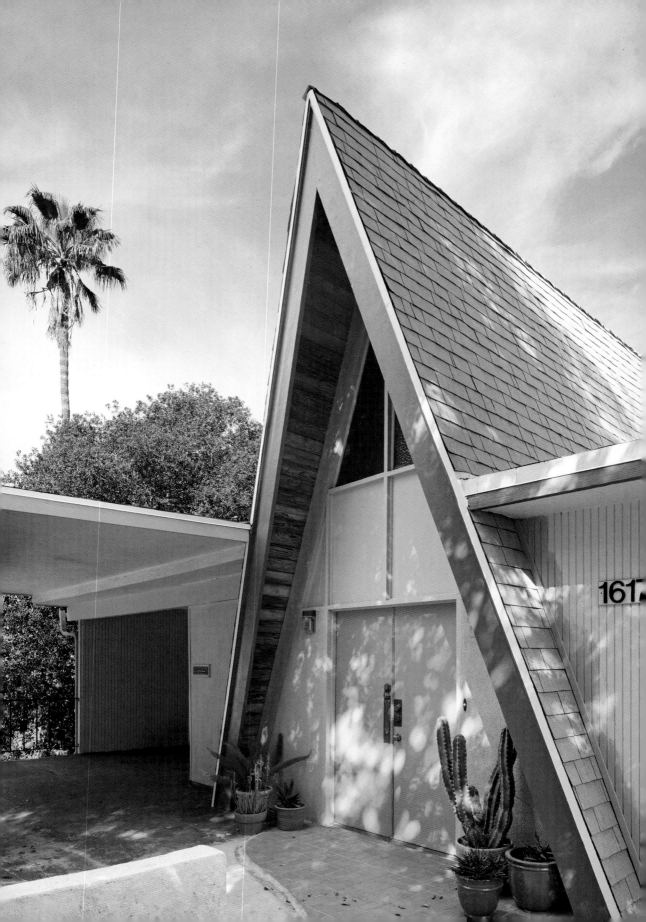

EAGLE ROCK

Los Angeles, California

B old orange doors and a smattering of potted succulents greet visitors at the former home of geologist Joe Birman, father and creative scientist who generally aspired to experience the unusual.

Joe grew up in New England but fell in love with Los Angeles after serving as an officer in the Army Air Corps in the 1940s, followed by moving to Southern California for his education. He went to the California Institute of Technology and UCLA, where he received his PhD.

His interest in the unusual was reflected in where he chose to live. Early on, Joe raised his family in a Schindler home, a place best known for its stylish modernity, until it was taken by the 134 Freeway construction. He would eventually purchase Eagle Rock House because he could not resist the unique architecture. The 1963 A-frame (and its eponymous neighborhood) takes its name from a prominent rocky outcropping in the area resembling an eagle with outstretched wings.

Joe bought the Eagle Rock A-frame from a well-known Los Angeles DJ. He found the idea that an artist had owned the home before him most intriguing. The home was designed for people to enjoy. Neighbors were treated to concert-level

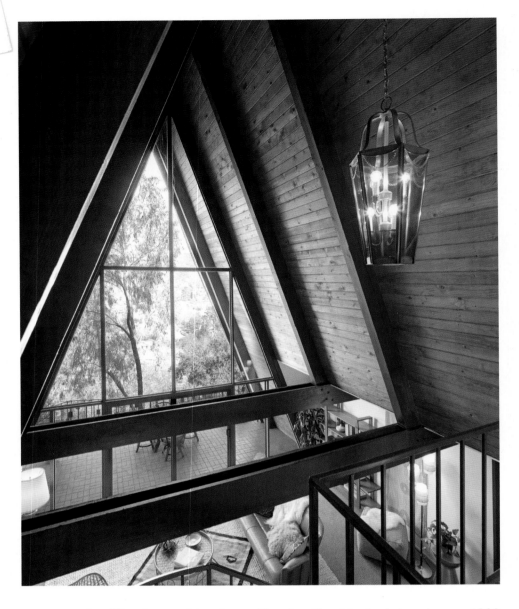

piano music of Beethoven, Mozart, or Chopin—if not by Joe's hands on a 1909 baby grand piano, then certainly from his amazing midcentury stereo system. The vaulted ceilings are a delight for their acoustics, but even more so for the view they afford of the San Gabriel Mountains. Joe never tired of that view for the roughly forty years he lived in his A-frame. Nor did anyone who would come to visit. The Eagle Rock A-frame is truly a special place by any measure: though humble in size, it has a grand impact. ▲

ABOVE: Upon entry, guests are greeted by a showstopping window spanning two levels of the home.

OPPOSITE: A quiet nook beside the stairs to do one's work.

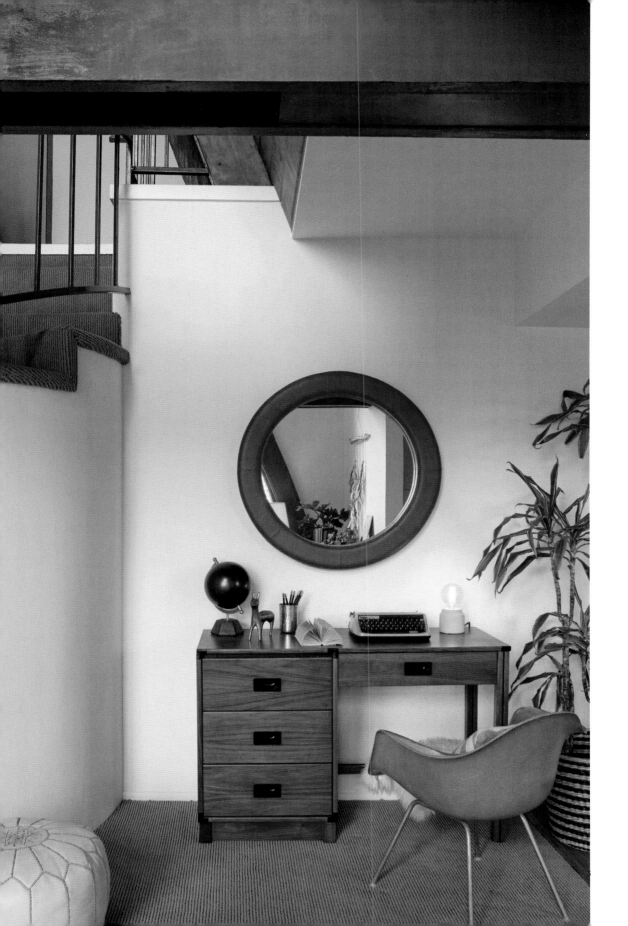

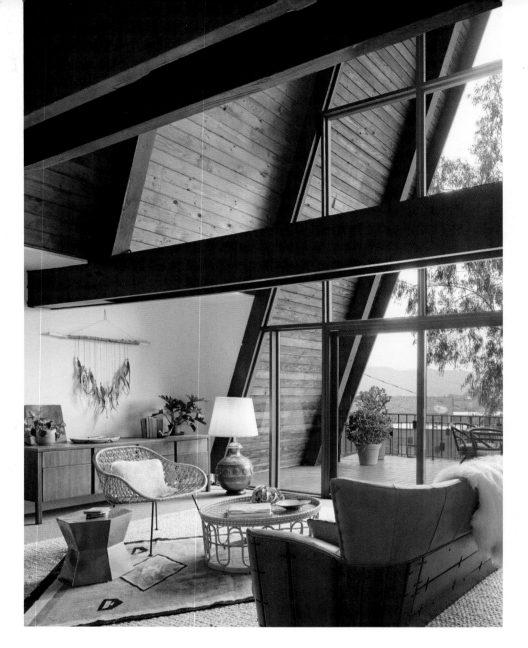

ABOVE: Joe had an eclectic taste in furniture; while the home was staged and photographed after his passing, the A-frame was always filled with unique pieces, 1960s and earlier.

OPPOSITE: The living room opens onto a partially sheltered deck, ideal for entertaining and offering enviable views of the San Gabriel Mountains.

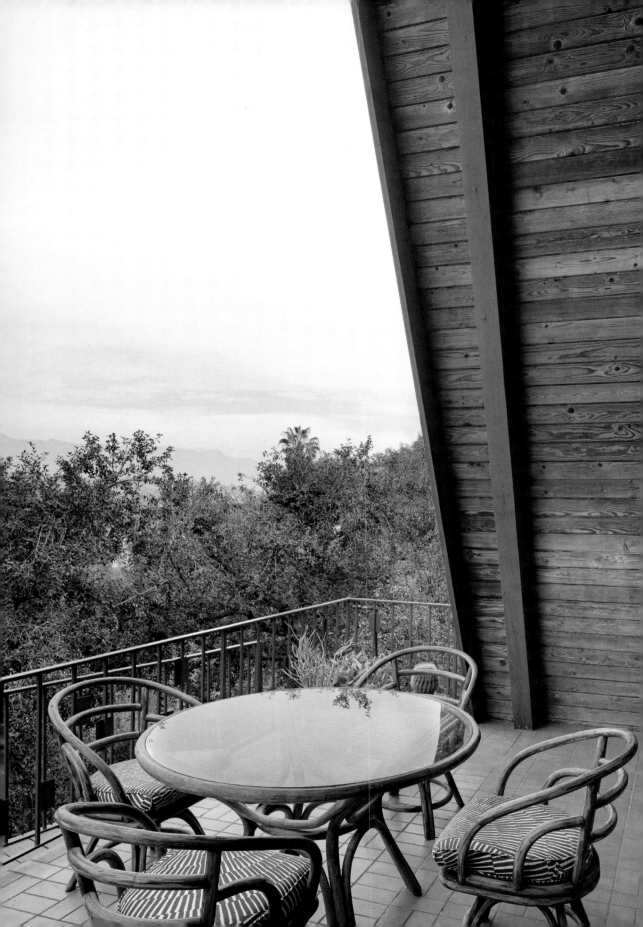

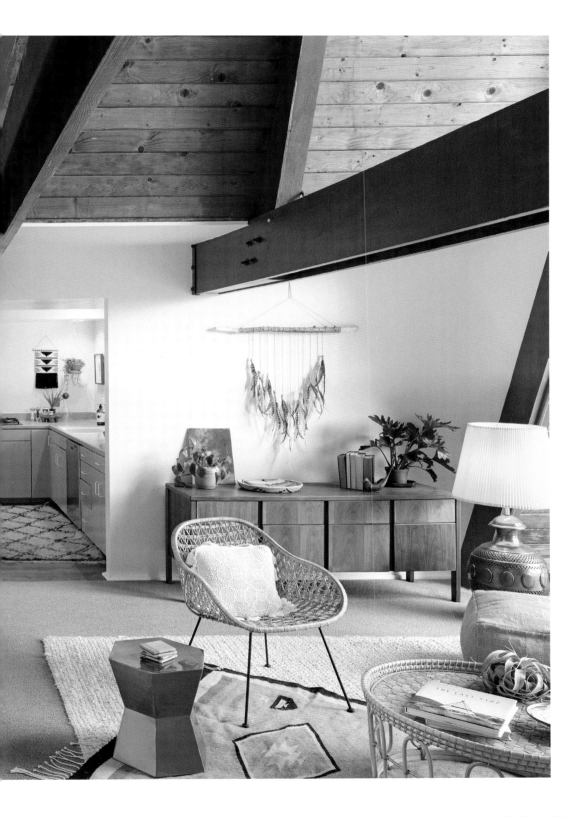

ABOVE: In the 1980s, Joe worked with an architect to design a third bedroom/office space to match the style of the house. The fireplace was added at that time.

OPPOSITE: Two of the three bedrooms decorated in a mid-mod bohemian style.

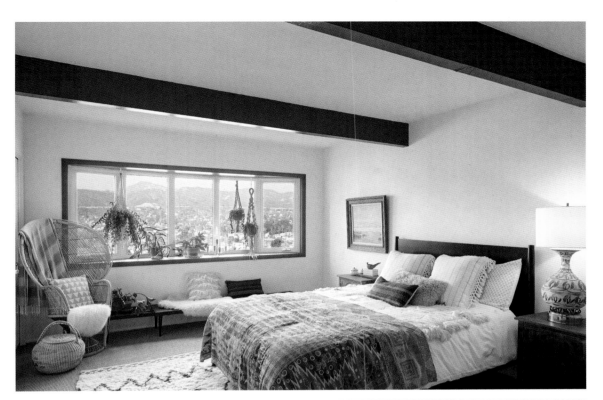

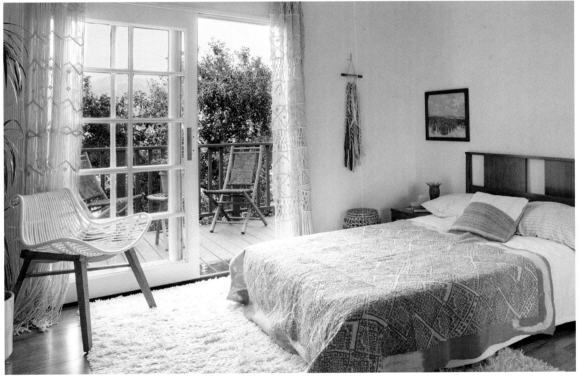

ARTISTS
AT WORK

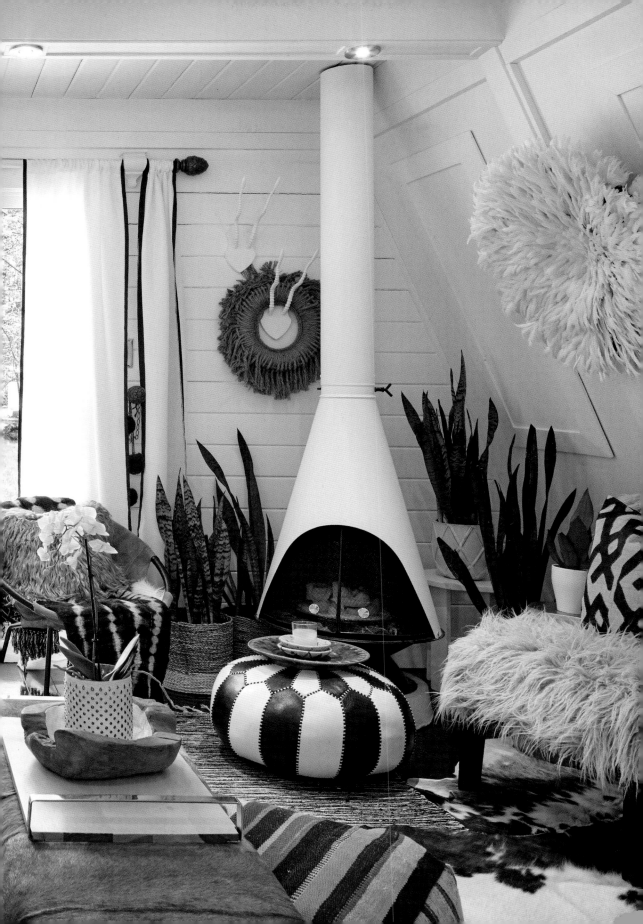

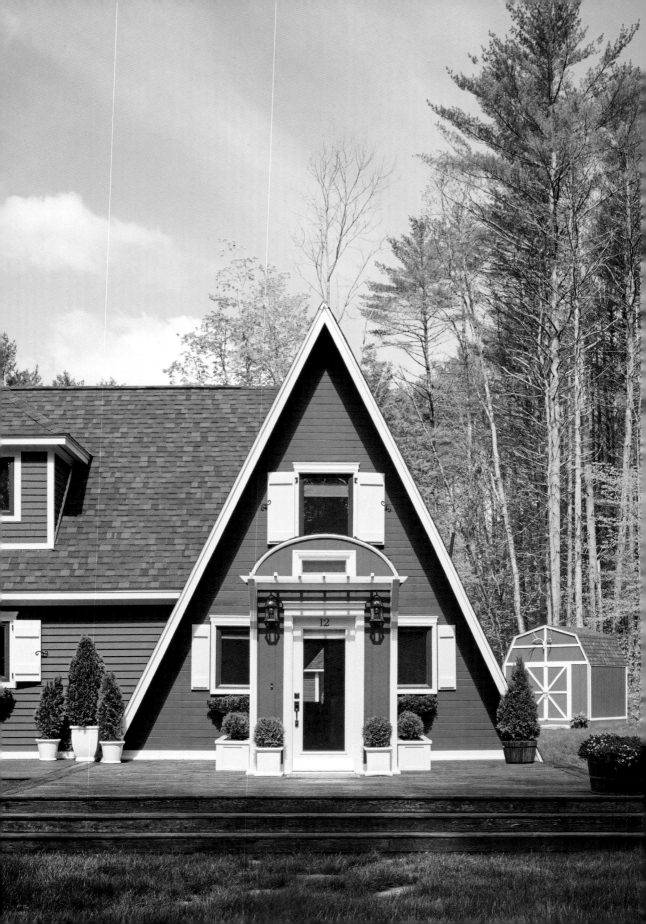

INSIEME HOUSE

Sanbornton, New Hampshire

For homeowners Astrid and Brian, Insieme House started out as a ramshackle, seasonal cottage tucked away in the woods of New Hampshire. Previously a derelict, uninsulated structure used only during the summertime, the home hadn't been inhabited for years. Thanks to a full remodel of the interior and exterior, the Insieme A-frame has since become a year-round residence to this family of three.

Extensive renovations have allowed this creative couple, both with backgrounds in the fine arts, to put their collective stamp on the unorthodox home. When designing their space, Astrid (an interior decorator by trade) didn't feel inclined to decorate it as a traditional, woodsy cottage that one might typically find in the Lakes Region of New Hampshire. "I really wanted our home to feel like a worldly retreat, especially because we live in such a quiet and remote area," Astrid explains. "It was my intentional way of connecting to the vastness of the outside world."

Whitewashed walls throughout most of the home bring freshness and serenity to the space while serving as an ideal backdrop for a mélange of colors, patterns, textures, and objects to be appreciated. First-time guests

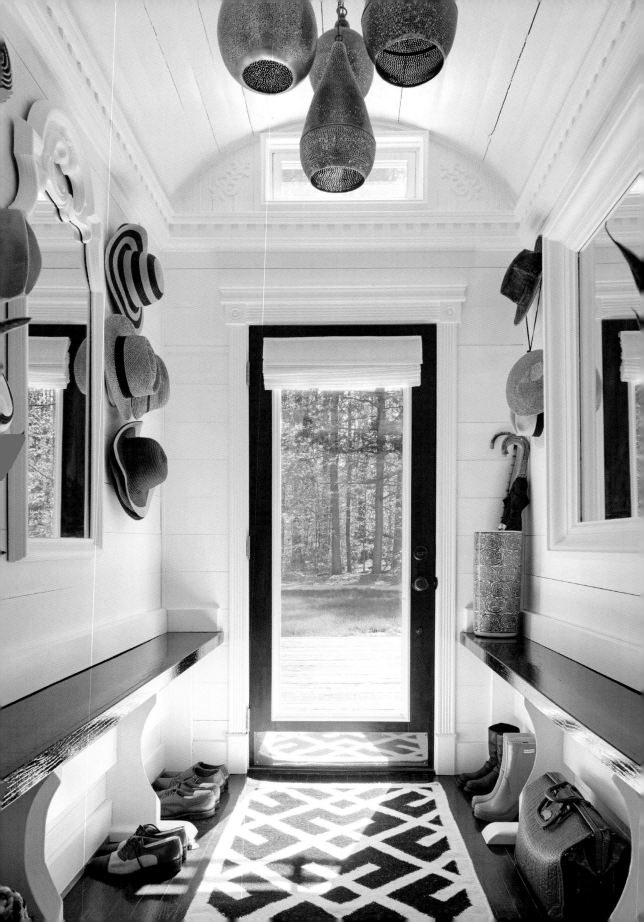

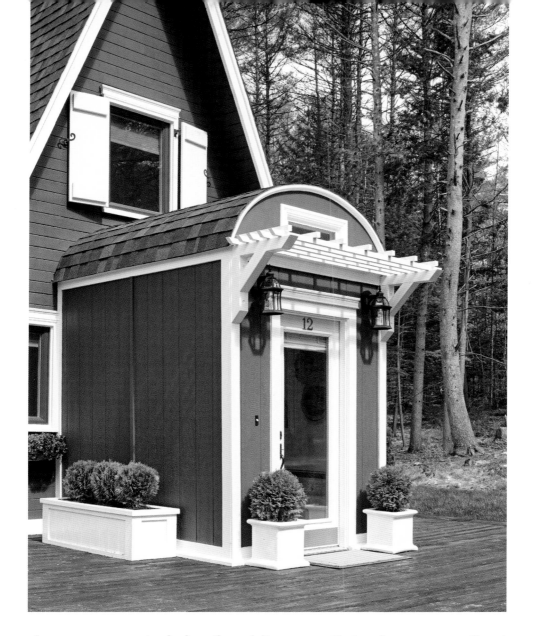

always seem surprised when they visit, commenting on how unconventional the space is; yet at the same time the home feels cozy and familiar.

The family's widespread interests in the arts range from design to painting, men's couture to heavy metal. Their creative eye is reflected clearly in the unique architecture and decor. The home's design aesthetic is eclectic, greatly

OPPOSITE: The barrel-vaulted foyer was added onto the A-frame as a much-needed entry space/boot room, and is lit by this cluster of Moroccan pendant lamps.

ABOVE: Foyer design was conceived and the project executed with help from Astrid's father, visiting from Portugal.

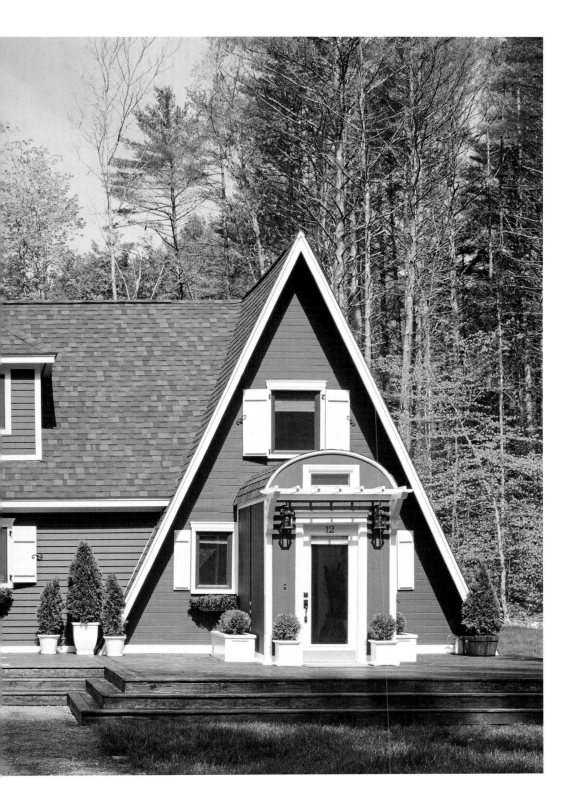

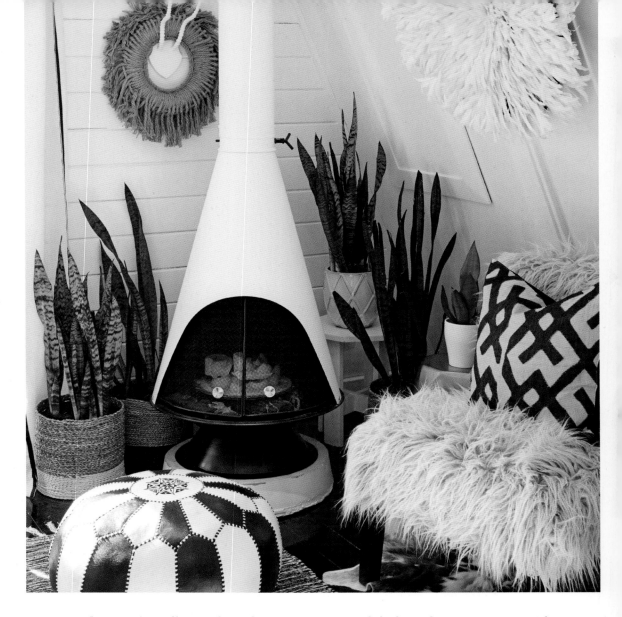

reflecting Astrid's penchant for incorporating global touches in contrast with traditional forms, always with the underlying intention of creating an environment that feels comfortable and inviting while still being subtly chic. "I adore artful, layered spaces that exude exoticism and elegance—but they have to be livable," Astrid adds. When asked which designers have inspired her in this

ABOVE: Vintage fireplace was found online, painted a 1970s orange. Astrid and Brian resurfaced it with high heat white paint.

OPPOSITE: Cowhide rug was purchased from an eBay vendor. The hide-upholstered bench is used as a coffee table. Moose skull was found by Brian in the woods by their home during a morning run.

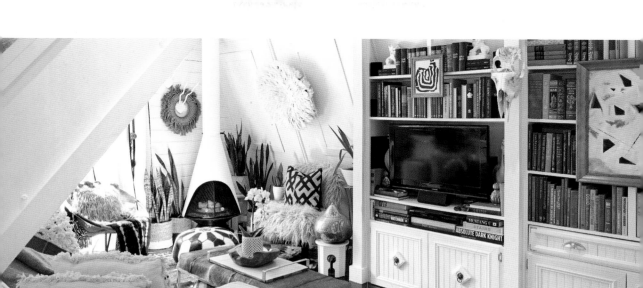

home, she declares, "There are so many inspirational designers who come to mind as having influenced my particular style, but Sig Bergamin [an architect and designer based in São Paulo, Brazil] is definitely one of my favorites. Very few can masterfully layer, mix, and manipulate colors, patterns, periods, and styles like he does."

The unique, almost surreal experience of living in an A-frame is something the whole family has come to appreciate. As Astrid points out, "A standard home with regular walls can never be compared to living in a triangle!" In response to the very signature A-frame element of steeply angled walls, they resorted to using built-ins wherever possible to create more storage and to maximize usable space.

The barrel-vaulted foyer, which the Insiemes added to the A-frame, represents one of the most unique features of the home because of its unusual

architectural design. It's nothing more than a very narrow entry space leading into the kitchen, but it adds an element of unexpected drama when one enters the A-frame. To add to the impact of the space, the homeowners hung a cluster of perforated Moroccan pendant lights—which happen to be Astrid's most cherished collection of wares—from the arched ceiling.

Vintage mirrors in the foyer and kitchen were thrift store finds and painted white. Rugs are woolen dhurrie runners. Mirrored rack shelving olive oils and vinegars is a door concealing the electric panel.

Ensconced in nature in Sanbornton, New Hampshire, the A-frame is sequestered behind a grove of pine trees in the front and side of the house. The property also enjoys the added luxury of lake access: Hermit Lake, situated just a few hundred feet from the property, can be seen from their front yard. The family enjoys swimming and canoeing in the summer months and are able

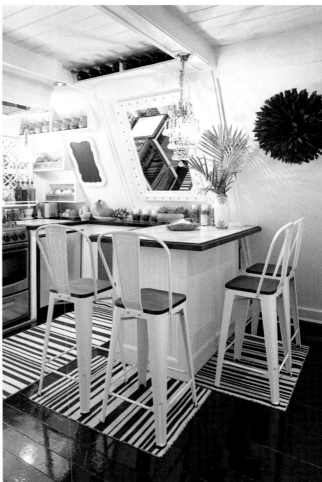

OPPOSITE: Door to the home's only bathroom is the original front door to the A-frame, re-purposed. It was painted white with some graphic detailing and its inset glass panes were replaced with mirrored insets.

ABOVE: The bathroom's diminutive yet bold presence, at roughly 5 x 6 feet, is reminiscent of a jewelry box. Sink vanity was a hand-painted Moroccan nightstand which was upcycled.

ABOVE: Moroccan pom-pom bedspread and pillows contribute to the exotic bedroom. Photographs in hallway were taken during Brian and Astrid's travels.

OPPOSITE: Perforated Moroccan pendant light adds a unique shimmer to the peaked ceiling.

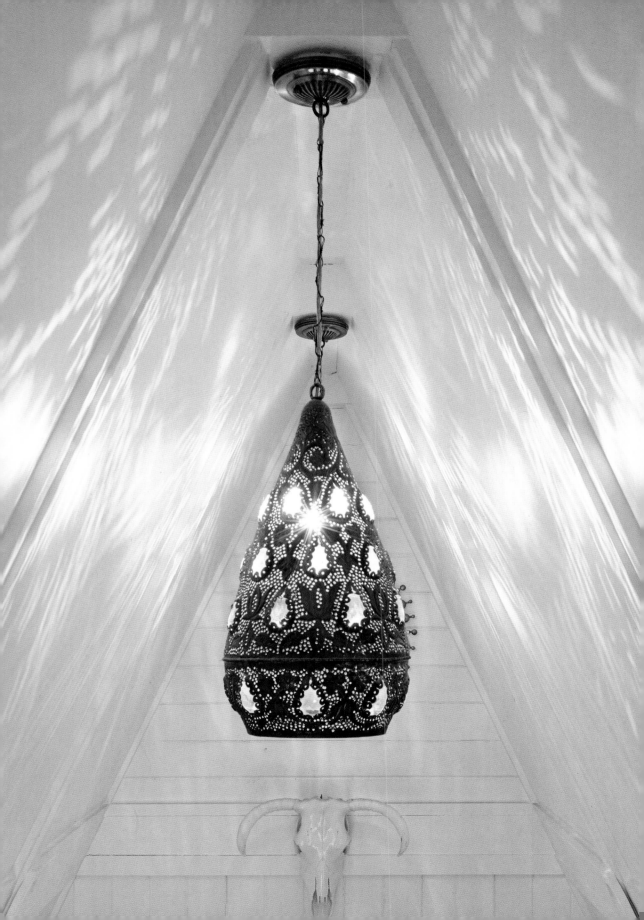

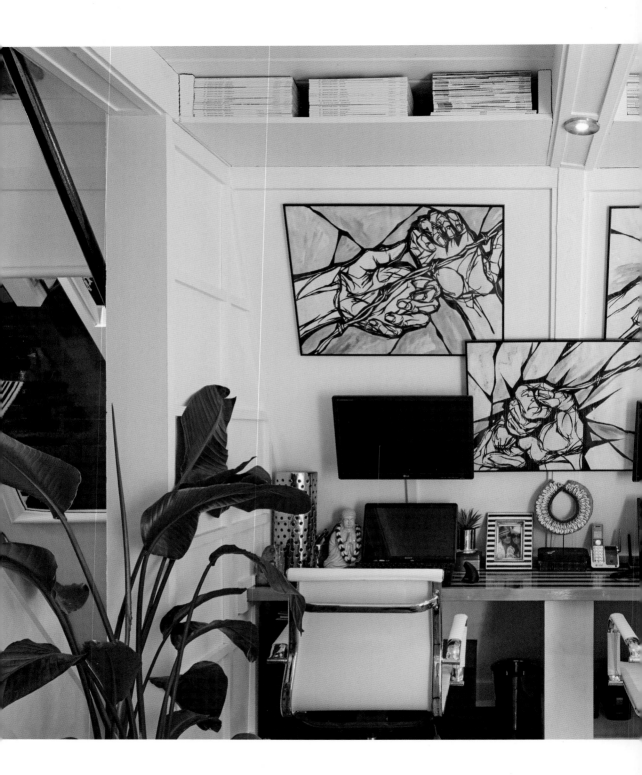

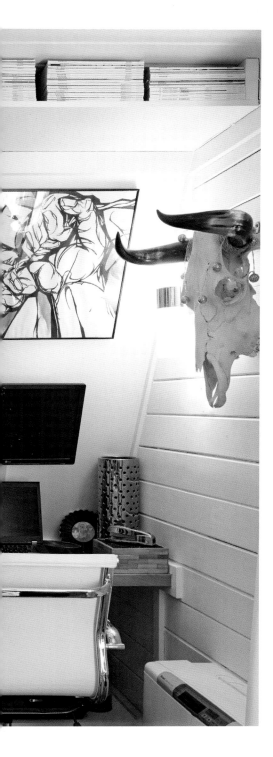

to witness the passage of season color and snow descends upor long months of winter. The family has ma ority to maximize their backyard for as much or the year as the weather permits. Decks for lounging have been added, as well as a permanent fire pit farther back in the yard, for those evenings of drinking wine and roasting marshmallows. One memorable summer while renovating the bathroom they actually bathed outdoors using a makeshift shower rigged to a pine tree.

The evolution of Insieme House truly reflects both Astrid and Brian's creative personas, as the renovation and transformation of this property has very much been a labor of love from them both. While renovating this house together has been playfully referred to as the largest installation piece these artists have ever worked on, they admit their work is far from complete.

"I truly believe homes are entities on their own and should evolve organically, just as their inhabitants," Astrid explains. As a family, the Insiemes want to continue dedicating themselves to the personal and professional pursuits that fulfill them—and keep living the life they've designed for themselves in their A-frame in the woods of New Hampshire. ▲

Black-and-white paintings are mixed media on paper, created by Brian when he was a teenager. The desk surface was made using wood recycled from Brian's childhood family dining room table.

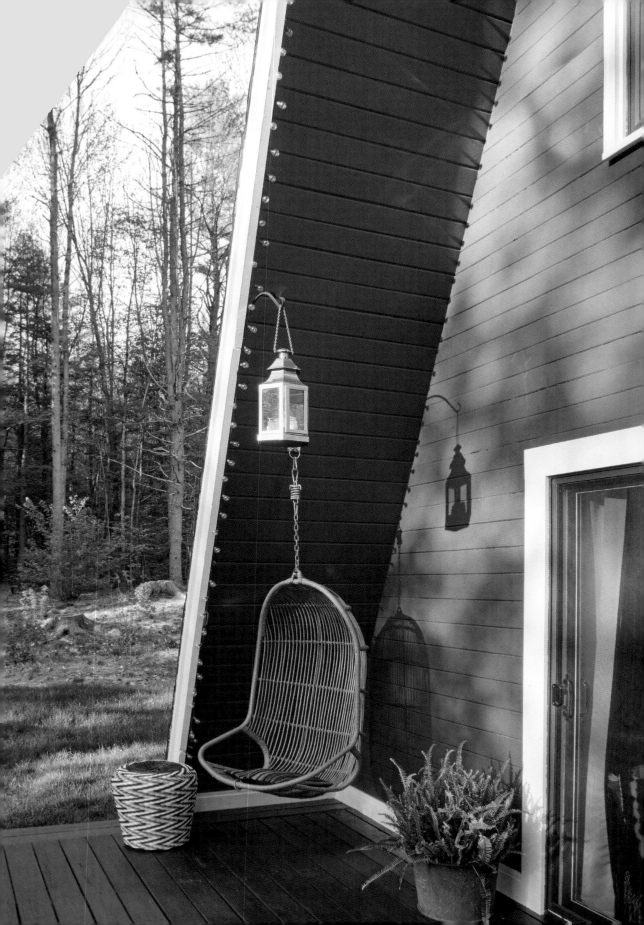

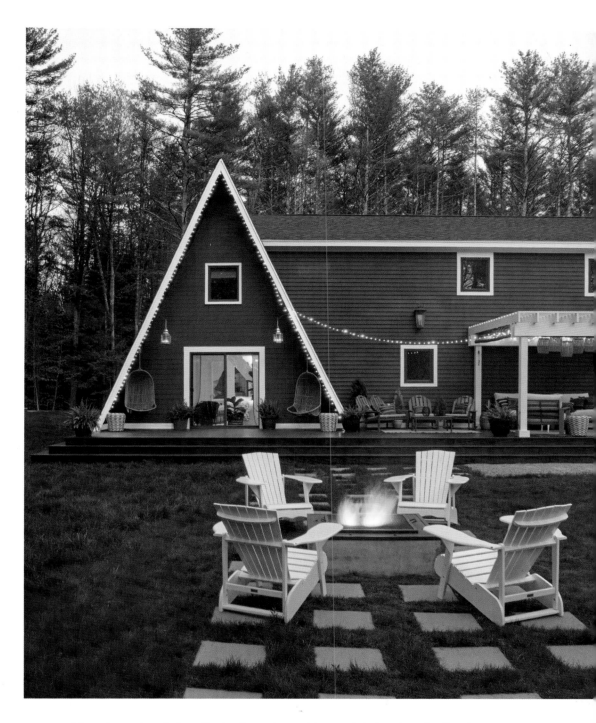

OPPOSITE: A hanging swing chair on the back porch provides a quiet place to enjoy the view.

ABOVE: Astrid and Brian built the concrete fire pit themselves and complemented the outdoor space with Adirondack chairs.

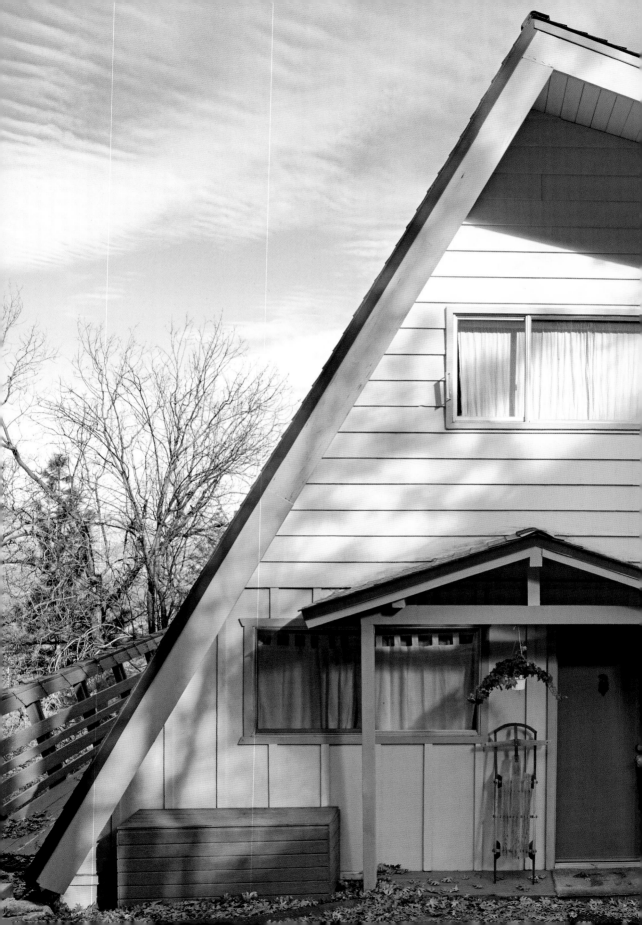

ROOM TO GROW

Lake Arrowhead, California

When Savannah and David resolved to move to the mountains, they were determined to find a proper mountain home to get the full experience. Stumbling upon this Lake Arrowhead A-frame on a rental agency listing, Savannah and David knew it was the perfect place for them to focus and grow.

Their idyllic escape was not pursued for the sake of avoiding career and responsibility, but rather to open up both the time and the space to dive in headfirst. Savannah is a graphic designer, and her one-time hobby of making plant holders has taken off into a part-time business. David is in real estate development and maintains a business making furniture, such as tables and benches, from reclaimed wood. Together the pair own and run the lifestyle shop Road Trip, which supports local and American-made products and is run out of another A-frame just a short drive from their home. Savannah and David's desire was to get out of the city to focus on establishing all of these endeavors and developing them into something they could build on.

The polar opposite of where they were living before (Burbank, California), their A-frame is secluded and brimming with nature and animal life. Seasons

are experienced at their fullest with bursts of autumn foliage, winter snowstorms, spring showers, and a proper sun-filled summer. Because of this new connection to the land, Savannah and David encounter changes in nature in a new way—such as the daily growth of buds in the spring, birds nesting in a nearby tree, and woodpeckers storing acorns in their deck. In the summer, the house feels like a tree house from its position on the hillside, enveloped in leaves.

The cedar wood A-frame rests on this hillside on stilts. The bottom portion of the house was previously built out to include a basement which Savannah and David use as an office or extra sleeping space for guests.

Humorously contrasted to most people's experience in downsizing for an A-frame, this Lake Arrowhead property is actually the largest home the couple has lived in together. It's bigger than they need for just the two of them, but with the extra space, Savannah and David are able to entertain often, inviting friends and family to stay with them and enjoy the mountains as well.

Savannah and David have so adored their experience of living in an A-frame that they're already on the lookout for

Years ago, part of the A-frame was pulled out to allow for more space in the home, creating a lopsided effect on the exterior. Many homes in the area share the same update.

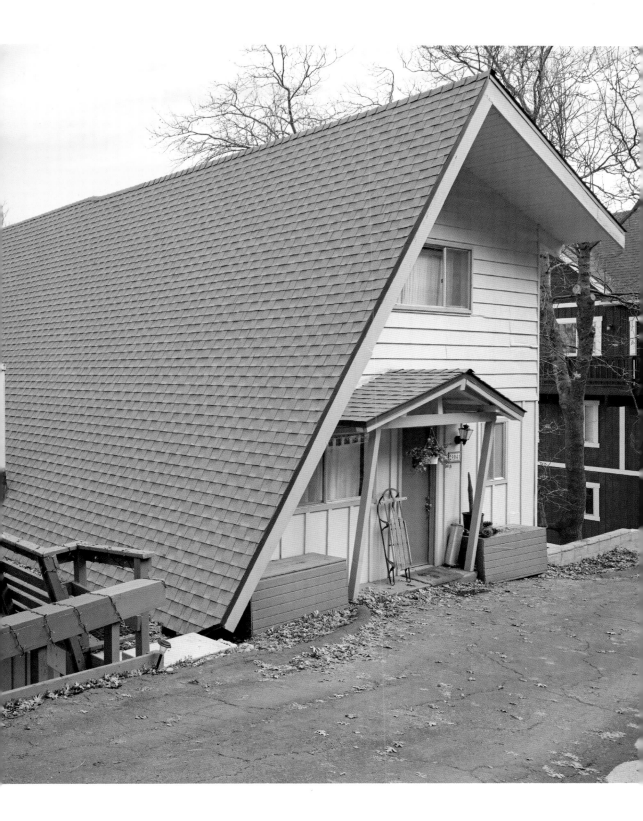

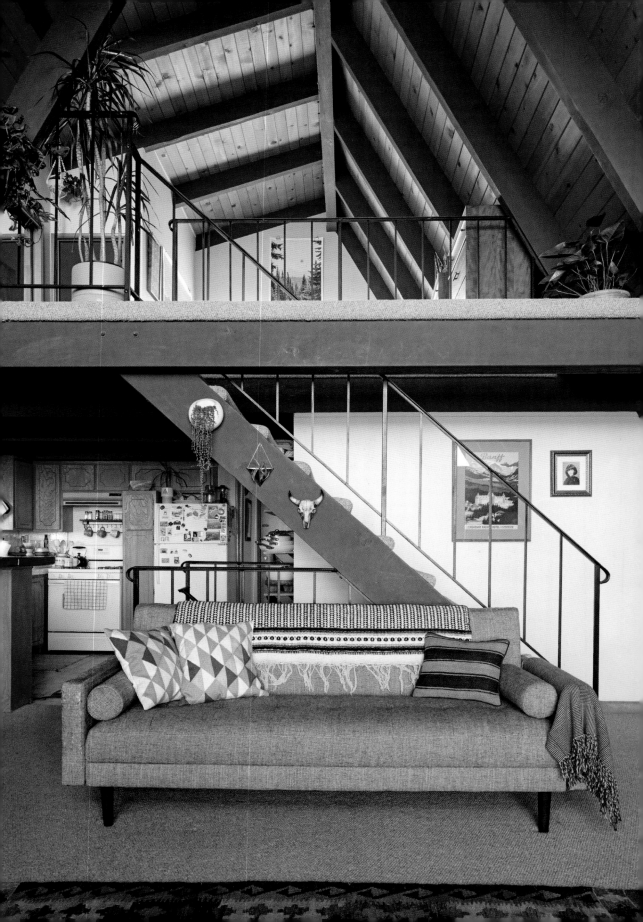

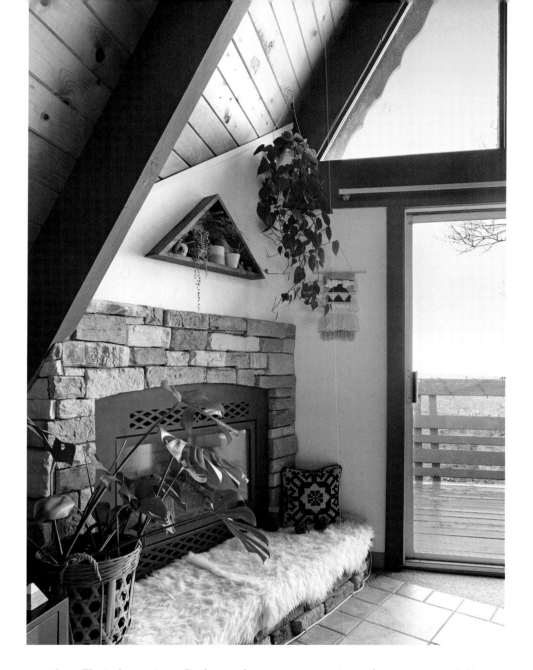

another. Their hope is to find one they can renovate and rent out to visitors—thereby sharing the beloved midcentury home design with others to discover and fall in love with. Consider it paying it forward, the A-frame way. ▲

OPPOSITE: Stairs lead to the master bedroom in the loft.

ABOVE: The fireside pillow was stitched by David's grandmother in the 1970s. Triangular shelf unit's shape is perfectly suited for the A-frame. Weaving to the right of the fireplace was made by designer Rachel Graves.

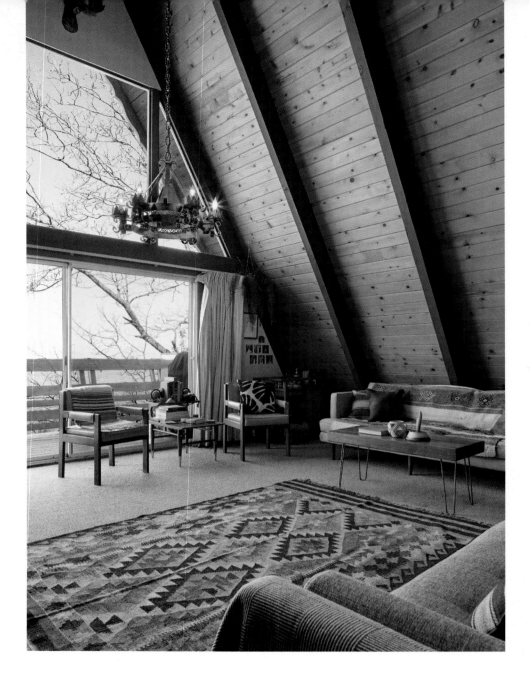

ABOVE: The rug is vintage kilim, found by Savannah at a flea market. The coffee table was made by David.

OPPOSITE: A window of plants blurs the line between outside and in.

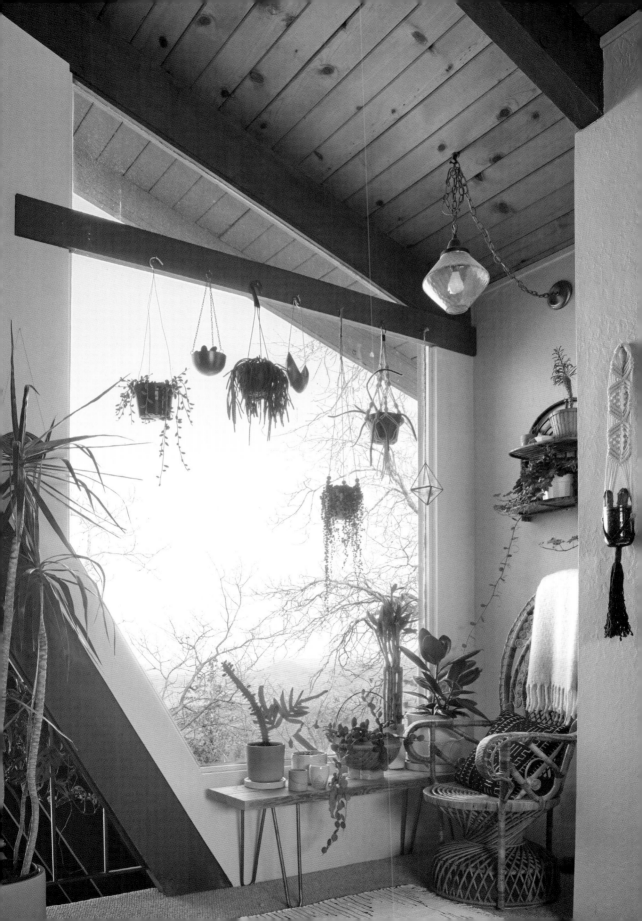

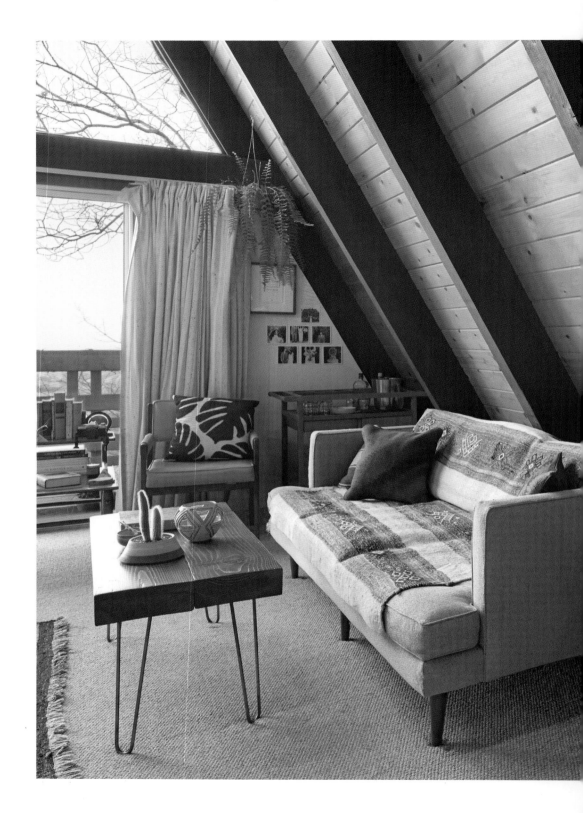

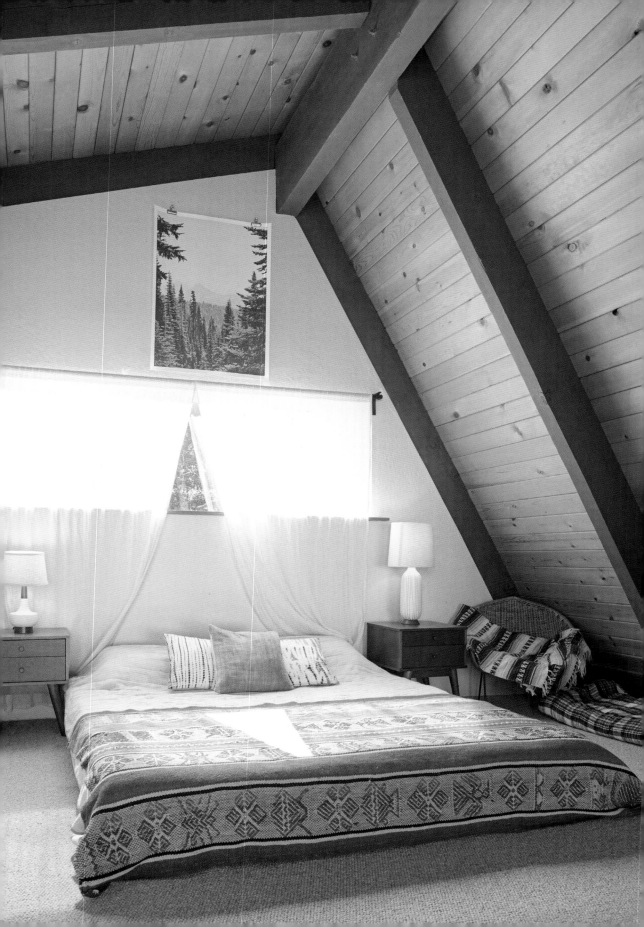

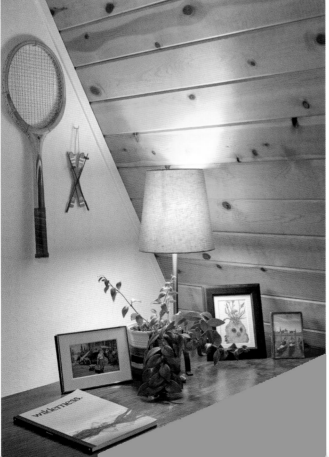

OPPOSITE: Print hanging over the bed, a nature scene reminiscent of the view out the A-frame's windows, was found at a thrift store.

ABOVE: In the guest room, a New Moon Tapestry hangs by the bed. Framed cabin drawing was sketched by an artist friend. Map is vintage. Woodpecker lamp was found at a thrift store.

BELOW: Vintage tennis racket was found at a flea market.

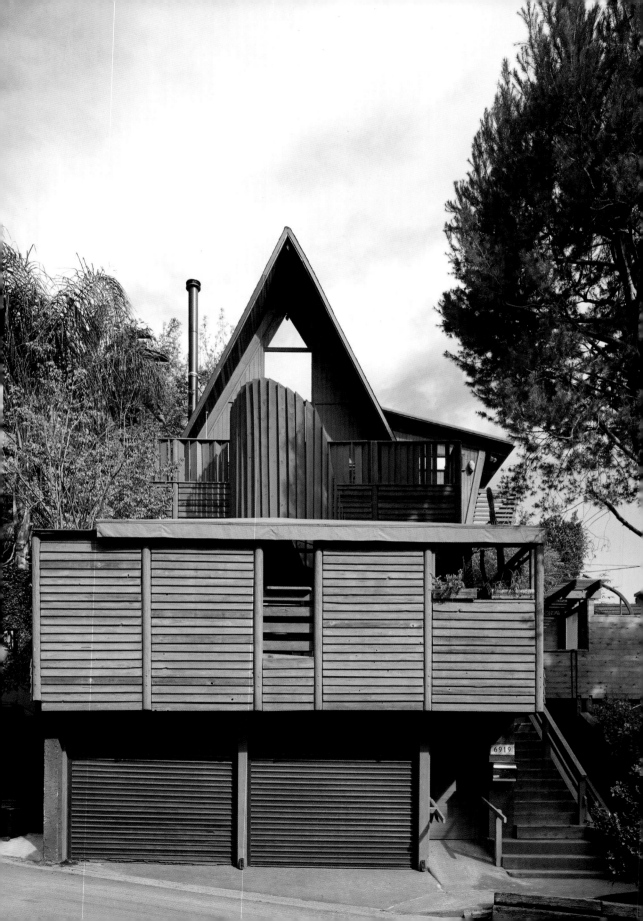

LUX LODGE

Hollywood Hills, California

Nestled in the Hollywood Hills, a modest two-bedroom A-frame reposes quietly among its more ostentatious neighbors. Lux Lodge is not to be dismissed, however. Just like the most interesting people in Los Angeles, the A-frame has a layered history.

The home was built from a Sears kit in 1963 but has been added to, altered, and refined by multiple homeowners over time. The property, which looks out onto the famous Hollywood sign, is now occupied by three: designer and ceramicist Desanka; her partner, Ryan (a photographer); and their infant son, Rocky.

After her purchase, Desanka discovered her A-frame had been previously owned by the uncle of a friend of hers who recalled playing with her cousins in its oversized backyard. A-frames certainly do have a lasting effect on the kids who grow up under the shadow of those iconic rooflines. Desanka herself grew up spending summers at her father's lake house, an A-frame cabin he built himself on Cheat Lake in West Virginia. He sold it when she was only eight, but not before Desanka had developed fond memories of the A-frame and its enchantment.

When Desanka found Lux Lodge (via an online listing) in 2012, it was in dire need of repairs, but it reminded her so distinctly of her dad and her childhood summers at the lake, she knew she had to make it her own. She undertook a full-scale remodel that retained the home's original woodburning fireplace and spiral staircase—a retro nod to its 1960s beginnings in an otherwise more contemporary and eclectic bohemian interior design. Citing Biba, Big Sur, and the Golden Girls as her decor influences, the home simply exudes California calm. Desanka openly gushes that she loves everything about her A-frame—it is her dream home. Except maybe it could do with more storage.

As an artist, Desanka has been able to hold workshops, events, and photo shoots here thanks to the space being perfectly suited to host a small crowd. A studio apartment in the bottom level is rented out to a musician, a longtime friend of Desanka's. Her art studio resides in the garage, which allows her to work from home, creating ceramics and other products she sells via her online shop. The home boasts many of her ceramics and artistic experiments as its decor as well as a handful of stunning pieces Desanka has collected over time.

Hyphy, one of Desanka's two dogs, lounges on a custom sofa purchased in Los Angeles; white chair is a reupholstered 1980s swivel chair.

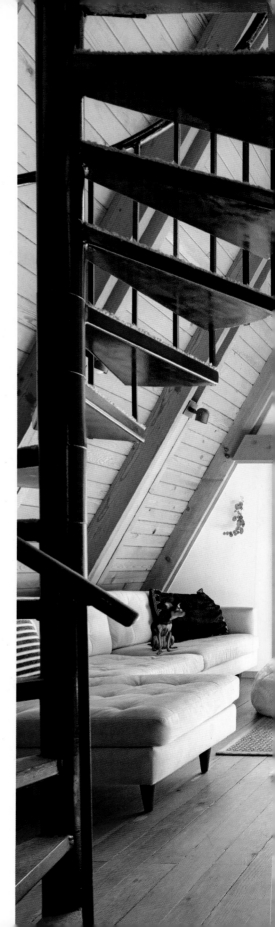

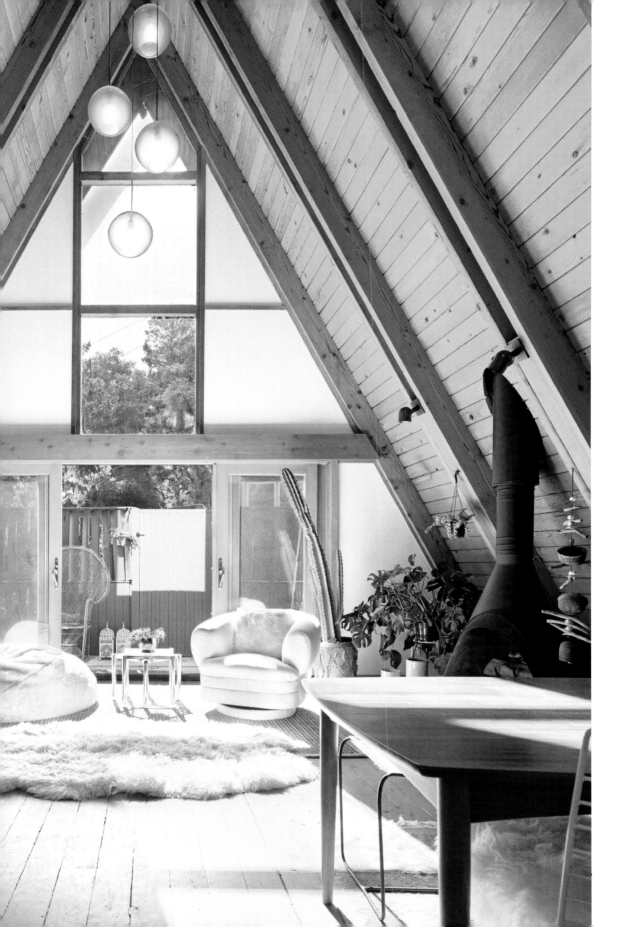

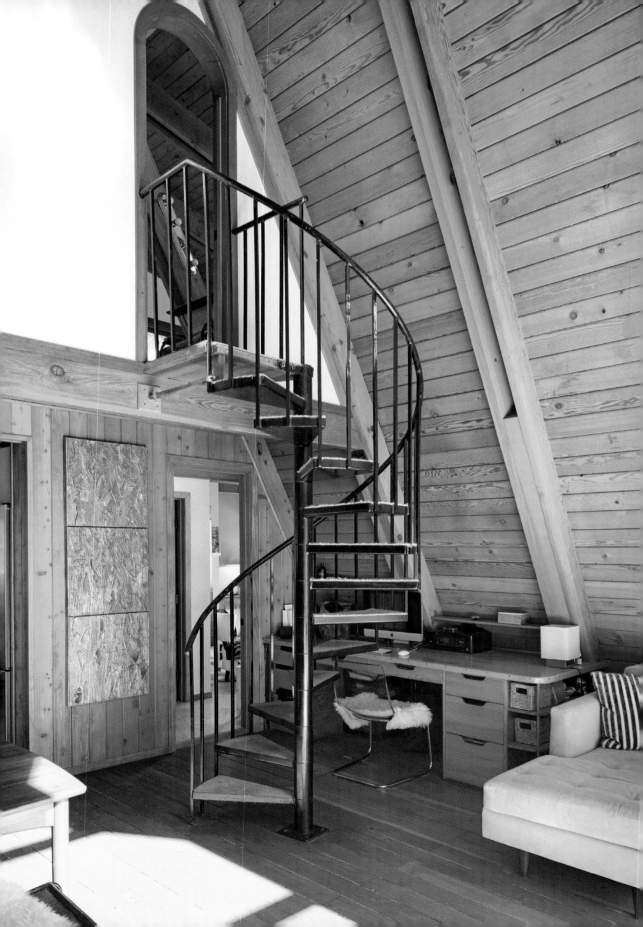

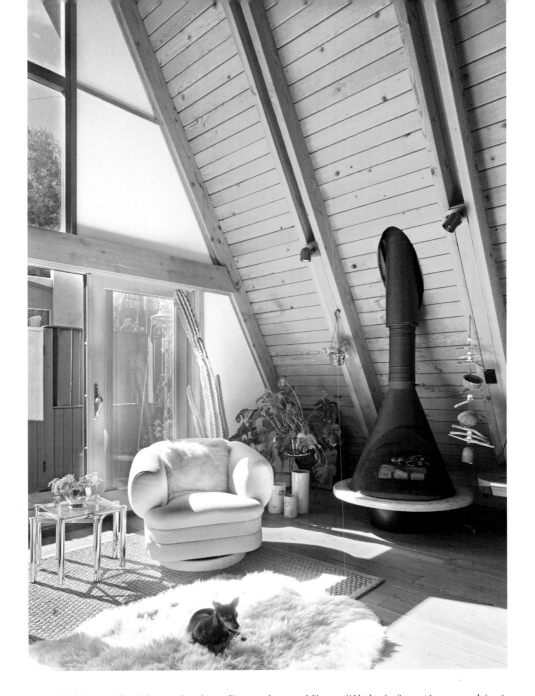

Self-described homebodies, Desanka and Ryan fill their free time cooking, watching movies, and entertaining friends. The pair looks forward to watching their son grow up in this cozy A-frame with its spectacular backyard, learning to swim and climb trees as he creates lasting A-frame memories all his own. ▲

OPPOSITE: Original spiral stairs lead to the master bedroom and nursery.

ABOVE: Original fireplace heats the A-frame in cooler months.

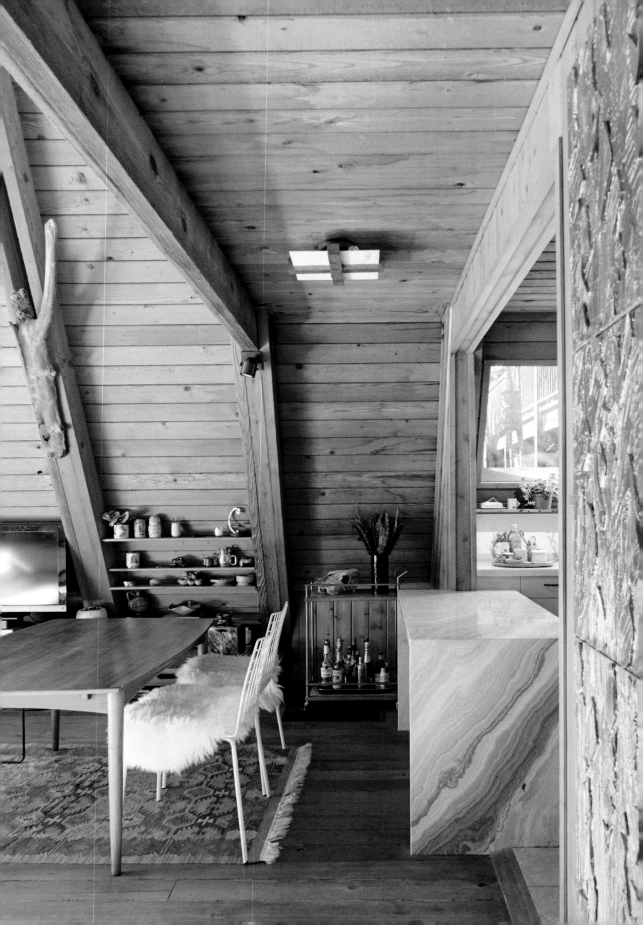

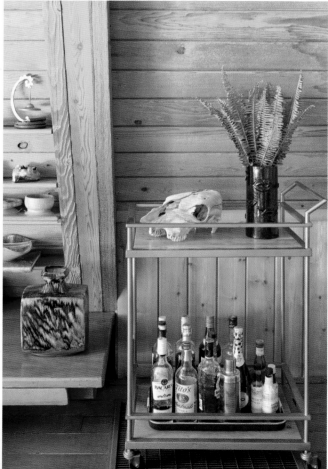

OPPOSITE: Midcentury dining table was found at the Rose Bowl Flea Market. Rug beneath belonged to Desanka's mother who purchased it in New Mexico.

ABOVE: Blush-colored backsplash tiles above the stove were made by Desanka. She enjoys spending time in the kitchen, which she remodeled from a galley into a large, full-size kitchen.

BELOW: Many of the ceramics found throughout the home are Desanka's own creations.

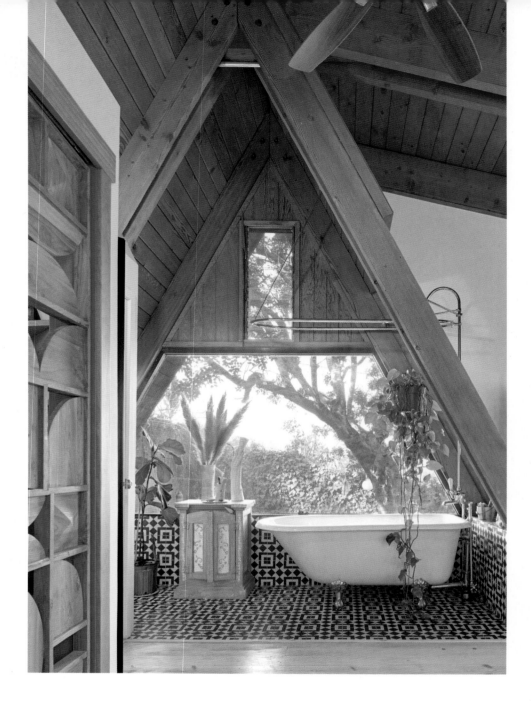

ABOVE: A dormer was added to the side of the bedroom during the remodel to add a water closet and a walk-in closet with custom wood doors. A claw-foot tub sits inside the A-frame's dormer bay window.

OPPOSITE: Sliding doors off the main room open up to a patio closure, which provides privacy from the street below. The macramé plant holder is vintage.

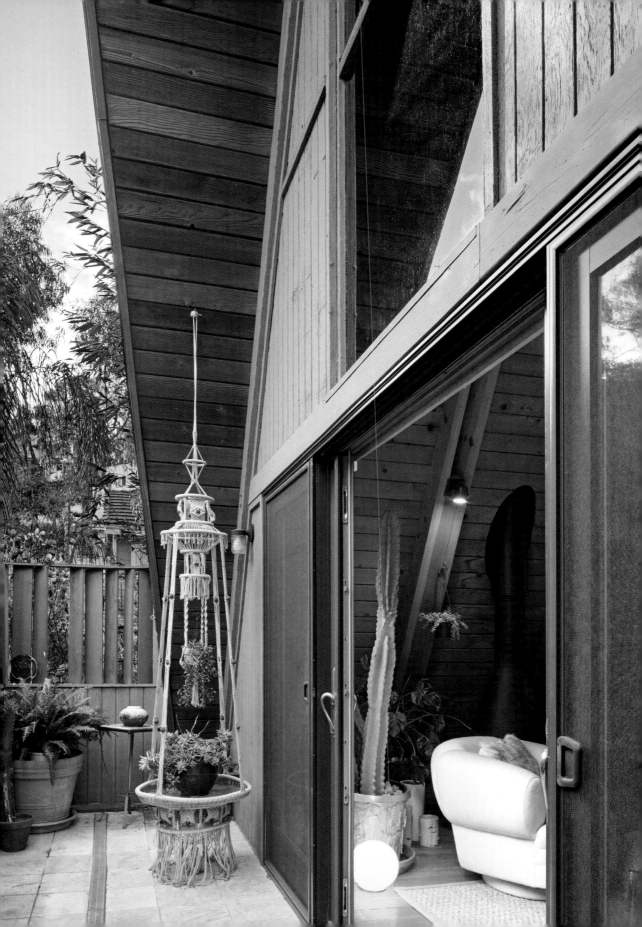

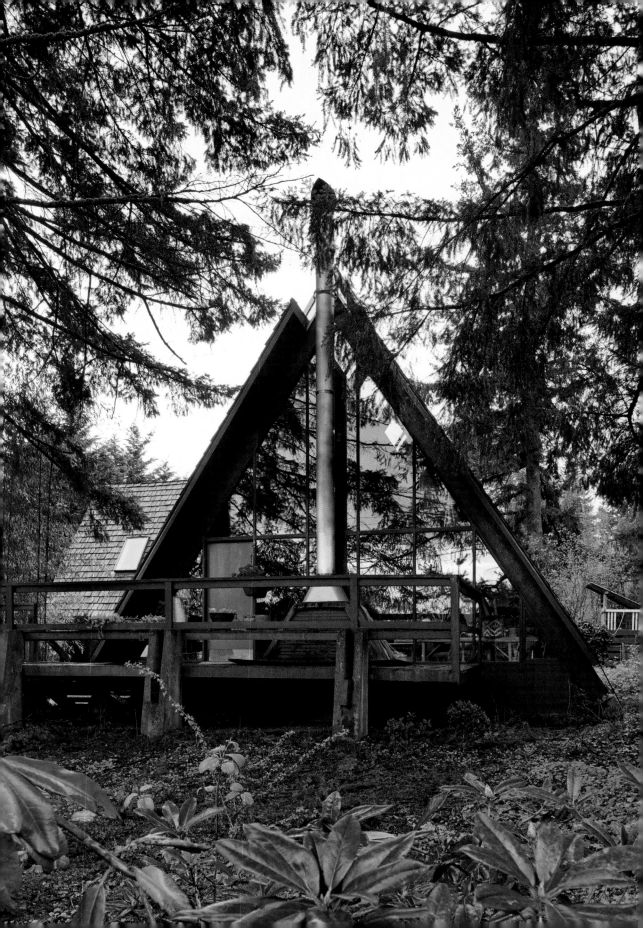

OUR MAGIC A-FRAME

Portland, Oregon

The A-frame structure, with its steeply angled walls and limited floor space, is anything but ordinary—it takes a creative soul to embrace the eccentricities of these midcentury modern homes. Homeowners Anna and Srijon of Portland, Oregon, have taken the idea of eccentric and run with it in the best of ways.

To start, the two refer to their home as "Our Magic A-Frame" and speak of her more as a trusted friend than simply a place to put one's things. When they originally found her, she was in poor condition, but Anna and Srijon saw so much potential; it was love at first sight. "I knew she was my spirit home!" exclaimed Anna.

Both Anna and Srijon love to travel and have amassed a large collection of colorful rugs and textiles along their journeys. Srijon, a painter, fills the (non-slanted) walls with art created by both himself and his friends. Anna finds herself inspired by artisan weaving techniques and natural dyes; she mixes her thrifting and antique finds in the home with globally sourced items and plenty of houseplants.

The couple has been able to nurture a space that fits their needs (they both

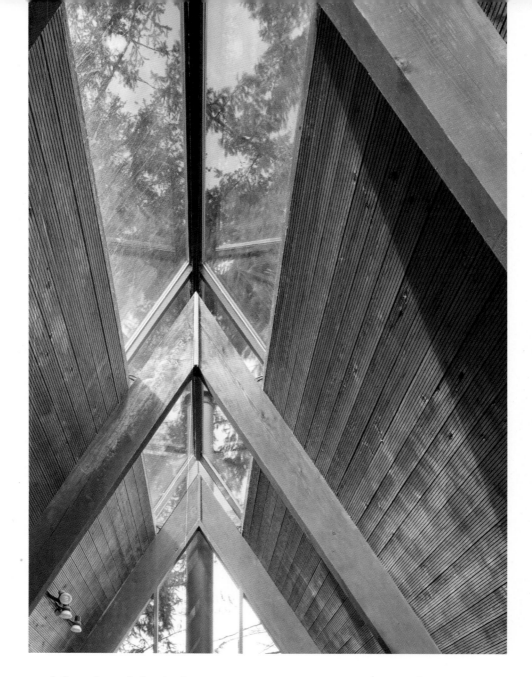

work from home), feeds their creativity, and is still comfortable for the entire family. Anna owns and manages an online boutique called Le Souk Le Souk, and Srijon works as an artist. Together they share the 3,600-square-foot home with Anna's daughters Ava, age fourteen, and Lilith, age ten.

ABOVE: The A-frame's skylight offers a heavenly view.

OPPOSITE: An abundance of natural light in the living room keeps the family's many house-plants thriving year-round.

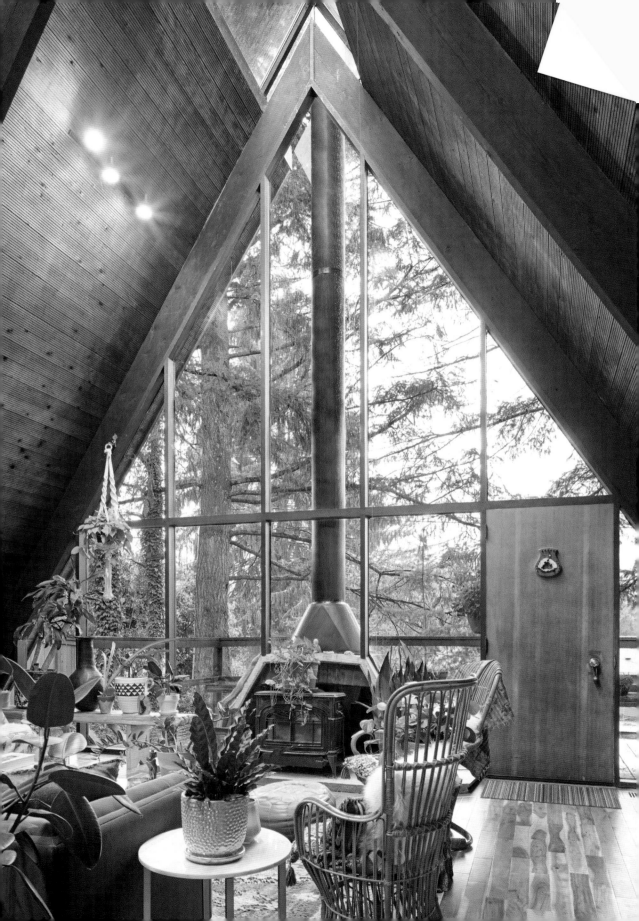

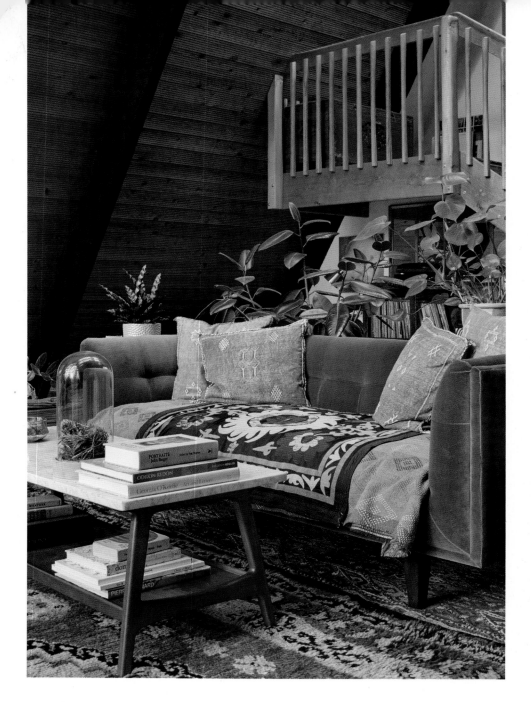

ABOVE: The Moroccan cactus silk pillows are from Anna's shop; textiles are Suzani and Afghan; the glass dome houses a bird's nest and wasp's nest from the yard.

OPPOSITE: Cherry blossoms from the backyard are illuminated with a modern light fixture, and accented with a vintage Suzani table runner.

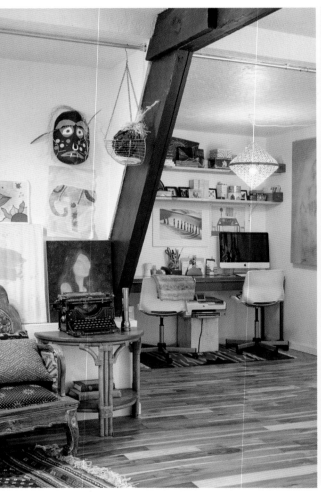

Anna, Srijon, and the girls have filled their A-frame with artwork—much of their own, a few store-bought items, and many antique finds. Rug and cushions (middle) were brought back from a trip to Morocco.

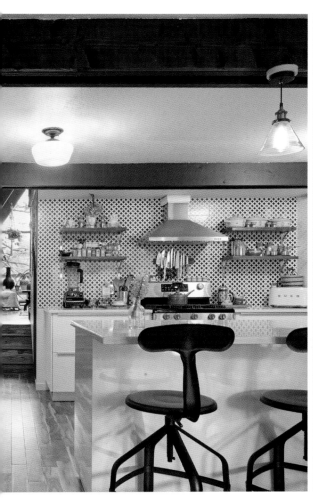

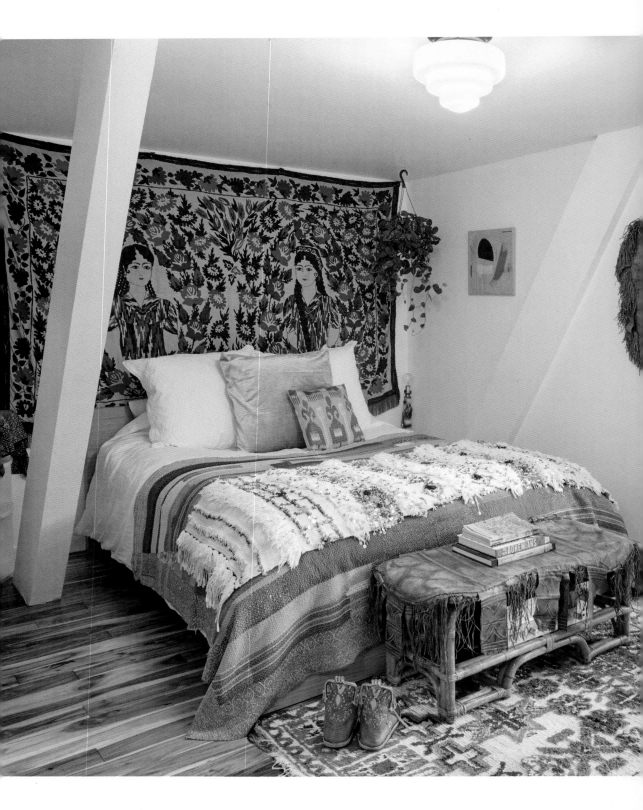

This home was built as a traditional A-frame in 1961; the bedroom wing and the garage were added on in the early 1970s. Anna, Srijon, and the girls have called Our Magic A-Frame home for three years and counting. Cooking together, entertaining guests in the backyard, and listening to their record collection are some of the things the family most enjoys together. During the summer months they spend most of their time in the backyard gardening, grilling, and sunbathing.

With views of the abundant greenery that Oregon is known for, the unique charm of the home, and the opportunity to pursue their art and interests together in comfort, Our Magic A-Frame truly does work a kind of magic on this family that is lucky enough to call her home. ▲

Large wall hanging in the master bedroom is an antique silk hand embroidery from Uzbekistan that Anna found online. Kantha quilt on bed was brought back from Bangladesh; handira (Moroccan wedding blanket) was purchased in Morocco. Leather piece on bench (and smaller leather piece on the wall) is a nomad's pillow cover. Rug was found in Chefchaouen, Morocco.

THIS PAGE: The creative couple opened an art gallery in their chicken coop called Chicken Coop Contemporary, where they hold public exhibitions once a month.

OPPOSITE: The master bedroom overlooks the backyard via French doors leading to a balcony. The dining room offers direct access to the yard.

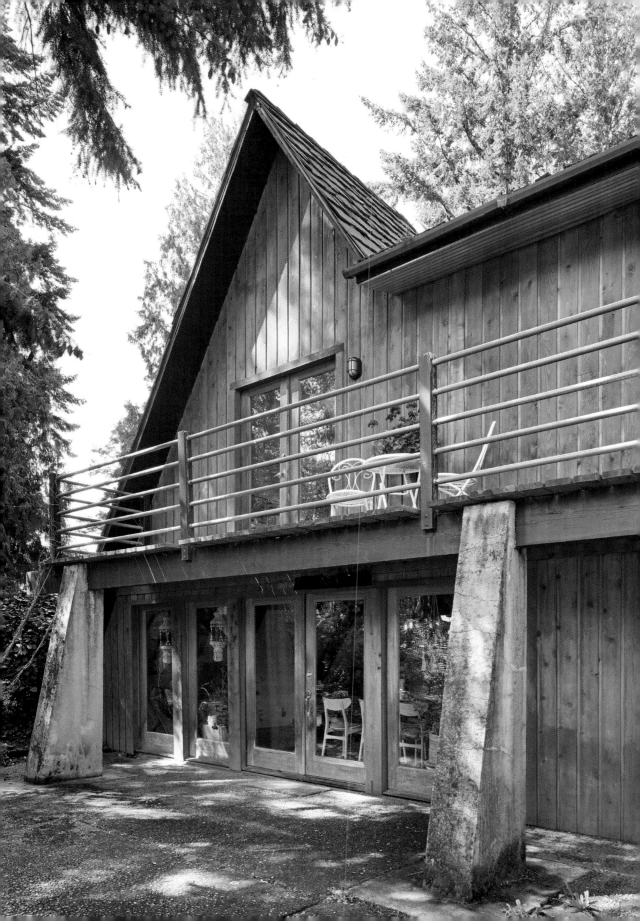

NOSTALGIC
ESCAPES

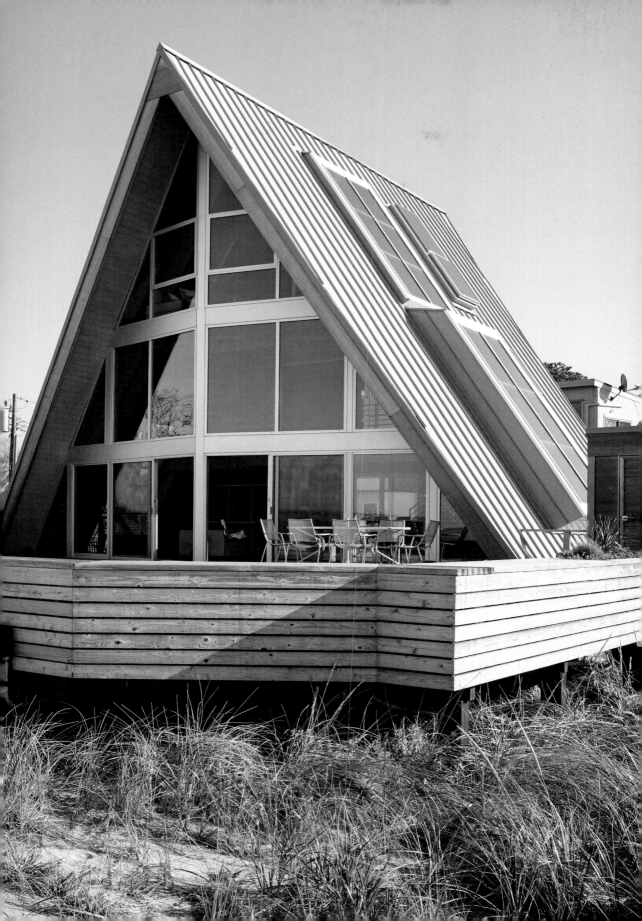

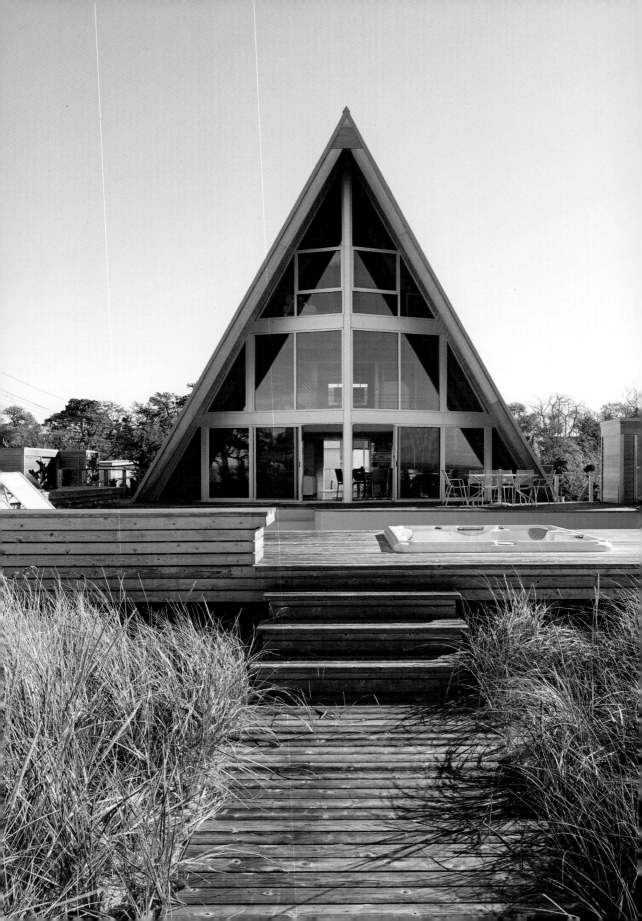

STREAMLINED SERENITY

Fire Island Pines, New York

Homeowners Doug and Bill are no strangers to the busyness of New York City and the demands of corporate life, so when it came to purchasing a seasonal home where they could get away from it all, two things immediately came to mind: a serene location and a midcentury modern aesthetic.

When they stepped onto the A-frame's island property, they felt an instant connection. The house sits on a bay-front lot at the end of a secluded walkway. The location affords direct kayak access to Great South Bay and—being at the very crest of the island—sweeping views down the shore. It was everything they wanted in a locale, with the added bonus of a fair amount of privacy.

As for the house itself, Doug and Bill have never lived in anything so streamlined before. But since they share a proclivity for midcentury modern design, influenced partly by an emotional attachment to the iconic A-frame architecture (they are, after all, children of the Space Age), the mid-mod aesthetic of the Fire Island A-frame was precisely what they were looking for.

While it was this decades-old charm that drew them in, the age of the home was not without its costs: the couple had to replace nearly everything

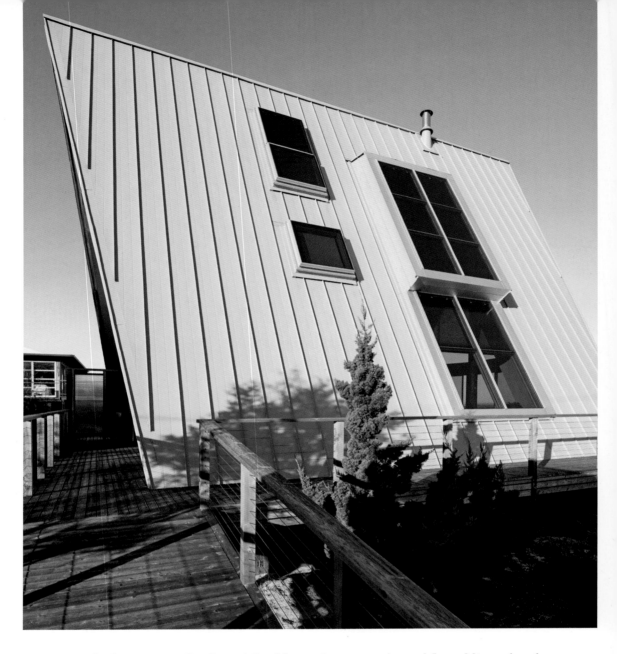

on the house, save for the original frame beams and wood floor. Miraculously, the heart pine floors sanded down beautifully once liberated from fifty years of polyurethane—hands down the most pleasant surprise during the renovation. Not so pleasant was the discovery of several rotten pilings that extended only two feet below sea level (as opposed to the ten feet that building code requires of them), which necessitated strategic replacement.

ABOVE/OPPOSITE: Elegant in its simplicity, this newly renovated Fire Island Pines A-frame is a streamlined modern beach house.

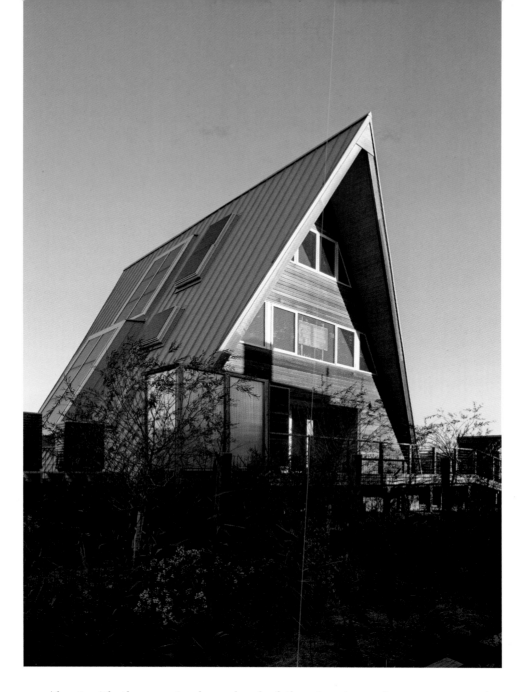

Along with the required overhaul of the structure also came opportu-
nities. Working with architectural firm Bromley Caldari, Doug and Bill were
able to combine their nostalgia for the midcentury with the efficiency of the
twenty-first century: an emissive metal roof made from recycled materials is
visually striking while reducing energy costs and the home's carbon footprint;
smart glass in the master suite allows for privacy without compromising the

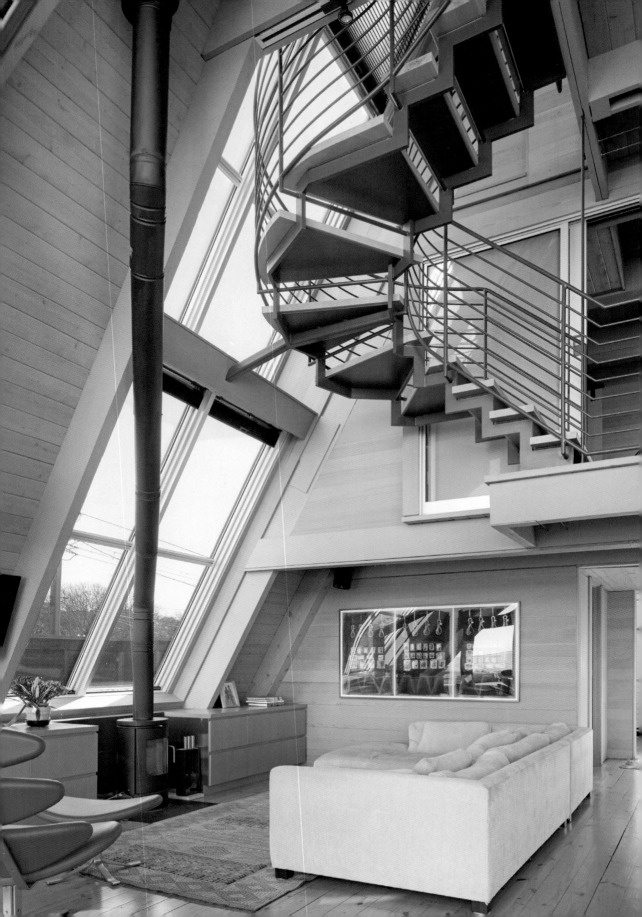

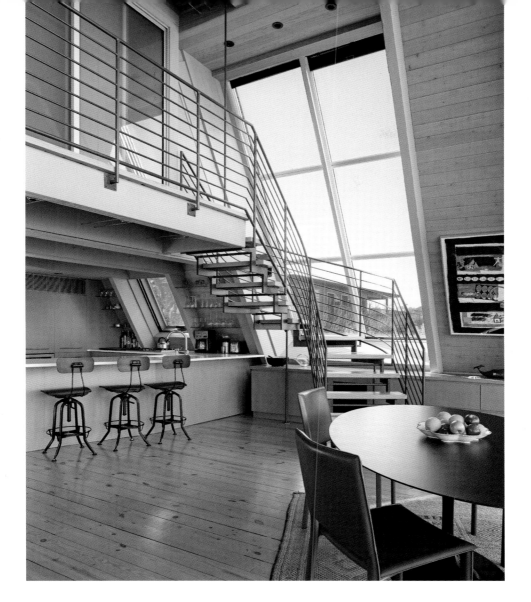

stunning views; and the split suspended staircase is a jaw-dropping feature that serves the beauty of the home not just functionally but sculpturally.

Tranquil and exhilarating at the same time, the house respects its siting while maximizing its location; skylights on both sides of the house extend along the three stories of the home. The rough and smooth cedar combination both indoors and out is organic magic. The simplicity of the interior design allows the functional beauty and ingenuity of the architecture to really shine.

OPPOSITE: Corona Chair, 1961, by Danish designer Poul M. Volther based on time lapse photos of solar eclipses. Antique kilim rug purchased by Doug in Marrakech.

ABOVE: Split stairs from the ground level lead upward to a catwalk accessing the second floor.

Less is more here. The textures of the cedar interior and maple cabinetry are harmonized by precision millwork and a light wash. Nothing is fussy; it's a beach house, dammit.

Now Doug and Bill describe their home experience as nothing short of inspired. The house flows effortlessly from inside to out, worshipping nature every step of the way. With sweeping windows framing the bay at every elevation, and the forest and roar of the ocean at the back of the house, a person feels wholly connected to the outdoors no matter where they are in the home.

Its striking design is rivaled only by the role the house has played in the Fire Island Pines community through the decades. Doug and Bill had lived down the shore within sight of the A-frame for years and knew it as quite the notorious party house. "Sooner or later," Bill divulged, "everyone in the Pines seemed to have some sort of, um, *experience* at that house." The previous homeowners were legendary; there's an anecdote shared among the locals about Judy Garland allegedly spending time there, arriving at the A-frame by seaplane; and another recollected incident of Colleen Dewhurst popping over to visit from next door. The feeling of camaraderie continues to be tangible in this place: Doug and Bill have become friends with the former tenants, who still check in on the A-frame, and they've made a point to

Elliptical Saarinen table in marble accented with Madrid chairs.

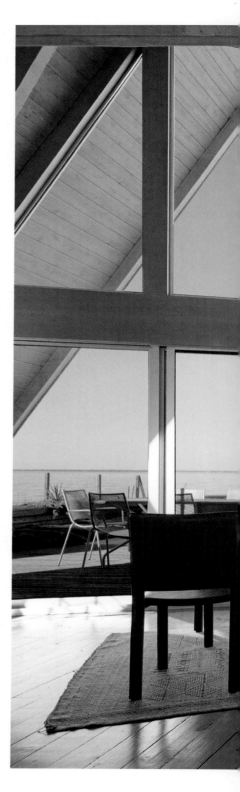

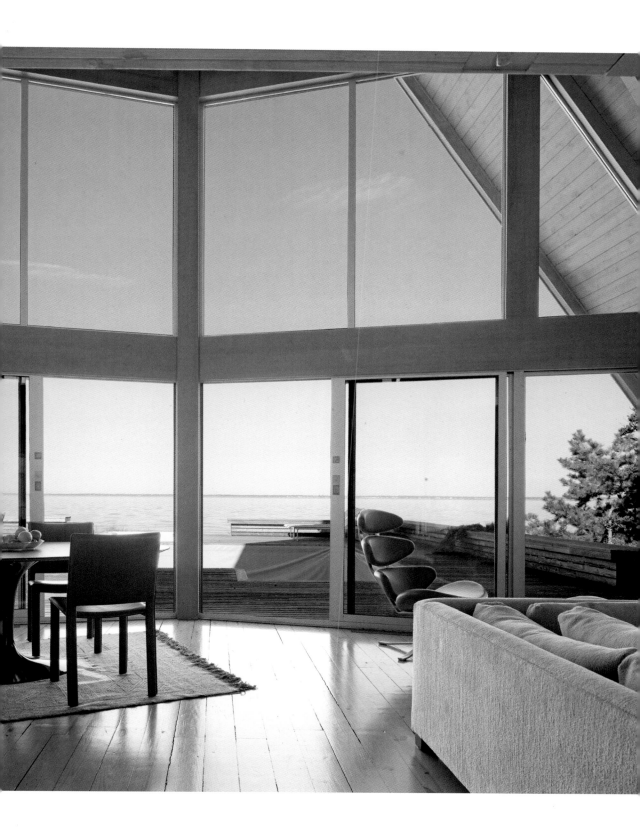

decorate their home with artwork done strictly by local Fire Island Pines artists.

Their A-frame has become a place that encapsulates their love for the Fire Island community, nature, and their time together. Whether sitting on the deck with friends or getting cozy in front of the woodburning stove with the sound of waves lapping in the sea breeze, they share a warm and loving bond

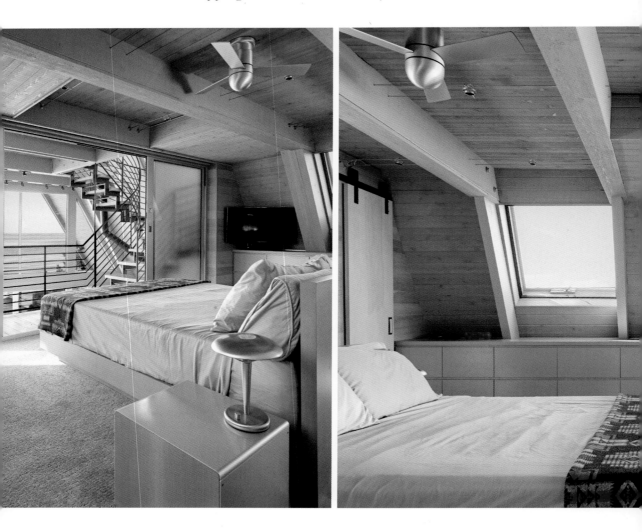

The master bedroom directly faces the ocean. To further enhance the unique space, smart glass windows that transition from clear to opaque and custom cabinetry were installed. A painting by Kate Rudin entitled *Houses* hangs outside the second bedroom.

with this magical place's past, present, and certainly future. Doug and Bill plan to enjoy their A-frame every minute they can, they explain, only willing to leave it for good feet first. ▲

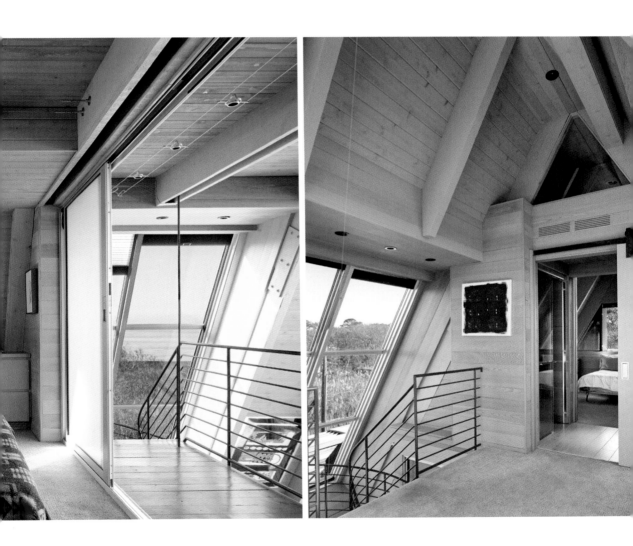

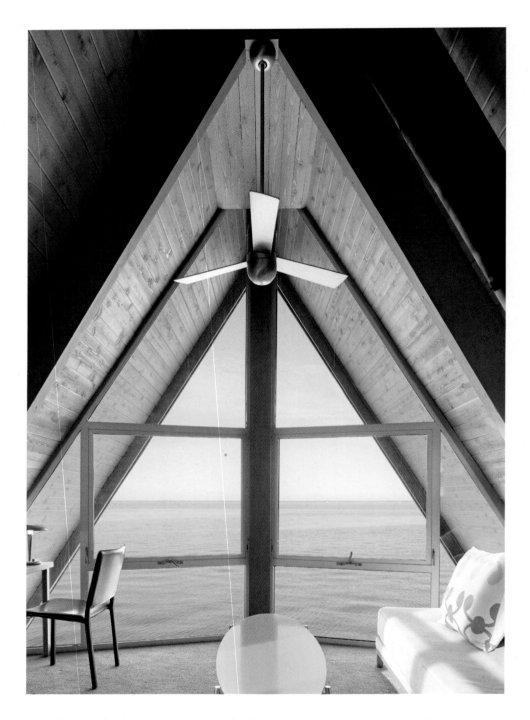

ABOVE: Den on the third level, known as The Crow's Nest, provides panorama views.

OPPOSITE: Chaise in front of the skylight is considered the captain's chair.

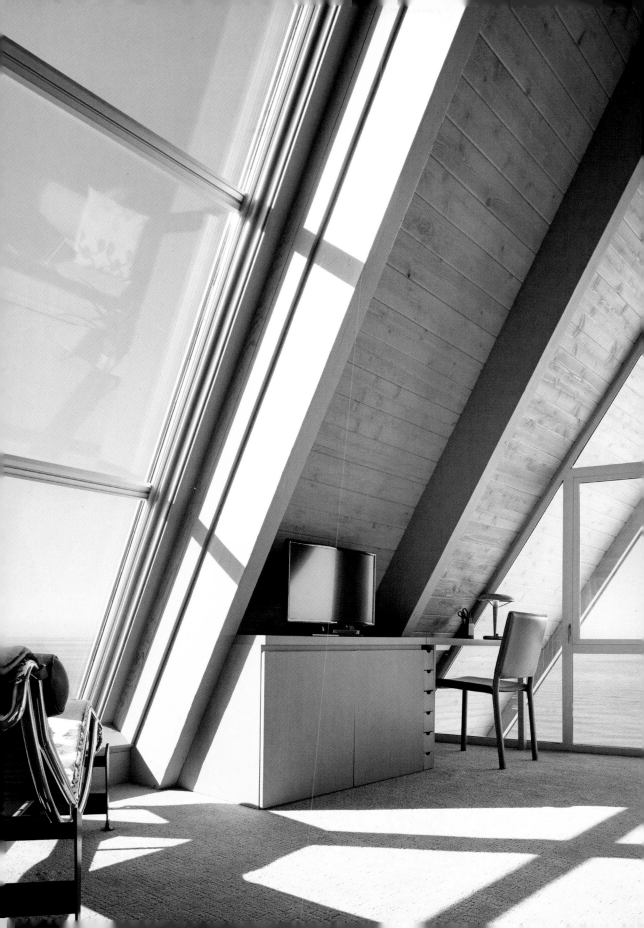

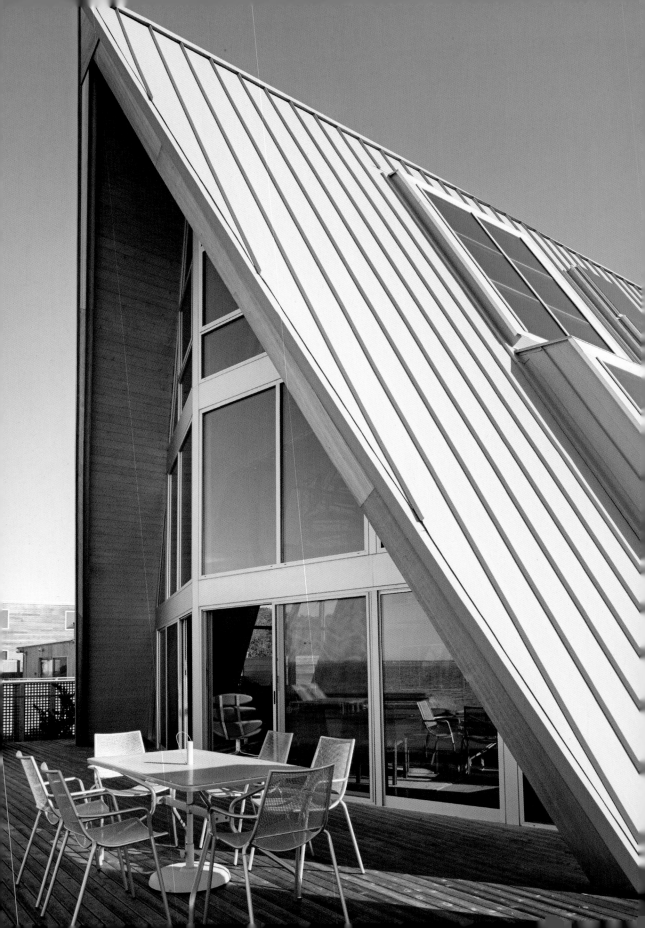

OPPOSITE: Doug, Bill, and friends practically live at their outdoor table May through September. Long, lazy prosecco-soaked lunches, sunset viewings fueled by Doug's signature frozen watermelon margaritas (with jalapeño), and lantern-lit breezy dinners al fresco are the norm.

ABOVE: Vintage oxidized "Dan Lurie" weights, a surprise gift from the architect.

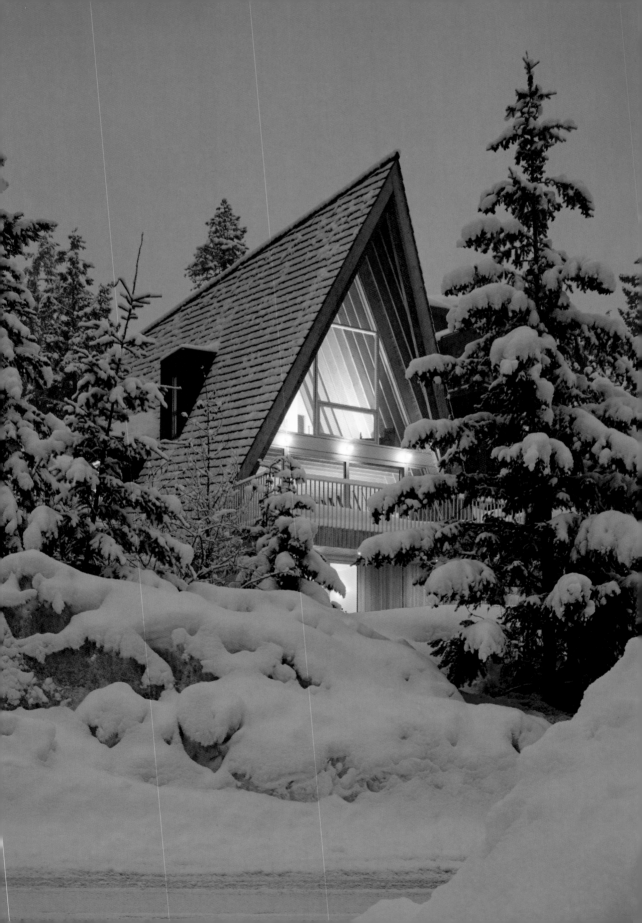

WHISTLER CABIN

Whistler, British Columbia

In want of a modern spin on the classic cabin, Brenton and Melanie built the perfect retreat for themselves and their family in Whistler, British Columbia.

It was after a decade of ski weekends spent at the A-frame home of some friends in the same area that Brenton and Melanie decided it was high time to find a retreat of their own. While keeping an eye out for a home to purchase, the family just couldn't find anything they absolutely loved. When the lot that Whistler Cabin is now built on became available, it was the final push for Brenton and Melanie to take on a new build and tailor their new weekend getaway to their wants and needs.

The home blends in seamlessly with its surroundings. Scott & Scott Architects, based in Vancouver, built the classic A-frame structure out of locally sourced Douglas fir, cedar shakes, and stone quarried on Vancouver Island. The 2,000-square-foot cabin stands three stories tall and was intentionally positioned to maximize panoramic views through its floor-to-ceiling windows: as a result, there are majestic 180-degree views of the Wedge and Weart mountains and Whistler Blackcomb resort views from the side.

Despite being close to the coast, Whistler winters are long, often seeing

snowfall as late as May. But the weather patterns suit this family of four just fine, as they love nothing better than spending long days on the ski slopes. In fact, Brenton grew up snowboarding on Mt. Baker in the early 1980s—a hobby he has enjoyed passing on to his children. Warmer months allow the family to go on hikes to nearby lakes, and any time of year they can be found sitting by the woodburning stove to comfortably while away the evenings.

Melanie, an interior designer by trade, loves the retro feel of the A-frame which they were able to accomplish in spite of the home being a new build. And because the pitch of the roof means there are limited sidewalls, the home naturally encourages a simple, minimalistic interior. The perfect place of respite, Whistler Cabin is this family's break from the city. Having lived abroad for a time in both London and Paris, they're now settled full time in bustling Vancouver in a 1910 Craftsman. The Whistler Cabin is their second home, the place they spend every weekend and extended holidays—a completely original cabin with everything they love: clean lines, a minimal design, and easy access to the outdoors. ▲

The steeply angled roofline helps prevent snow-pack during the long Vancouver winters.

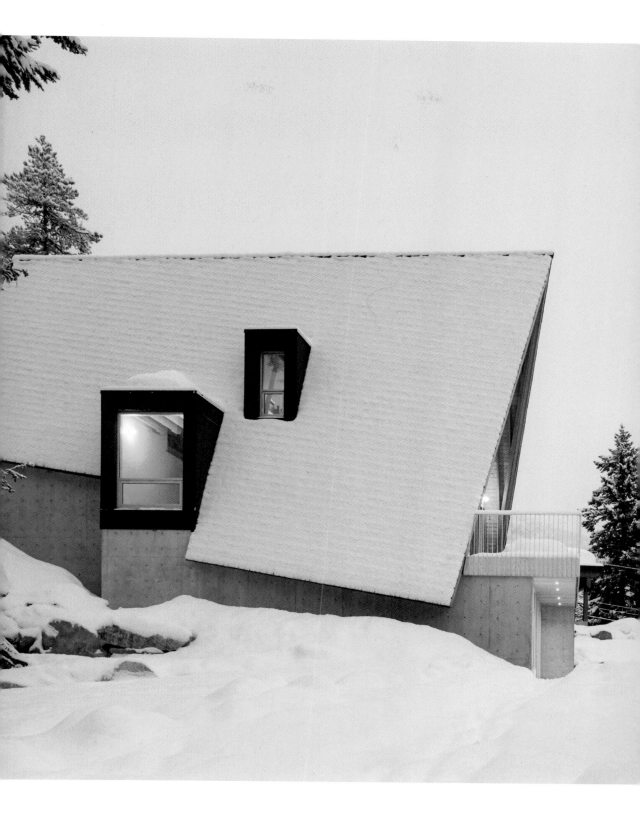

ABOVE: Flora collected during family hikes are put on display to bring the outside in.

OPPOSITE: Coffee table is an off-cut from the home's stonework; its legs are leftover cores from the home's foundation. Brenton and Melanie foraged them from the debris of the building site.

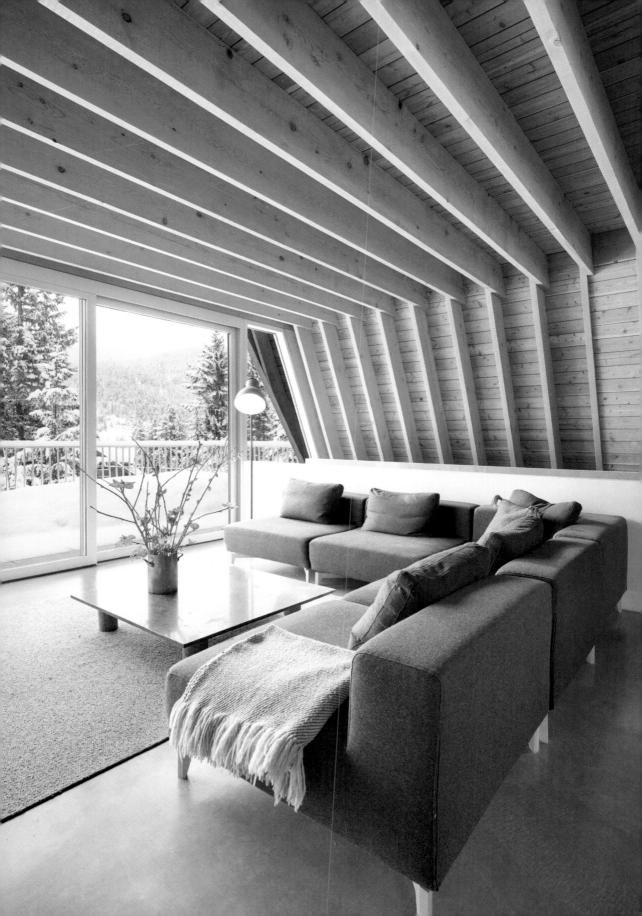

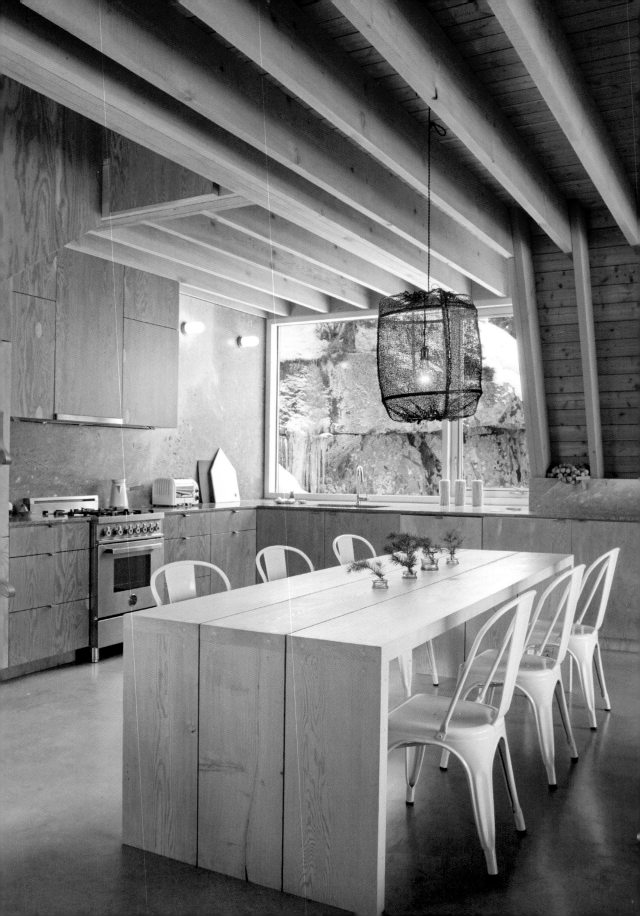

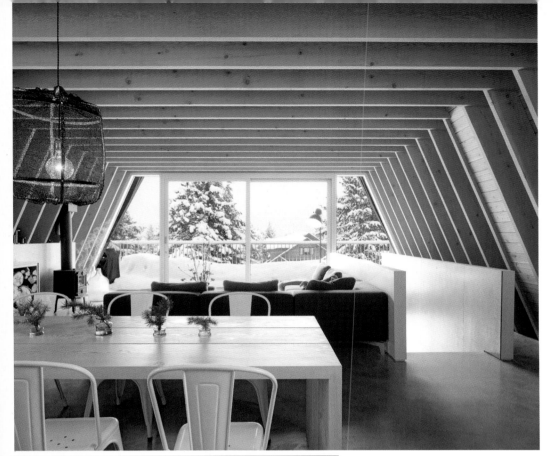

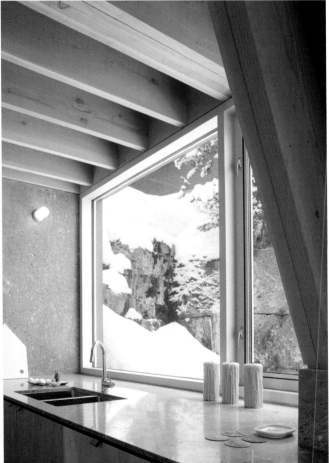

OPPOSITE/ABOVE: Kitchen table was built from reclaimed timber sourced from old Vancouver warehouses.

BELOW: Stone countertop was quarried from Vancouver Island. Cupboards are treated marine plywood.

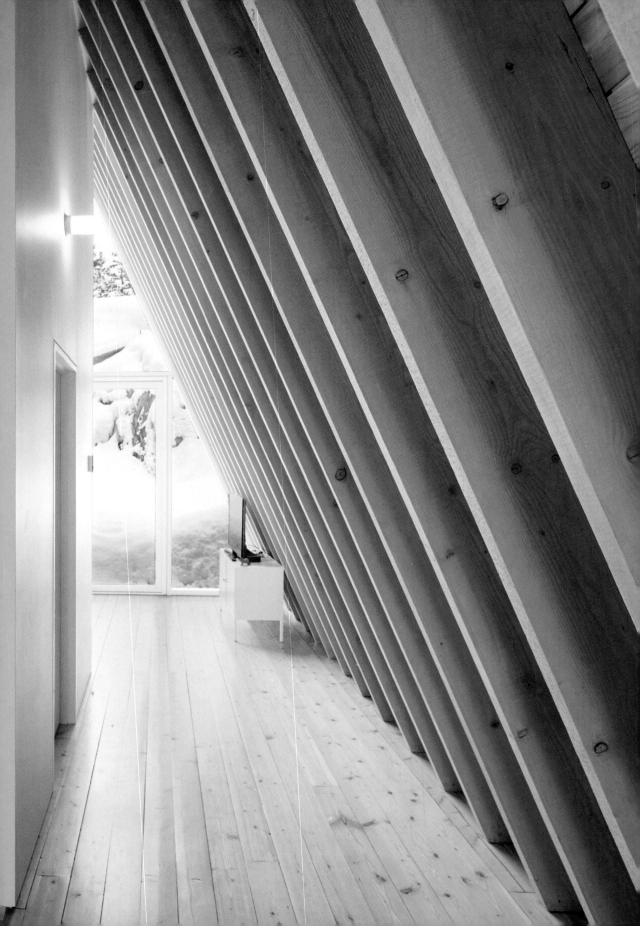

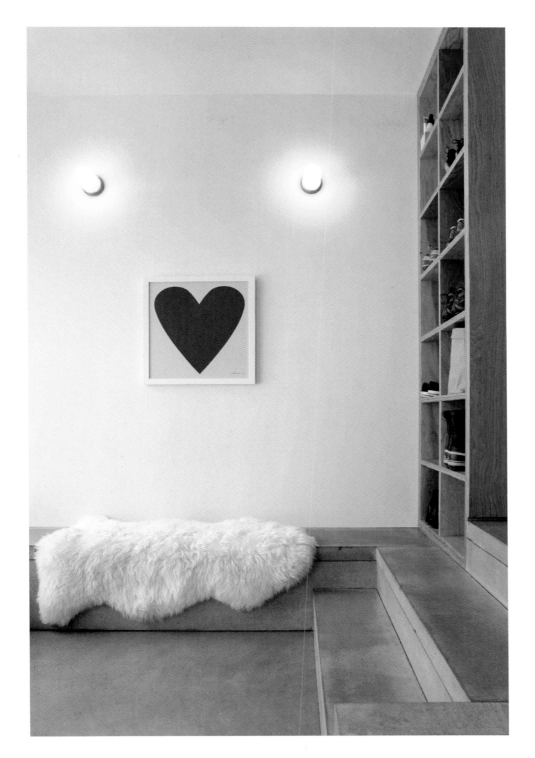

OPPOSITE: A hallway of exposed beams entices guests toward the back den/guest room.

ABOVE: The A-frame's entryway was completed with a concrete bench and cubbies to streamline coming and going, particularly when removing ski and snowboard boots.

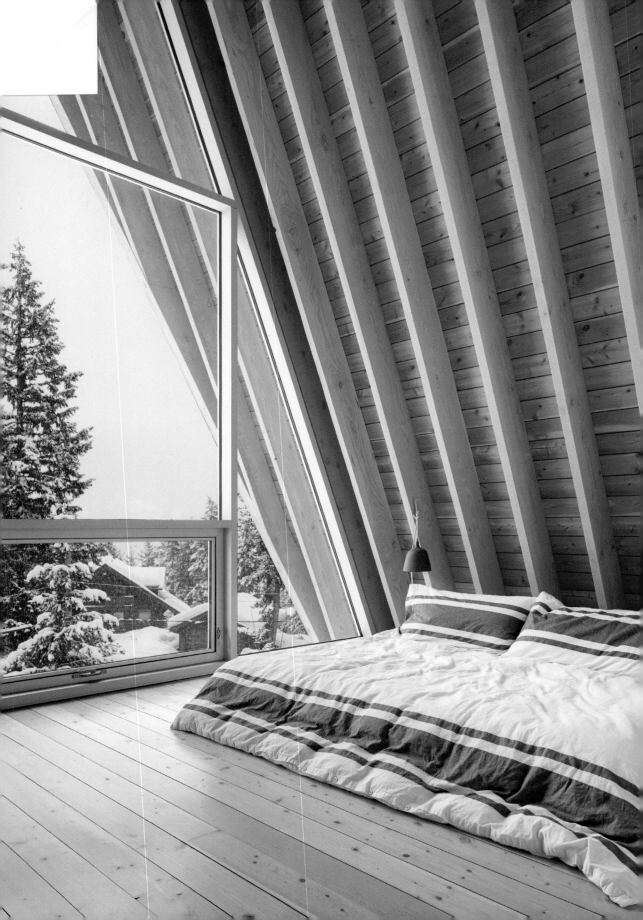

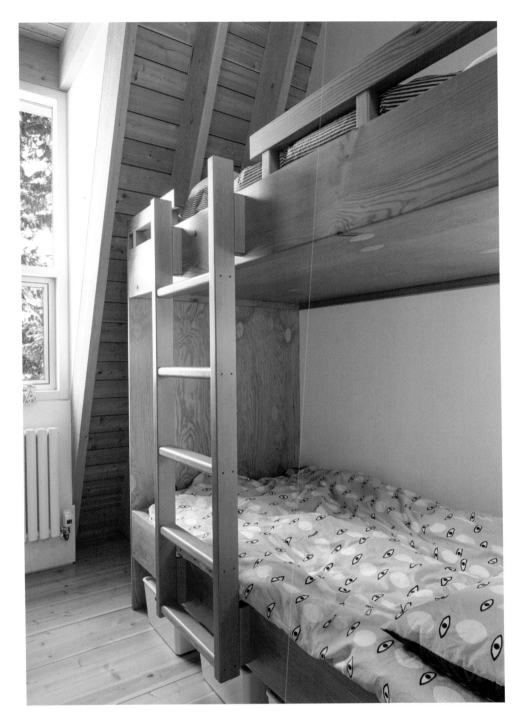

OPPOSITE: Soaring ceilings in the master bedroom reach a height of 22 feet.

ABOVE: Bunk beds in the kids' room are handcrafted.

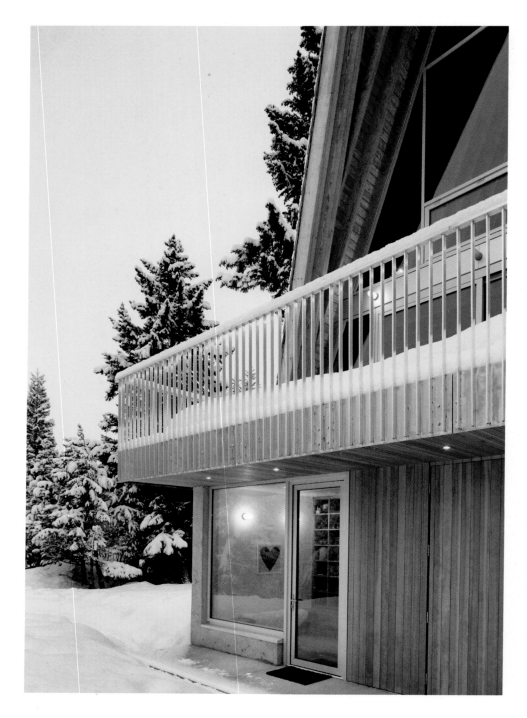

ABOVE: Plenty of storage built into various rooms on the bottom floor solves where to put recreational gear and utilitarian items.

OPPOSITE: The new construction blends in effortlessly with the neighborhood.

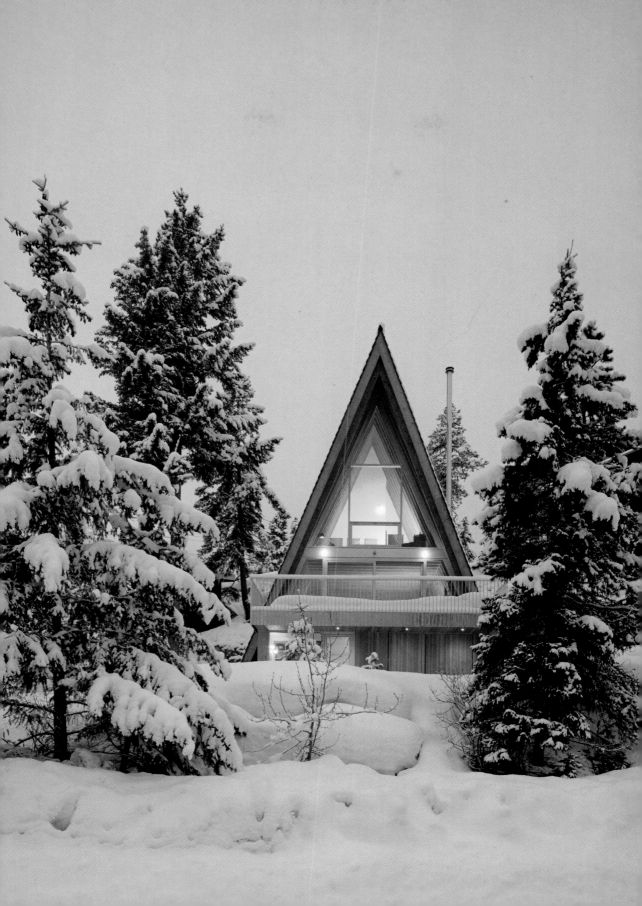

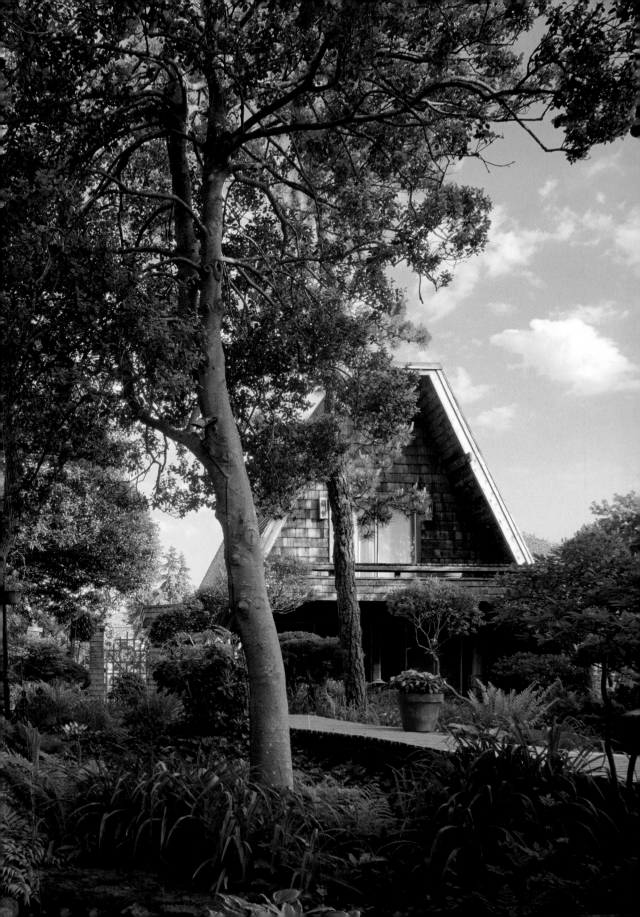

A-FRAME IN BLOOM

Fire Island Pines, New York

Lush gardens surround the A-frame summer home of Sumner and Roy on the Fire Island National Seashore, in Fire Island Pines, New York. A veritable paradise, just a two-minute walk from the beach, its location on a barrier island means the homes here are only accessible by boat. This pristine A-frame has become an ideal warm-weather escape for the couple and a perfect gathering place for their extended family.

The home and surrounding grounds haven't always been so exemplary, however: Sumner and Roy have cultivated their A-frame, inside and out, over the span of nearly forty years. The house, believed to have been built in 1965, was purchased by the couple in 1980. Its affordable price and distinctive architectural design were the two main components in their decision to take the plunge—and so the hard work on their summer retreat began.

The previous owners had chosen a fairly hackneyed approach to interior design, so it was a pleasure for Sumner to redesign the previously unimaginative space to the couple's liking. They chose to go with Bauhaus-influenced modern furnishings, perfectly suitable to the A-frame's midcentury origins. They accent the interiors with an ongoing rotation of flower arrangements

from their own gardens. A feeling of wide-open space has been achieved inside the A-frame with the floor-to-ceiling windows that bring the outside gardens in.

At the time of purchase, the garden area was covered in scrub growth and poison ivy so high you couldn't see the house. The whole property had to be cleared and topsoil hauled in, as well as rocks from the north shore of Long Island. Pines, sassafras, and pepperidge trees, which are indigenous to the area, were planted. Japanese maples, blue spruce, and evergreens, while not indigenous, were added and have thrived. The property is built on a sand dune, and Sumner puts it simply, "Whatever will grow, we're happy to have." One stroll through the verdant gardens proves they've been gracious hosts to the many varieties of plants, flowers, and small animals that have called this place home over the years: rabbits, turtles, muskrats, foxes, moles, and a multitude of songbirds are commonplace in this garden, which covers about a fifth of an acre. Sumner has devised most of the outdoor designs and works closely with landscaper Kenneth Ruzika to complete each vision. "Kenneth is very artistic," Sumner shared. "He improves upon every idea we come up with."

Handsome lounge chairs line the cedar deck. The chairs, with complex engineering, were designed by Richard Schultz.

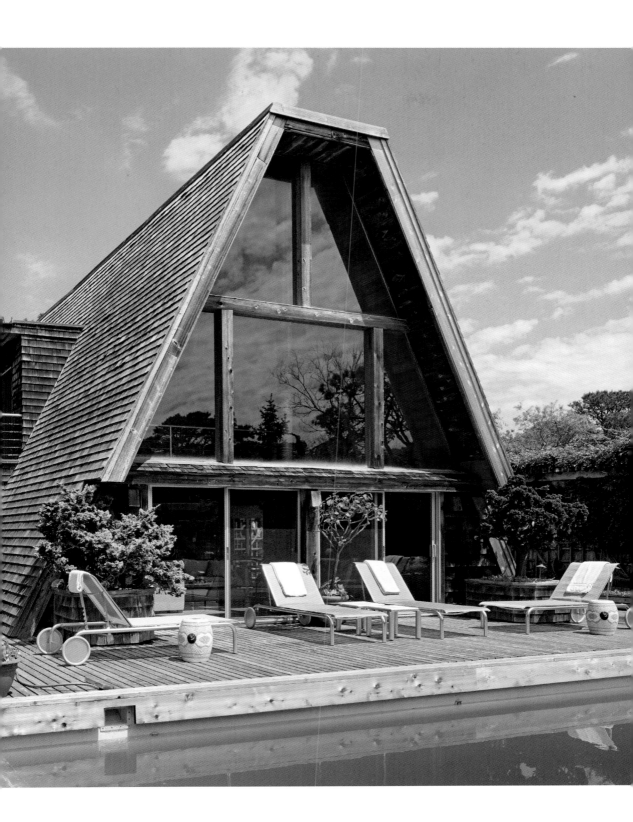

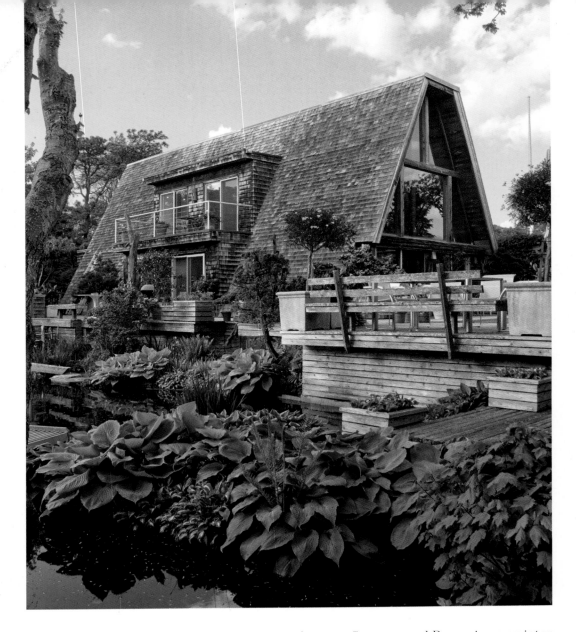

Now both retired from their careers as doctors, Sumner and Roy enjoy a quieter pace. The gardens require a fair amount of maintenance, accomplished by Sumner and Roy themselves with some additional help with the weeding, watering, and fertilizing. Simplicity remains key in this summer residence; the A-frame is a place for Sumner and Roy to relax and enjoy time with their family. ▲

ABOVE: Rather than reach a traditional peak, this A-frame cuts off at exactly 30 feet to conform to the local building code requirements.

OPPOSITE: The striking fireplace was found online by architect Scott Bromley—it replaced the original fireplace which had been lost in a 2015 fire which damaged much of the A-frame.

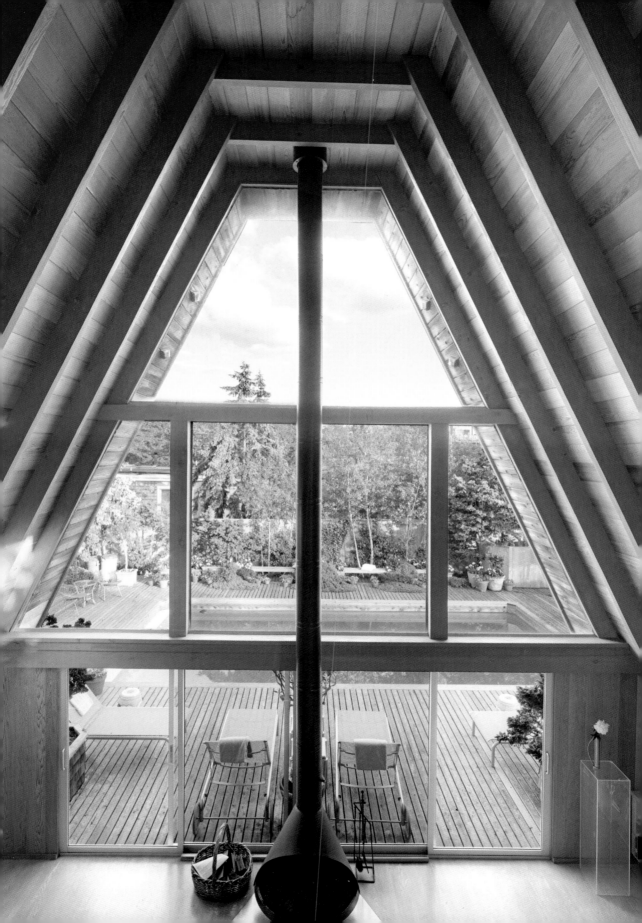

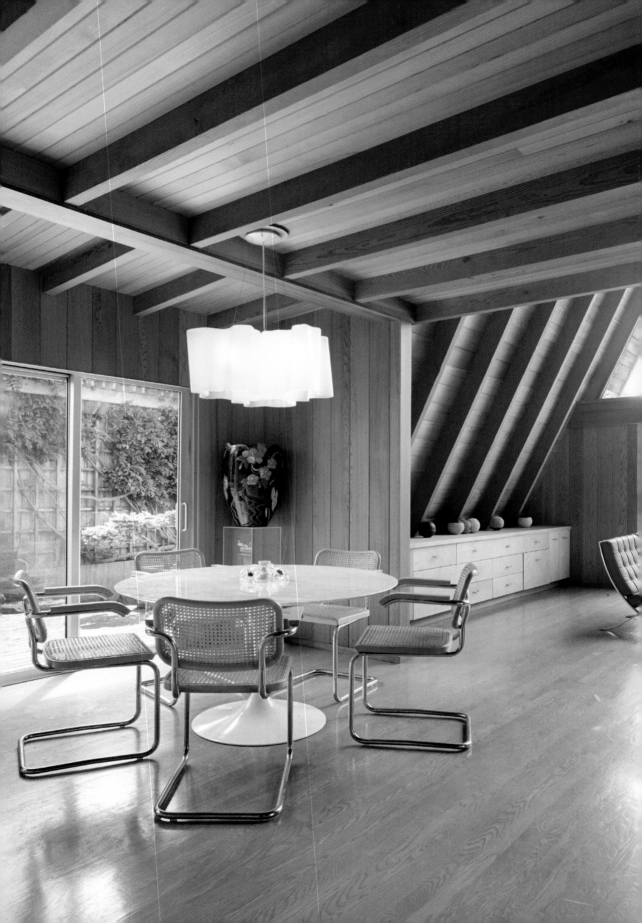

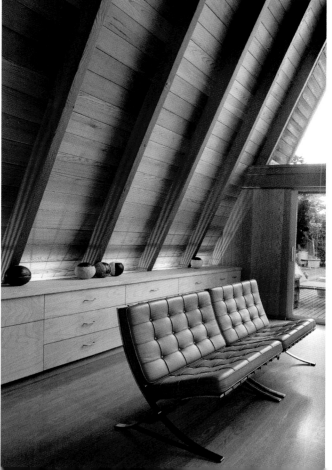

OPPOSITE: Saarenin table.

ABOVE: Ceramic and bronze sculptures were made by Virginia Scotchie.

BELOW: Built-in side cabinets where the "A" sides meet the floor were one of many updates done during a 2002 remodel. Sumner designed the uplighting behind the cabinets to dramatize the angles of the walls.

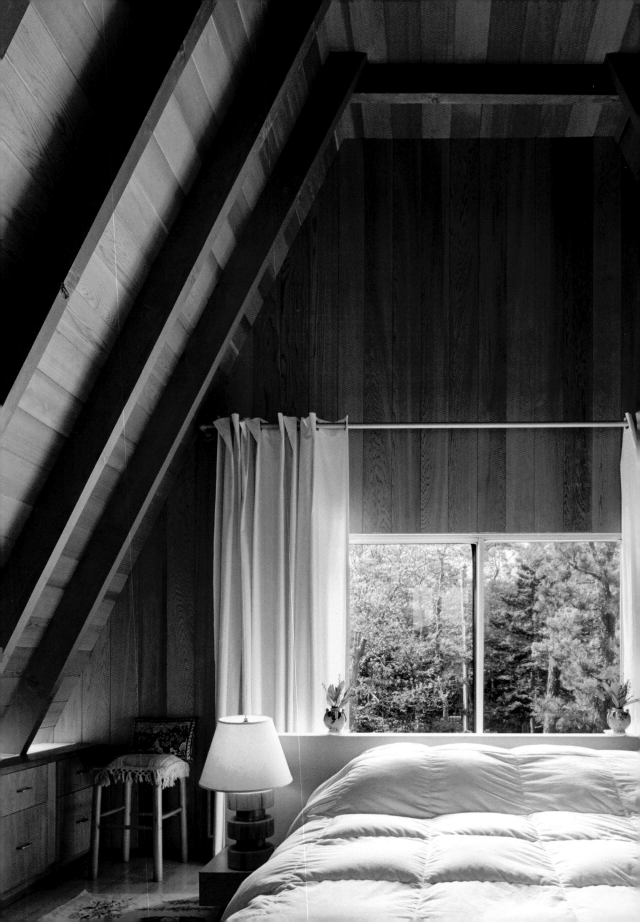

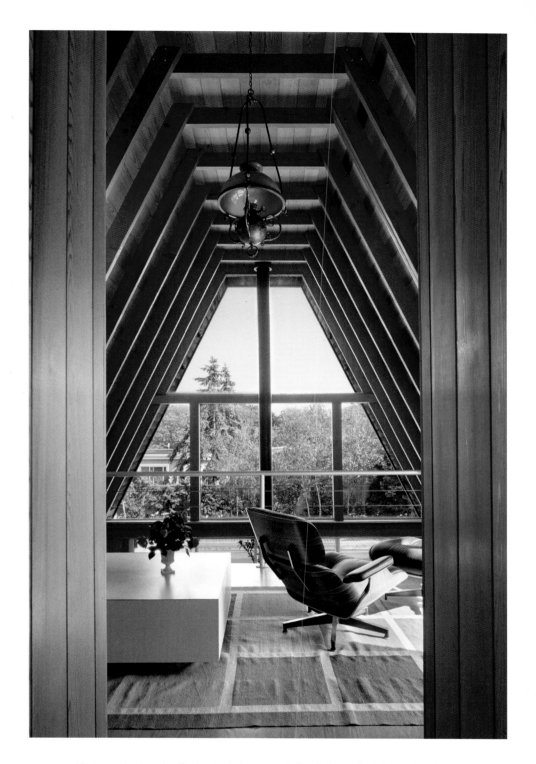

OPPOSITE: Vintage steel and raffia bedside lamps suit the A-frame's style perfectly.

ABOVE: A spacious balcony, also used as a guest room, looks out over the cross piece of the "A." Pendant lamp is a French gas lamp from 1890, converted to electricity.

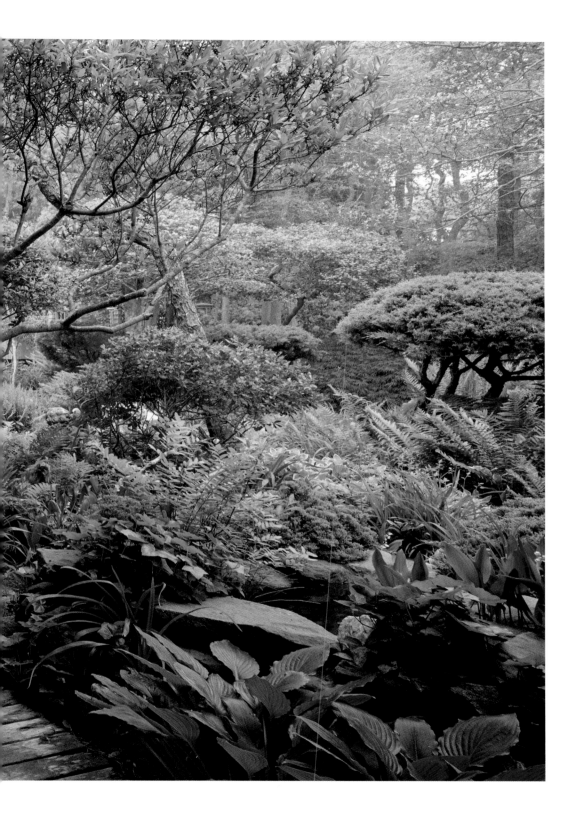

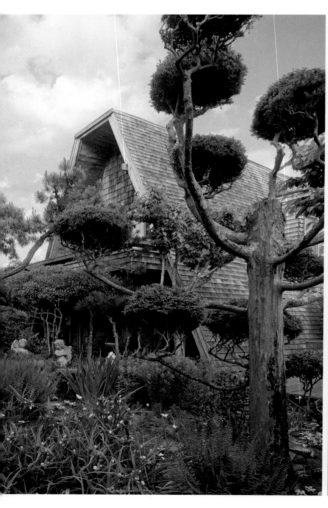

Paths, bridges, and wooden walkways invite garden guests to meander, stop, and look. A six-foot fence around the entire property protects the foliage from roaming deer. The birdhouses were picked up at a local craft shop; Kenneth Ruzika fashioned their tree from driftwood logs.

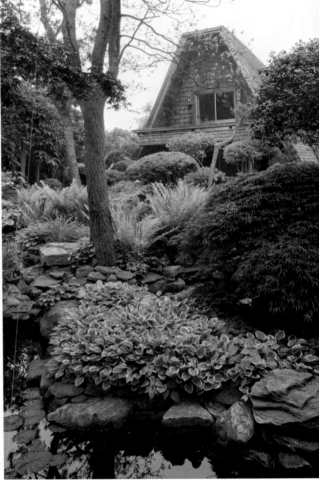

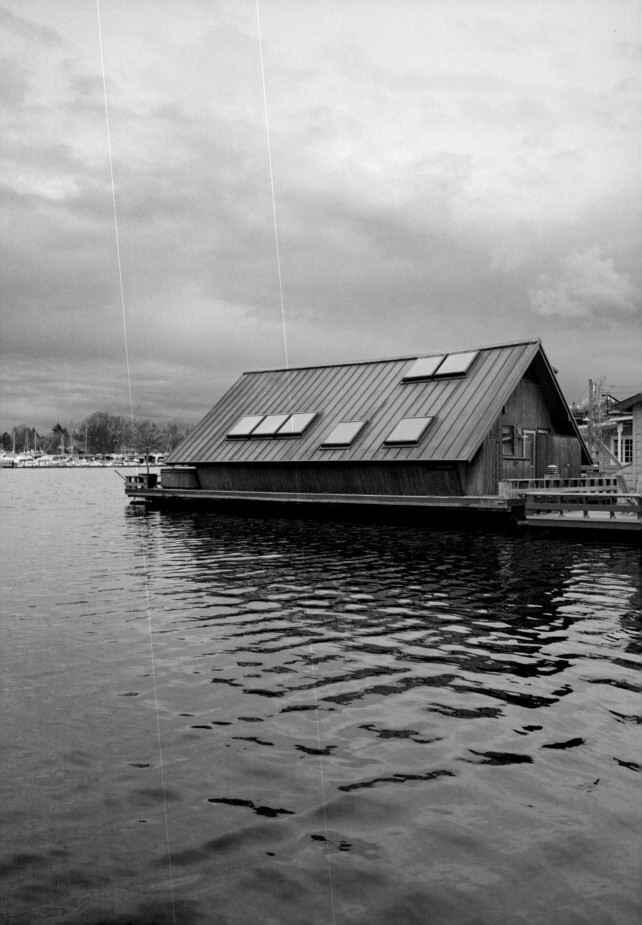

FLOATING
A-FRAME

Seattle, Washington

One home stands out among all the others along the worn docks of Portage Bay, in Seattle, Washington—an A-frame unique by even A-frame standards. Located at the end of the pier with no immediate neighbors, this floating A-frame provides loads of privacy with the unmatched benefit of sensational views. The main floor living room looks out onto the bay, with a nearly panoramic vista of the water. The Seattle skyline, the yacht club, and the University of Washington are all taken in with one sweeping survey of the landscape. And because the bay is a microclimate, the sun can be shining on the pier even if rain is pouring down on fellow Seattleites just a mile away.

The floating A-frame was built in 1968 by the former owner of the largest steel smelting operation in the state of Illinois. He built it as a music studio for his wife who was a professor of music at the University of Washington. There is rumored to have once been a grand piano in the living room.

The newest owner of the floating A-frame, David, is still settling in. A life-long Seattle resident, he has always been drawn to houseboats in the area and knew it was quite rare for one to become available at the end of the pier.

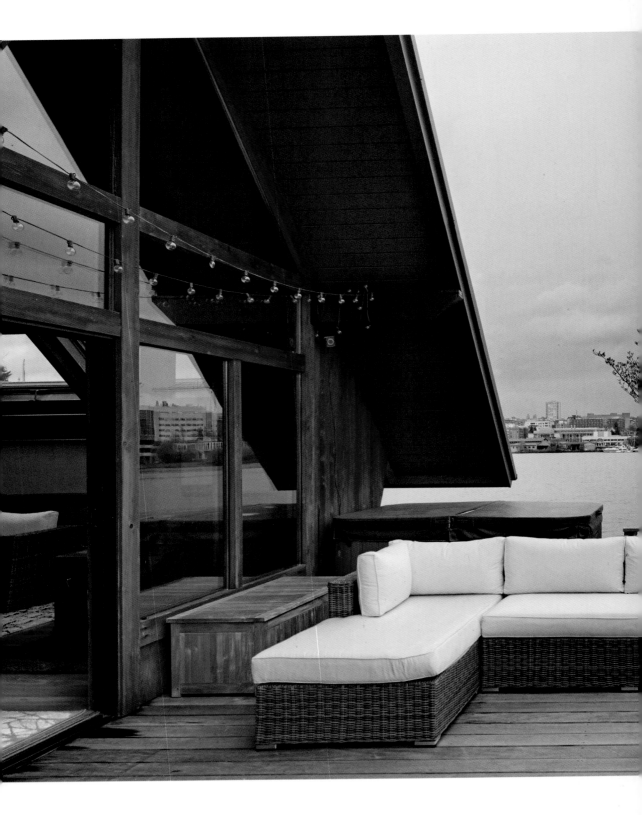

When David saw this well-kept A-frame on its platform of ironwood decking listed for sale, he purchased it immediately.

At just over 1,000 square feet, the house is modest in size. Gorgeous cherry hardwood floors and cherry wood kitchen cabinets bring warmth and beauty to the interiors. A dozen four-by-four–foot skylights throughout the A-frame open to the outside to let in fresh air and sunshine. Twenty-foot-tall trees line one side of the houseboat. The sunlight reflecting off the water at the close of day is beautiful, and watching boats drift by from the front-row seat of the hot tub on the deck is a perfect way to unwind at the end of the day. ▲

String lights, outdoor seating, hot tub, and un-matched views create a festive atmosphere.

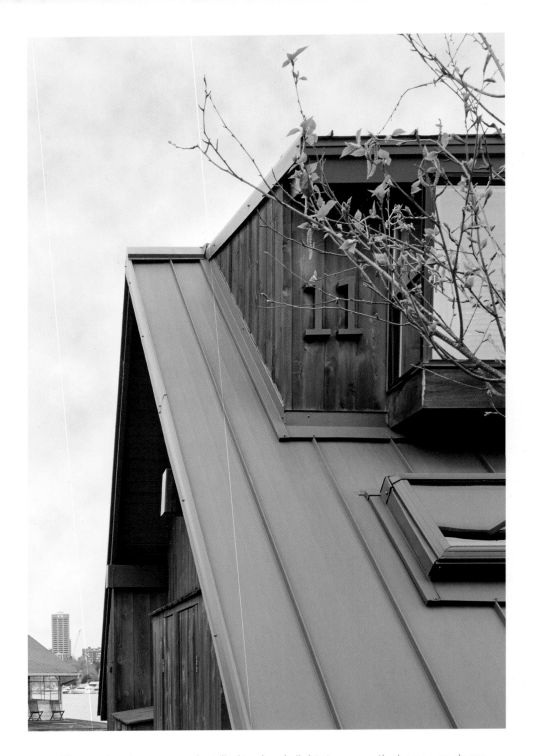

ABOVE: The previous homeowner installed twelve skylights to ensure the home was always flooded with natural light.

OPPOSITE: Stacks of wood waiting in the wings along the cedar siding to be used in the A-frame's woodburning stove.

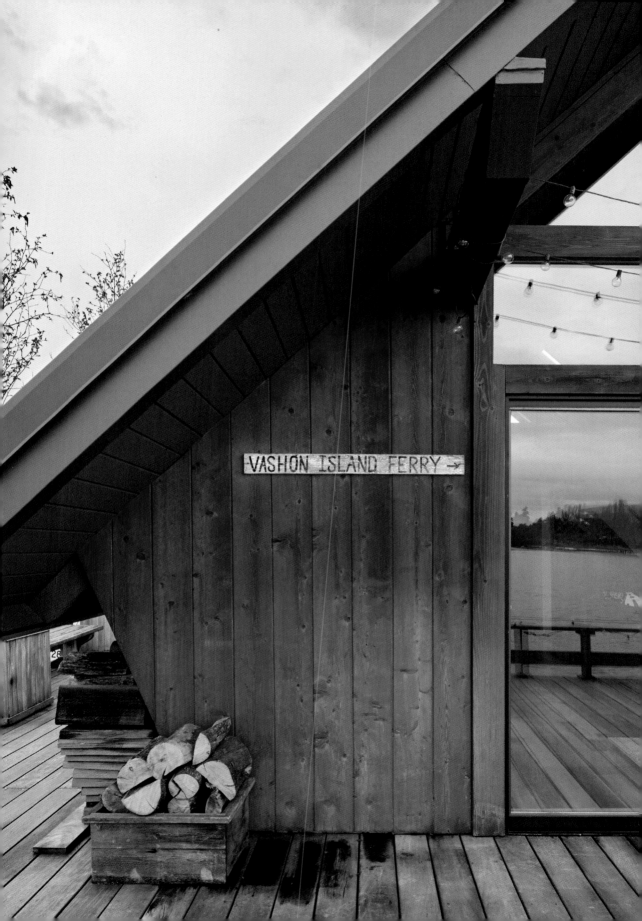

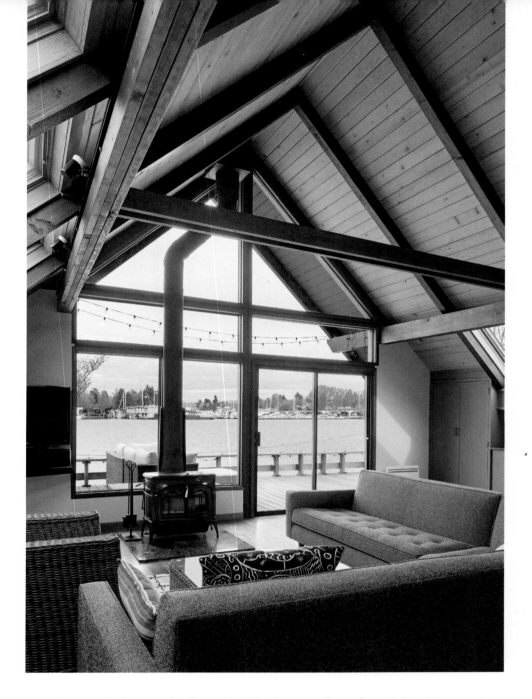

ABOVE/OPPOSITE: Yachts traveling from Lake Washington to Puget Sound glide right past the floating A-frame. The home's previous owner described its living room as "a never-ending gallery of sailboats and powerboats and yachts and kayakers."

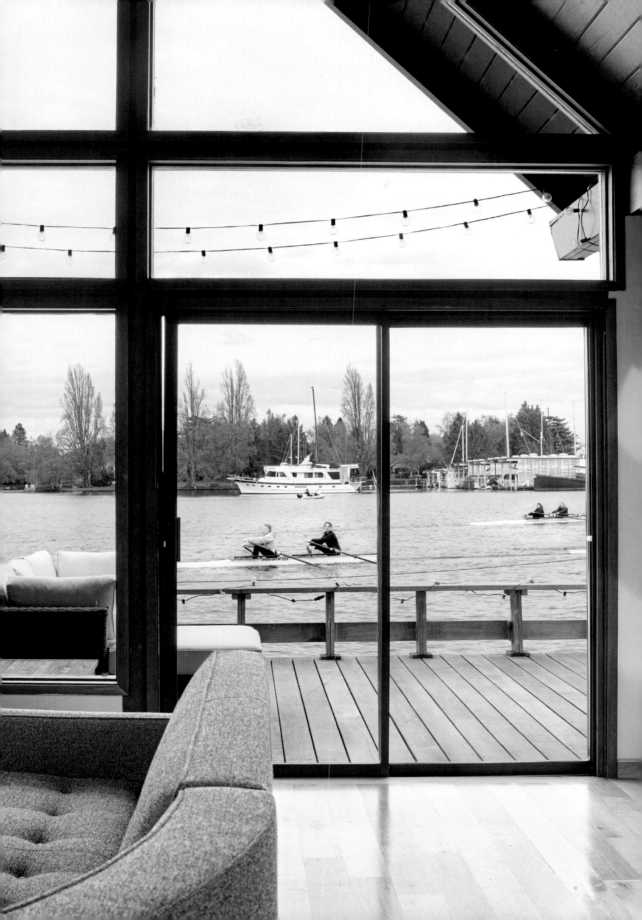

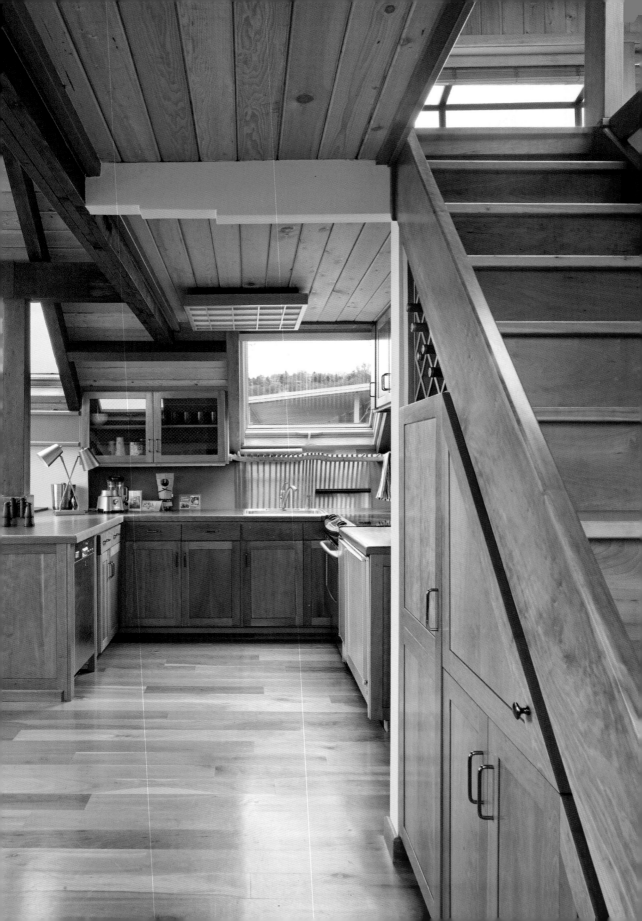

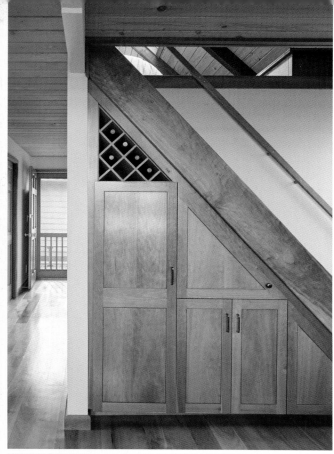

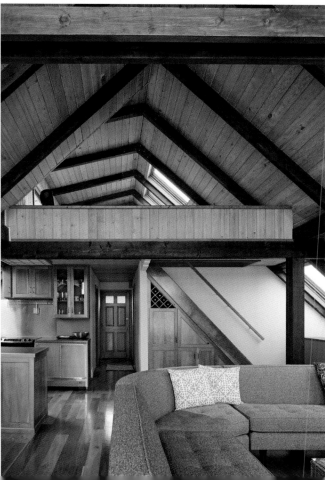

OPPOSITE: A modestly sized kitchen in this unconventional house-boat has been fully renovated to include modern amenities.

ABOVE: Cherrywood floors and custom cabinets bring warmth and a pleasant sheen to the interiors.

BELOW: Stairs lead to the master bedroom in the loft.

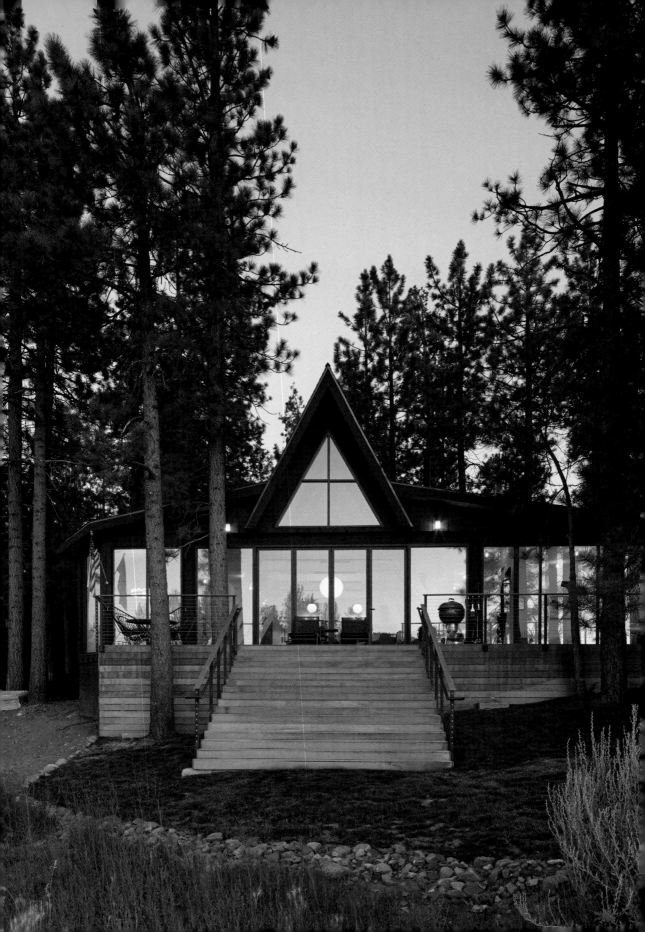

MOUNTAINTOP
MODERN

Big Bear, California

O nly a few hours' drive from Los Angeles, Big Bear is situated in the San Bernardino National Forest and is home to abundant ski trails plus twenty-two miles of shoreline surrounding its freshwater lake. It was with these benefits in mind that Jason and Laura set out to find a weekend home for their family of four.

While on a day trip to Big Bear in 2014, just before the new year, they discovered a little A-frame online that hadn't been used (or maintained) in years. The home was positioned on the water, with 125 feet of lakefront to call their own—enticing enough for Jason and Laura to make a visit to the property. When they arrived, they had to carry their two kids in their arms because the home was so overrun with mice. While it wasn't much to look at, and would require a significant remodel, Jason and Laura were willing to take the risk. They had lived in an A-frame in Lake Arrowhead a few years prior and knew the appeal and impact of those soaring ceilings and dramatic windows firsthand. And as home developers themselves, with Jason acting as lead architect and designer, they had what it would take to tackle the project with confidence. An offer was made that same day, and the A-frame was theirs six weeks later.

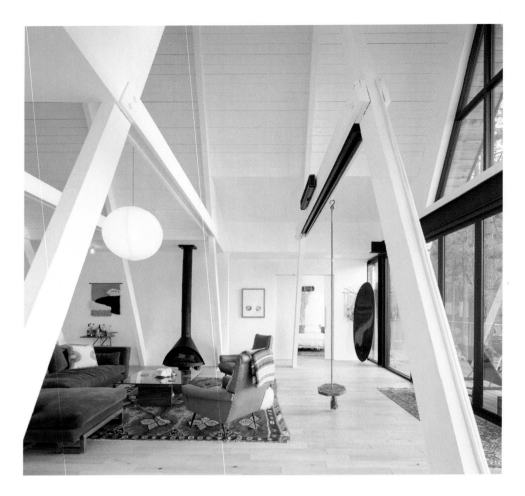

During the design process, the house's poor condition rendered it entirely unusable for the time being. Seven months after Jason and Laura's offer, construction began. The second story inside was completely removed, and they added wings onto three sides of the house to make it sizable enough for their growing family. In total, the house covers 2,000 square feet, all on one level.

Their kids, now three and six, have already learned to appreciate the beauty and the slower pace of mountain life in their beloved A-frame. Able to spend all day outside, they often wind down with a movie in the evenings. Jason was able to teach them how to snowboard their first winter at the house, while

ABOVE: Rug and chairs are vintage. A movie screen is hidden in the first interior crossbeam. Noguchi lamp is on a pulley system which raises the lamp when the screen comes down; a subwoofer was placed in the floor under the sofa for an optimal movie-watching experience.

OPPOSITE: Ceilings in the A-frame reach 28 feet. The rear of the sofa has a built-in walnut shelf to add visual interest, as the sofa is a centerpiece in the room.

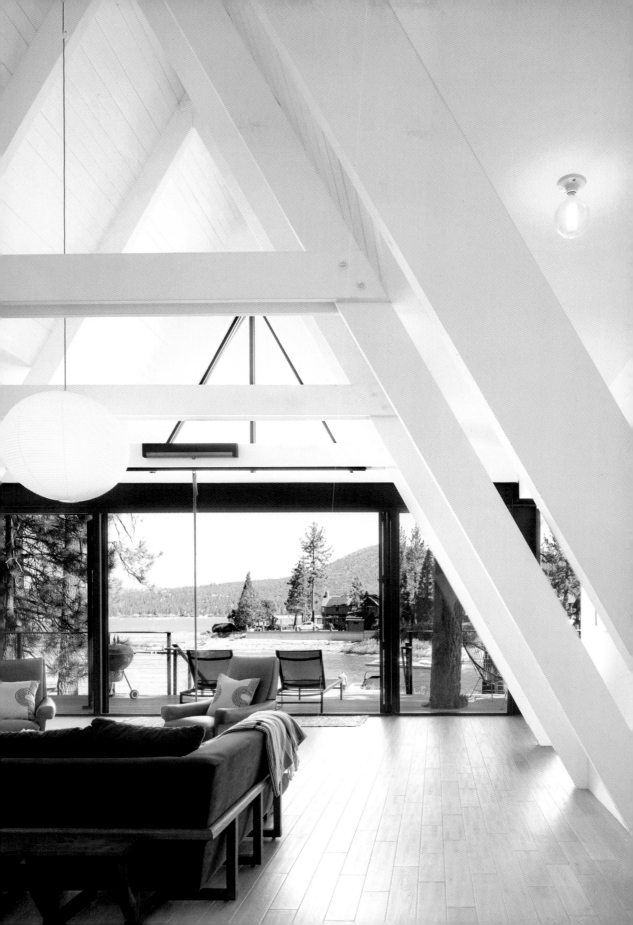

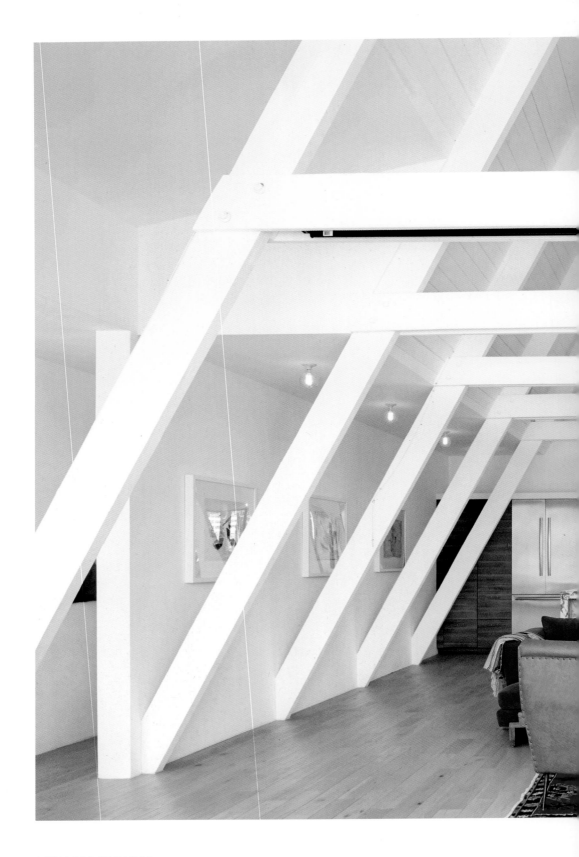

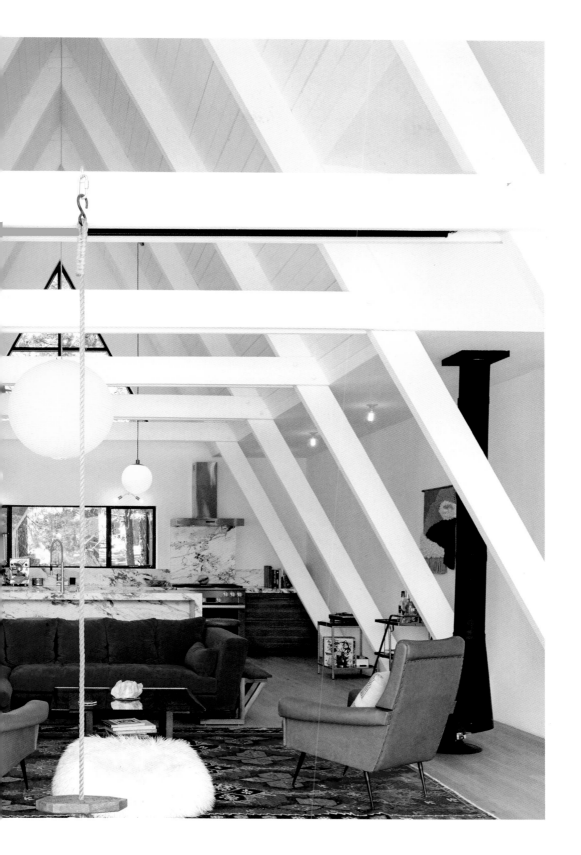

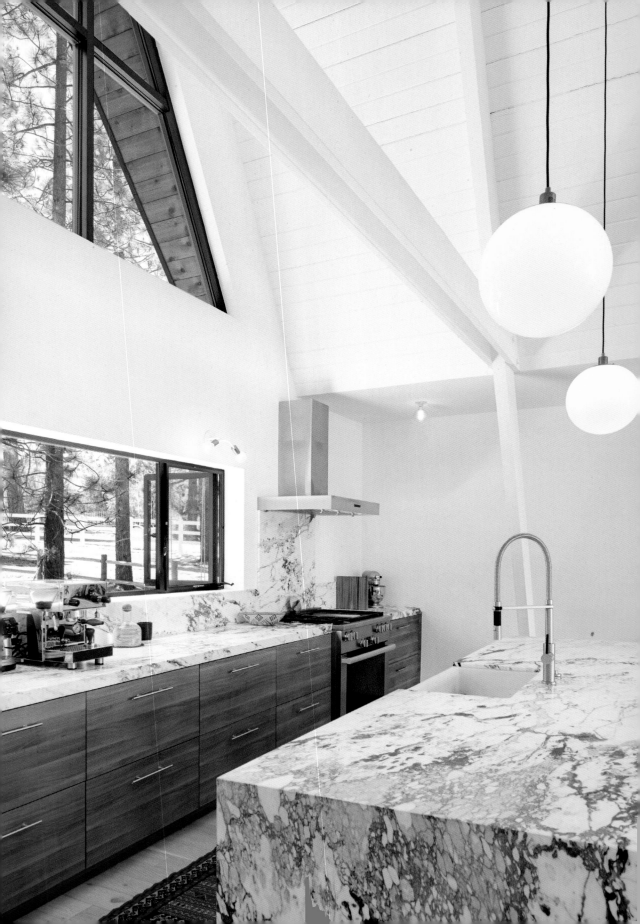

during the summer wake surfing is a daily activity.

The shoreline that beckoned to them from their first visit now has a dock for their boat in their own backyard (or front yard, if you ask Laura). With a third child on the way, the family intends to spend as many weekends as possible in their modern mountain A-Frame, where they can let go of everything and recharge together. ▲

OPPOSITE: Kitchen countertop is calacatta marble, known for its distinctive veining. The fabricator had to work with absolute precision to ensure the seams of the waterfall aligned.

ABOVE: A wall of windows provides views of the yard and lake beyond.

BELOW: Macramé wall textile by designer Kelly Sørensen Hansen hangs above a vintage bar cart.

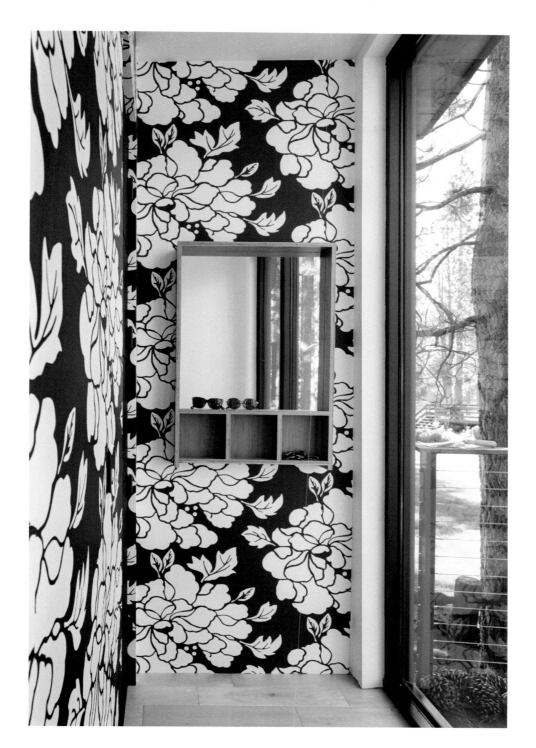

OPPOSITE: Custom-made pocket doors provide privacy when needed, and disappear when not in use. Macramé in master bedroom by designer Emily Katz, who created this piece using driftwood Jason and Laura found while on a hike in Big Sur, CA. Wall art is by Cara Levine.

ABOVE: Entryway wallpaper is designed by Laura.

Brushed brass fixtures and walnut cabinets throughout the home add a warm contrast to modern white. Bunk beds were custom built into the framing of the house, complete with custom cup holders in case the kids want a sip of water during the night.

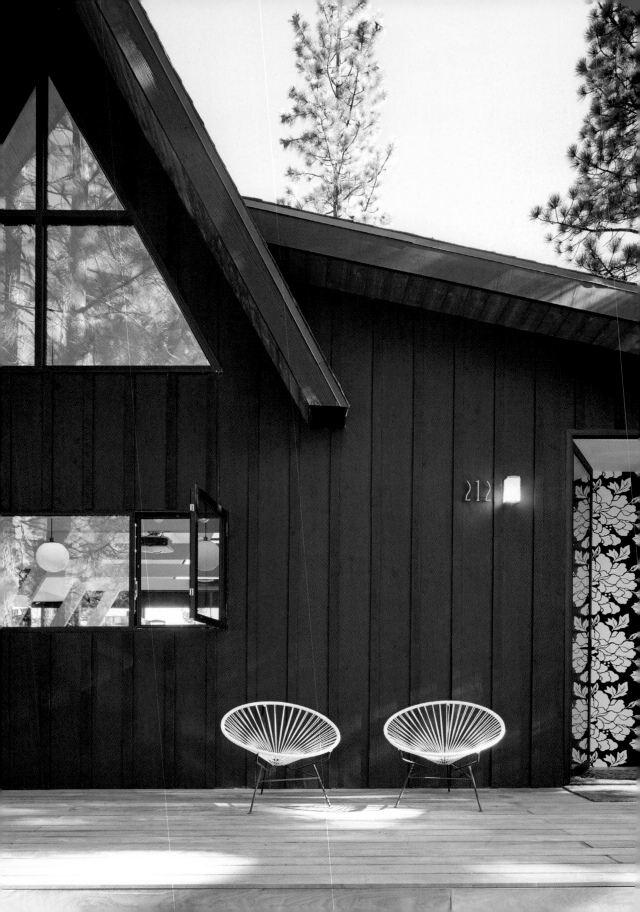

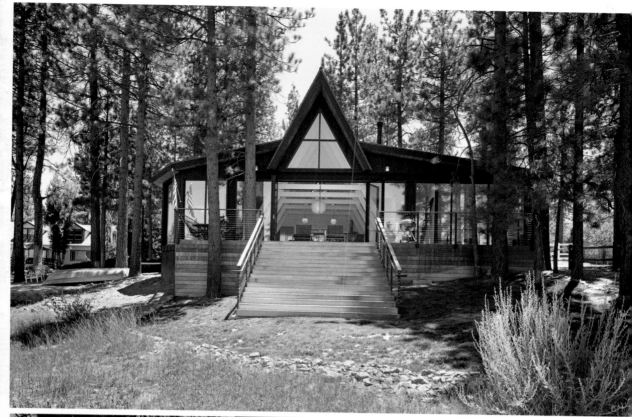

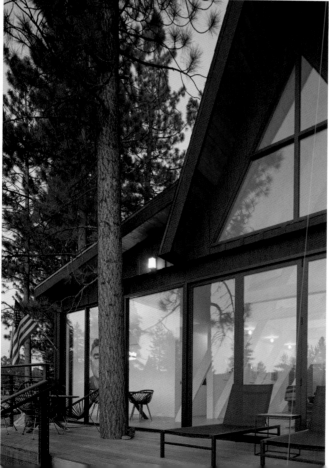

OPPOSITE: Sleek modern deck chairs ornament the home's entry.

ABOVE: The house is positioned at the end of a cul-de-sac; the grand stairs lead directly to the lake, and the family's boat dock.

BELOW: Chaise lounge chairs provide a picture-perfect spot to recline.

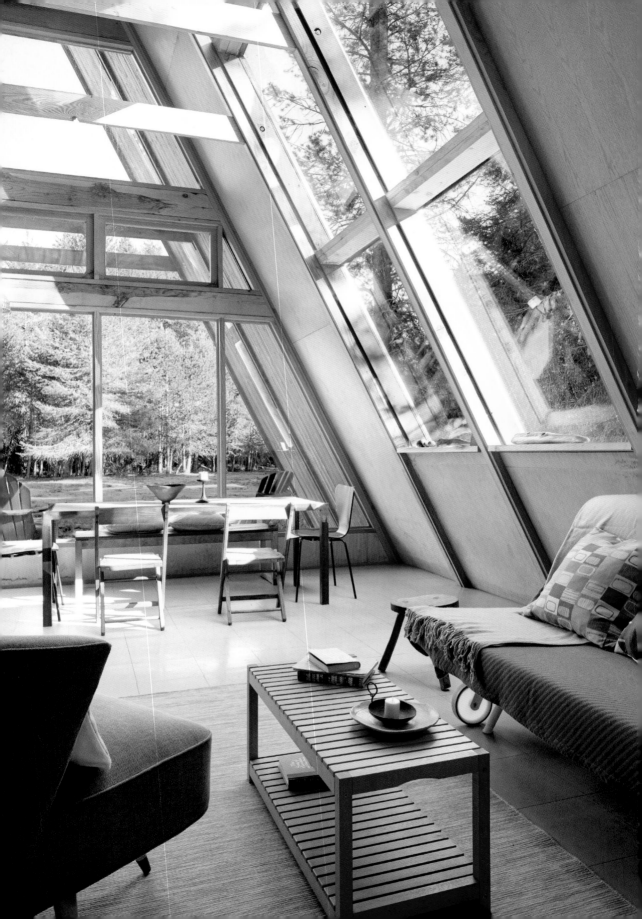

ACKNOWLEDGMENTS

Thank you to the A-frame homeowners: Matt and Orson Frisbie; Jason and Laura Odell; Dan Birman; Doug Harris and Bill Van Parys; Sumner Freeman and Roy Yeager; David McCallum; Curtis and Susan Popp; Astrid and Brian Insieme; Christine Boyer and Antonie Scholtz; Anna Margaret and Srijon Chowdhury; Desanka Fasiska and Ryan Mossé; Paul O'Neil and Andrew Loesel; Julia Brabec and David Pickman; Savannah Cotter and David Lipchik; Olive Meyer; Sarah Reid and Matthew Latkiewicz; Chiara and Ron Gajar; Freddie Friedler and Theresa di Scianni; Edgar Papazian and Michelle Lenzi; Jocelyn Chapman; Brenton and Melanie Brown; Heinz Legler and Veronique Lievre; and Kris Roni—thank you for your generosity, letting me into your homes, feeding me, and sharing your stories. This project has made me realize that only interesting people live in A-frames.

Scott Bromley and Scott & Scott Architects for designing beautiful spaces, and for connecting us with your clients.

Katie Killebrew of Gibbs Smith for all your help editing and assembling this book, and especially for coming to us with this idea and having the confidence to trust us with a book, even though we'd never done one before.

James Morley and Nichole Silva for holding down the fort while I was away and taking such good care of the photographs when I got back.

Ceri Marsh, Esme, and Julian for putting up with my repeated absences and graciously accepting T-shirts and snow globes as compensation.

And especially Erika Jacobs for helping research, plan, and edit every photo shoot. Without you, this book would not have happened. Your efforts and enthusiasm made it a pleasure to work on and a book I'm very proud of.

The interior of this classic A-frame vacation rental in Far Meadow, Yosemite, California, is rustic and simply modern.

Ben Rahn has been photographing architecture and interiors for more than twenty years. He founded A-Frame in 2003 out of a desire to combine his love of design with his keen photographic eye. Since then, his work has been recognized internationally and has appeared in a variety of publications. When he isn't traveling for work, Ben splits his time between Brooklyn and Toronto.

SECTION A-A
SCALE ¼"=1'-0"

BALCONY RAIL

LADDER
TO
SECOND
FLOOR

SHELVES

REFRIG.

WATER
HEATER

COOK. SUR.
& CAB.

STORAGE

SHELVES

GRADE

SECTION B-B
SCALE ¼"=1'-0"

SHELVES

REFRIG.

GRADE

WATER AND SOIL LINES FOR KITCHEN
AND BATH TO EXTEND THRU FLOOR
AND BE INSULATED AGAINST
FREEZING BETWEEN FLOOR AND
FROST LINE BELOW GRADE.
PROVISION SHOULD BE MADE FOR
SHUTTING OFF WATER TO CABIN
AND DRAINING ALL LINES.

SECOND FLOOR

FIXED GLAS

2'-4"W x 6'-0
SOLID PAN
SCREENED

FIXED GLAS

BED RO

PORCH

2'-4"W x 3'-6"H
D.H. WINDOW

2'-6"W x 6'-8"H
GLAZED DOOR
SCREENED

2'-6"W x 6'-8"H
SOLID PANEL

2'-6"W x 6'-8"H
SOLID PANEL
DOOR

2'-4"W x 3'-6"H
D.H. WINDOW

BATH

FLOOR LOCKER 18"H

4'-0" 4'-0" 4'-0